Otis Kaye

Money, Mystery, and Mastery

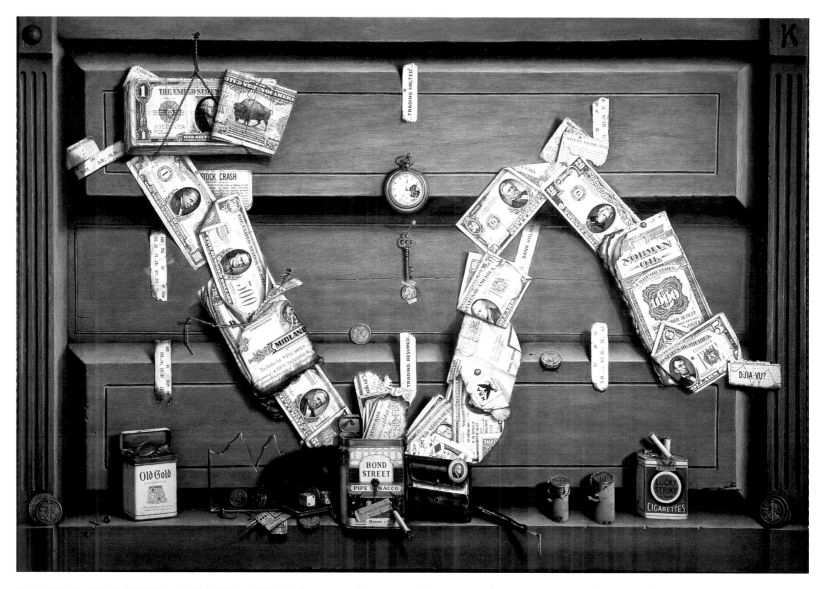

OTIS KAYE, *D'JIA-VU?*, 1937, Oil on panel, 27 x 39½ in., Signed: Otis Kaye, Cordover Collection, LLC

Otis Kaye

Money, Mystery, and Mastery

James M. Bradburne
Geraldine Banks

With an essay by Mark D. Mitchell

New Britain Museum of American Art
New Britain, Connecticut
Distributed by University Press of New England

This book is published in conjunction with the exhibition
Otis Kaye: Money, Mystery, and Mastery, organized by the New Britain
Museum of American Art.

Otis Kaye: Money, Mystery, and Mastery
January 17 to May 10, 2015

New Britain Museum of American Art
56 Lexington Street, New Britain, Connecticut 06052-1414
Telephone: (860) 229-0257 / Fax: (860) 229-3445
www.nbmaa.org

Permissions
New Britain Museum of American Art
56 Lexington Street
New Britain, Connecticut 06052-1414

Distributed by University Press of New England
One Court Street
Lebanon, New Hampshire 03766
www.upne.com

Edited by Devorah Block, Firenze, Italy
Catalogue Entries edited by Pamela Barr, New York
Designed by Melissa Nardiello, New Britain, Connecticut
Photography of Otis Kaye works with the exception of the appendices
by John Urgo and Elizabeth Sirrine

Library of Congress Control Number: 2014958524
ISBN: 978-0-9724497-5-5

Printed in the United States of America

This catalogue is funded by The Cordover Family Foundation
and the David T. Langrock Foundation.

TABLE OF CONTENTS

INTRODUCTION

For thousands of years, artists have aspired to capture two dimensionally what nature has created in the round. The goal is to give life to an inanimate object. People have been entranced by paintings that trick the eye since the very dawn of civilization. Related by Pliny the Elder in his *Natural History*, the rivalry between two competing Greek masters of the 5th century BCE, Zeuxis and Parrhasius, illustrates how keenly they vied to establish pre-eminence in the genre of still life painting. Observers saw birds pecking at fruit painted by Zeuxis and were amused to realize the deception had succeeded so convincingly. But, when Zeuxis told Parrhasius to part the curtain obscuring his still life, Zeuxis was compelled to cede the victory to Parrhasius because the cloth was itself an illusion and while one artist had fooled a few birds, the other had tricked a human being.

Since its founding in 1903, the New Britain Museum of American Art consistently has acquired significant *trompe l'oeil* paintings for our permanent collection, among them examples by Raphaelle Peale, John Frederick Peto, William Harnett, Ken Davies, and dozens of others. The Museum also has mounted exhibitions which have championed the genre. The pioneering art historian Alfred Frankenstein, who devoted his expertise to uncovering little known practitioners, collaborated with my predecessors over many years. Founding director Sanford Low was one of the first to discover and display major examples by Connecticut artist John Haberle; when he acquired *Time and Eternity*, in 1952, Low was given the artist's watch and rosary beads by Haberle's grateful daughter, who was overjoyed that her father's genius would be appreciated at the oldest museum of American art in the nation. In 2009, the Museum mounted a Haberle retrospective, which traveled to the Brandywine River Museum, Chadds Ford, Pennsylvania, and Portland Museum of Art, Portland, Maine.

In 2004, the New Britain Museum assembled 59 *trompe l'oeil* paintings and sculptures in what proved to be one of our most enduringly popular shows, and in 2008 we recognized the extraordinary skill of Michael Theise (b. 1959), another Connecticut artist who continues the tradition of Zeuxis and Parrhasius.

Thus, we were readily receptive to Geraldine Banks, who is Research Coordinator for the Otis Kaye Family Trust, and James M. Bradburne, Director General, Palazzo Strozzi, Florence, Italy, when they communicated their wish to work with the Museum on the first major museum exhibition and catalogue devoted to Otis Kaye, a brilliant *trompe l'oeil* artist. We are very proud to own *Win, Place, Show* (1958), by Kaye, a gift from the Otis Kaye estate. The painting hangs next to works by Peale, Peto, Haberle, Harnett, and others. Kaye deserves to be better known because his mastery of the art form, both in terms of technique and allegorical complexity, represents innovation as well as a fulfilment of his goal to add yet another chapter to a venerable tradition.

It goes without saying that this project is the result of years of study and devotion on the part of Geraldine Banks and James M. Bradburne, who have shepherded all aspects from the start. I am most appreciative. The essay written by Mark D. Mitchell, Associate Curator and Manager, Center for American Art at the Philadelphia

Museum of Art, "Hidden in Plain Sight: Otis Kaye and *Trompe l'Oeil* in America," places Kaye within the context of American art. All the staff—Stacy Cerullo, Anna Rogulina, Emily Misencik, John Urgo, Keith Gervase, Melissa Nardiello, Nick Artymiak, Claudia Thesing, Amanda Shuman, Jenna Lucas, Lacy Gillette, Tom Bell, Georgia Porteous, Melanie Carr, Terrance Regan, Sarah Rohlfing, Margaret Vaughan, Linda Mare, Heather Whitehouse, Katy Matsuzaki, Celina Marquis, and Michael Smith—have embraced Otis Kaye with enthusiasm and the results of their work are impressive. I would also like to thank Pamela Barr and Devorah Block for their editorial skills.

Of course, we are dependent on the many private collectors—Ron Cordover, Walter and Lucille Rubin, Richard Manoogian, Frank Hevrdejs, the Board of Governors of the Federal Reserve System and the Sheldon Museum, University of Nebraska—for their loans. Above all, I want to thank Ron Cordover for his generous contribution through the Cordover Family Foundation, which has allowed us to publish such an excellent monograph on Kaye with contributions by Geraldine Banks, James M. Bradburne, and Mark D. Mitchell, which are included in the catalogue, *Otis Kaye: Money, Mastery, and Mystery.* This publication consists not only of the insights of the contributors, but also extensive interpretive explanations of many of his masterpieces. It will be distributed by the University of New England Press. Published for the first time is a complete list of his known oil paintings, mixed media works, etchings and engravings, drawings, watercolors, and pastels. Future researchers will benefit from the letters, transcriptions, and magazine annotations included in the

appendices. Additional funding has been received from the David T. Langrock Foundation, which has supported now several of our important scholarly monographs.

Mystery about his origins and other aspects of his life and career has surrounded Otis Kaye since he first attracted notice. I am glad now that some of these questions have been answered. However, most importantly, with this exhibition and catalogue we may feast our eyes on some of the most exquisitely beautiful and complex *trompe l'oeil* paintings ever created in this country.

Douglas K. S. Hyland
Director

REFLECTIONS ON OTIS KAYE

Otis Kaye, *D'JIA-VU?*, 1937, Oil on panel, 27 x 39½ in.,
Cordover Collection, LLC

As a serendipitous consequence of having discovered Kaye's extraordinary painting *D'JIA-VU?* at the home of a private collector while organizing "Art and Illusions" at the Palazzo Strozzi in 2009, I met Geraldine Banks, who came to Florence with her daughters to see the exhibition in which Kaye's work was shown for the first time in Europe. We soon found ourselves investigating the mystery of Otis Kaye (1885–1974). Writing a biography means confronting very quickly how little one knows about anyone. It is an interesting paradox that, on the one hand, we all know something about one another (friends, partners, children) but by no means everything. On the other hand, everything is known by someone but often by many different someones—the bank teller, the flight attendant, the shopkeeper, the dentist, the co-worker, and the business colleague. The more complex the life, the more people are needed to complete the picture. Of course, I am not speaking of the interior world of thoughts, ambitions, and dreams but merely of the visible world, of being somewhere at sometime doing something, which in Kaye's case is already difficult enough.

"Otis Kaye: Money, Mystery, and Mastery" is an exceptional exhibition and Otis Kaye is without a doubt an exceptional artist. As Mark D. Mitchell describes in his essay, "Hidden in Plain Sight: Otis Kaye and *Trompe l'Oeil* in America," Kaye finds himself sometimes unwillingly, sometimes deliberately, in the tradition of American *trompe l'oeil* painting that began in the late-19th century with William Michael Harnett, John Haberle, John Frederick Peto, and Nicholas Alden Brooks. This exhibition explores the wide range of Otis Kaye's work—from highly accomplished *trompe l'oeil* paintings showing carefully detailed bank notes and share certificates, to finely engraved copies of other artists' masterpieces, to less accomplished still lifes, nudes and landscapes. Kaye saw himself as an artist first, and a *trompe l'oeil* artist second. But, like all artists, Kaye was much better at some genres than others.

Trompe l'oeil painting is notoriously difficult to pin down and often masquerades as other styles. Alfred Frankenstein argued that it is characterized by the use of shallow perspective in order to create the illusion of depth,[1] but that assessment seems limited and technical—an attempt to pour the fluid nature of *trompe l'oeil* into the rigid confines of an art-historical definition. *Trompe l'Oeil* is distinguished not only by its realism or shallow perspective but also by its wit. In the best *trompe l'oeil*, the artist deliberately sets out to trick you and, most important, to let you know that you have been tricked. *Trompe l'Oeil* is almost painfully self-conscious. It delights in the existence of the "other" and is the expression of an artist who directs the gaze outward in the expectation of meeting—and confounding—other minds.

1 Alfred V. Frankenstein, *After the Hunt: William Harnett and Other American Still Life Painters, 1870–1900*, (Berkeley: University of California Press, 1953), p. 54.

Trompe l'Oeil, to a greater degree than many other genres, is highly inter-subjective. Whereas a work by Monet or Rothko conceivably could have been made without consideration for a future viewer, *trompe l'oeil*, with its emphasis on deception and irony, seems unthinkable without an imagined observer—someone to appreciate the joke. In the case of Kaye, however, this assumption is called into question. Kaye was an engineer until the end of World War II and a nomadic semi-recluse afterward. Notwithstanding one unsuccessful episode, he never sold a painting in America during his lifetime. Every one of his major works, which took months of painstaking effort, was stored in the homes of friends and family. His most notable works by today's standards—his *trompe l'oeil* money paintings—were considered unseemly and odd, even by his intimates, and rarely hung. Two things are certain: Kaye never intended his works to be seen, except, perhaps, by his closest friends; and they are full of insider riddles that only his closest contemporaries could unravel. As insider jokes, laughing best and last, it seems the only person Kaye intended to please was himself.

If biography is among the most difficult forms of non-fiction, autobiography might be considered the supreme work of fiction. As can be seen in the catalogue entries and in the essay "Kaye, Money and Morality," the artist wrote his autobiography in *trompe l'oeil*. From his earliest teasing tributes to earlier *trompe l'oeil* artists to his later masterpieces such as *D'-JIA-VU?* (cat. no. 5), *Amor Vincit Omnia* (cat. no. 24) and *Season's Greetings* (cat. no. 33), Kaye told and retold the story of his life in *trompe l'oeil*. Every work is filled with visual puns, one-liners, and clues to the events that marked—and often scarred—his life. For Kaye, each painting served as a comment, a moral statement, a catharsis, a reflection, and a reconstruction of a chaotic, capricious, and seemingly immoral world in which everything could be bought, sold, and lost in a continuing game of chance. One of his last works, the imposing 1957 *Fate Is the Dealer* (cat. no. 25), is not a true *trompe l'oeil*. It shows a hooded figure dealing out cards while Kaye himself, with beret and painter's smock, palette in hand, looks over his shoulder— a self-portrait in an autobiography. If every author is her own first reader, a *trompe l'oeil* seen only by its maker is stripped of the pretence of illusion and is absorbed in the even greater illusion that is memory.

ACKNOWLEDGEMENTS

Every exhibition accumulates debts of gratitude, and in this case the debts are many and the gratitude especially heartfelt. We would like to extend a special thanks to Ron and Barbara Cordover, committed collectors who have been unflagging supporters of the exhibition and of Kaye scholarship since its inception and who helped make the catalogue possible. We would also like to thank Mark D. Mitchell for his contribution to Kaye scholarship and all the public institutions, galleries, and private collectors who generously supported the exhibition with loans, including Jonathan Boos, Ron and Barbara Cordover, the Manoogian and Hevrdejs families, and Lucille and Walter Rubin. Special thanks go to our colleagues and friends around the world, including Judith Barter, Sylvain Bellenger, Douglas Druick and Sarah Kelly at the Chicago Art Institute; Ilene Susan Fort at LACMA; David Smith and Jean Strouse at the New York Public Library; Sir Mark Fehrs Haukohl, Sophie Kaye, David Margolick, Lawrence Shindell, Lawrence Weschler, and Matthew Wander for their help at various stages of the research into the life of the mysterious Otis Kaye. Thanks

Otis Kaye, *American Union Bank*, n.d., Etching, 12 x 9 in., Private Collection

to Jan C. Jacobsen, Josua Littig, and Eva Schläfer at the Deutsche Werkstätten Hellerau and to Alexander Landia, Cornelia Schmalz-Jacobsen, and Matthias Warnig for their help looking for traces of Kaye's German past. Thanks also to Ingrid Kastel at the Albertina in Vienna, Austria, who allowed one of us to compare Kaye's engravings with the originals on which they were based. Thanks go to Carrie Haslett and Betsy Kennedy at the Terra Foundation for having suggested the New Britain Museum of American Art as the ideal venue for this exhibition, and introduced me to its dynamic director. Our most heartfelt thanks go to Douglas Hyland, Emily Misencik, Anna Rogulina, and the rest of the staff of the NBMAA who have provided constant support of every kind during the long gestation of this exhibition, to the catalogue editor, Devorah Block, and its designer, Melissa Nardiello, for their patience, critical intelligence and professionalism. Pamela T. Barr worked on the early part of the editing process and is to be thanked for her help and good humor. We would also like to thank the entire Banks family—Paul M. Banks, Kristen and Oscar Diaz, Craig and Liesl Stiegman, and Rachel and Nathan Young—for their help with this project and especially Paul III, who has protected Kaye's legacy since Otis Kaye entrusted the works to his father.

Geraldine Banks and James M. Bradburne

REFLECTIONS ON OTIS KAYE—POSTSCRIPT

Shortly before this catalogue was finalized, the authors realized we had an exceptional opportunity. Given the extent of the Kaye heirs' collections, we were able to include a series of appendices that documented, for the first time, almost all of Otis Kaye's substantial artistic output. The decision to include these appendices had several unexpected outcomes. First of all, it transformed a modest exhibition catalogue into a near *catalogue raisonné*—albeit without the full scholarly apparatus that would usually accompany such a work; the full *catalogue raisonné* must therefore wait until a scholar is able to devote himself or herself fully to this task. The second consequence was that, seeing all of Kaye's work together for the first time, it became clear to the authors that even the conclusions drawn in the essays in this volume—in particular with regards to dating and sequence—will need to be revised, a task that must be left to future publications. Finally, the ability to see, for the first time, the full breadth of Kaye's output in all media allows us to assess Kaye's enormous technical skills, the complexity of his allusions, the diversity of his interests and his strengths and weakness as an artist in different media. The result is a fuller appreciation of the artistic and philosophical motives underlying Kaye's art and, in the end, the enormity of the mystery that goes by the name of Otis Kaye.

GB and JMB
November 2014

THE LIFE OF OTIS KAYE—NOTES FOR A FUTURE BIOGRAPHER

James M. Bradburne and Geraldine Banks

BACK AND FORTH

Let's start at the beginning. Kaye, and probably even Otis, were only the names by which the artist was known later in life to his family and friends—his German baptismal name is unknown. This makes writing Kaye's biography a challenge. Kaye's father, Werner Kaye (b. 1850?– d. 1903), is said to have immigrated to Illinois from Dresden in the early 1880s and married a Czech woman, Freda Kozlik (b. 1865?– d. 1915?). Werner's surname was also not Kaye; his baptismal surname is unknown. Like many immigrants, Werner simplified his name when he arrived in America, and, like many immigrants, he did not formally register the change of name.[1] Werner and Freda returned to Dresden where Otis was born in 1885, and returned to America in 1888, to Nahma, Michigan.[2] It is said that Werner had a lumber business there that prospered, where Werner and his partner were subcontractors. Nahma, north of Escanaba and near the Hiawatha National Forest in northern Michigan, was a company town founded by the Bay De Noquet Lumber Company in 1881. At the peak of the lumber industry 800 people lived in the town and 1500 men were employed at the mill and in the lumber camps.[3] In 1903, Werner Kaye died in a mill accident, although an extensive search has not turned up the death certificate. His wife sold their share of the business to his partner who suggested that the eighteen-year-old Otis study engineering rather than work in the mills because of his drafting skills. None of Kaye's childhood artwork exists. The Kayes left Nahma, stopped in Chicago, then moved to New York City for a brief time.

Kaye and his mother returned to Germany sometime around 1904, where they presumably found support from Werner's family. In Germany it is assumed Otis studied engineering, possibly at Dresden's famous *Gewerbeschule* (Technical University), where he learned to be a technical draftsman, engineer and engraver. In 1910 Otis married Alma Goldstein (1886–1937), a Jewish girl from Munich. According to the family, Alma's parents were wealthy business people, in banking and gems, and Alma was attractive, well educated, opinionated, and had a beautiful voice. Alma and Otis shared a love for classical music and in later life he listened to it constantly as he painted. They had two children, Freda (named after his mother) in 1911 and Oskar (possibly after himself) in 1913.

Up to this point, there is almost no documentation to confirm the simplest facts of Kaye's life: no birth certificate, no record of entry into America, no record of his father's death, no trace of his time in New York, where he may or may not have studied art, no trace of

1 Otis Kaye to Paul Banks 24 May 1944: "And you were right to push him to make the name change legal. I wish my father had done it." MSS, Archive, Otis Kaye Estate (Appendix 8 p. 173).

2 According to family accounts Otis Kaye was not born in Nahma, Michigan, as is stated in several accounts but was probably raised there. The family's account of Kaye's childhood in Nahma is given credence by the fact that Otis went back up there to see the town in 1949 and that he saved a Life magazine article about the town. *Nahma receipt, miscellany 1949* MSS, Archive, Otis Kaye Estate (Appendix 9 p. 187).

3 Nahma is north of Escanaba and near the Hiawatha National Forest. At the peak of the lumber industry in the late 1800s over 800 people lived in the town and 1500 men were employed at the mill and in the lumber camps. In Sept. 1951 Big Bay de Noc sold the entire town, all of its buildings, to American Playground Device Co. for $250,000.

his return to Germany, no university degree, no marriage certificate. While perplexing, this in itself is not exceptional given the sporadic nature of data collection in late 19th-century America. As early as 1815 Germans leaving for America had to register to ensure they were not avoiding military service, but the lack of Kaye's father's surname makes research difficult. Passports were not required of American citizens until 1941 (with the exception of the brief period from 1918 to 1921), foreign names were often changed or misspelled, and the regular US census, although thorough, was not a model of accuracy when it came to family names. So when it comes to Otis Kaye, with the exception of knowing that he was the son of Freda Kozlik, the elder sister of Anna Kozlik, who later would marry Paul Bancak, even the rough contours of his formative years are highly speculative. Otis Kaye starts to come into focus only when he returns to America.

Probably sometime after the end of the First World War in late 1918 the Kayes returned to America with their two young children, now around seven and five years old. Although America only entered the war in 1917, it would have been difficult during the war given the dangers of trans-Atlantic travel and the quota on German immigration. The family moved to Philadelphia, then an important center for engineering in the US, where Otis was able to find engineering work and profited from investing his wife's money in the active stock market of the 1920s. They visited Chicago periodically, and a number of cityscapes in gouache—some dated—remain.[4] These, along with several small money *trompe l'oeils* and a sketchbook from the Philadelphia

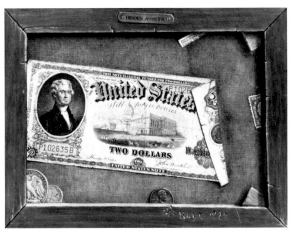

Otis Kaye, *Hidden Assets*, 1920, Oil on panel, 7⅛ x 9¾ in, Private Collection

period, allow us to fix Otis Kaye in time and space for the first time.

In the 1920s, Kaye began painting small *trompe l'oeil* oils of currency for his own amusement, money *trompe l'oeil* having been made illegal in 1909. He included puns and literary devices, and used the currency's faces to provide metaphorical comments on the state of the country. Possibly influenced by painters in Philadelphia, Kaye at first followed existing *trompe l'oeil* examples, which had been made popular in the late 19th century by artists such as William Harnett, John Haberle, John Frederick Peto and N.A. Brooks.[5] Their most famous works were widely diffused in the form of chromolithographs, and were known well before Edith Halpert's rediscovery of Harnett in 1935, which marked a revival of interest in the genre. The first signed work by Otis Kaye, *Hidden Assets (I)*, is dated 1920. For the next fifty years Kaye's paintings are a major source of biographical information. Although many of Kaye's works are undated, the bills and coins shown, as well as numerous other details, provide details about the artist's own life. In 1929, Kaye lost all of their savings, borrowed in part from Alma's family, which had been invested almost entirely in

4 Some of the gouache Chicago city scenes are dated 1928, others are not dated, and therefore could have been done either when Kaye visited Chicago or when he settled on Ruble Street.

5 Kaye's work *Breakout* (1930) contains references to Haberle, Harnett, and Peto.

the stock market. His *trompe l'oeil* oil entitled *Holding the Bag* from the 1930s includes a bank form with the following information: *Otis Kaye, Dec. 2, 1929, Your account is closed. $102,635.12 Due IMM Utility Securities Company, 230 S. LaSalle St. Chicago*. The amount, though possibly exaggerated, suggests the enormity of his loss, and many of Kaye's later paintings specifically document the impact of the 1929 stock market crash on his life.

OTIS KAYE AND THE BANKS FAMILY

While living in Philadelphia, Otis and his family visited the Bancak (Banks) family in Chicago periodically, Anna Kozlik (1882–1939)—Freda's younger sister—having married Paul Bancak (1873–1913) in 1905 and given birth to their son, Paul Banks II three years later.[6] Alma also had a cousin in Chicago, Margot Goldstein, who owned a small jewelry shop in the city at 522 South Michigan Avenue.

In the late 1920s Kaye lost his job in Philadelphia and may have worked for a while in Detroit before moving with his family to Chicago where they found support from the Banks family. The Kayes survived on Otis's part time work in the city and thanks to the cheap rent from his relatives on Ruble Street.[7] His cousin Paul Banks II (1908–1967), twenty three years younger than Kaye, was beginning a career in engineering, and provided Kaye with information on job opportunities. Paul Banks III (b. 1935–) remembers that his father attended Lewis Institute (later the Illinois Institute of Technology,

IIT), where he graduated in the early 1930s.[8] In Chicago the Kayes also formed a bond with Alma's cousin Margot Goldstein. They felt a close connection with Paul II's wife, Bessie Hoffman Banks (1905–2007) whom Paul married in 1931, because Bessie was also German; however, they were living in a predominantly Czech Catholic family and neighborhood. The Banks family was to play a fundamental role in Kaye's life, and much of what we know about Otis Kaye as an artist and as a person is based on the memories of Banks family members: Paul Banks II, who assumed the responsibility of preserving Kaye's legacy, his wife Bessie Hoffman, and their son, Paul Banks III and his wife Geraldine Banks.

According to family recollections, Otis and Alma had different ideas about religion, not surprising given Kaye's scepticism and Alma's Jewish roots. Alma was also unhappy with their frugal lifestyle. With their savings gone, Otis, who was working part-time as an engineer making $25/week, could only provide for the bare essentials, with no extra funds for the children's education. Alma was equally disappointed with the decision Otis made in 1930, following the market collapse the year before, to spend more and more of his free time painting. By 1932 Kaye was 47, Alma 46, Freda 21, and Oskar 19. Alma, increasingly isolated and unhappy, decided to return to Germany with the children for an arranged marriage for Freda, while Kaye stayed in Chicago. Alma returned to America briefly in 1933 or 1934, but she and Kaye soon officially separated, and sometime after 1935 Alma returned to Germany to live with her family and children.[9] Tragically, Alma and

6 There may also have been a third Kozlik sister, Vera, born c. 1892.

7 In the 1950s the city of Chicago began work on the Dan Ryan Expressway that cut through the old Ruble Street neighborhood, and many of the houses were torn down. The houses on the east side of the street still exist but the expressway runs over the west side where Kaye once lived.

8 Founded in 1895, Lewis Institute was the first institution to provide adult education programs, offering courses in engineering, sciences, and technology.

9 Kaye's painting *Amor vincit omnia* (1950) includes an envelope from A. Goldstein, 1908 Union St., Chicago, Ill. to Otis Kaye c/o Frank Becker, PO Box 36, Tremont, Ill. The envelope includes a poem: "Roses are red, violets are blue, lost your money. Lost me too" and Alma's photo. Significantly the postmark is Jun1, 6:30PM 1937 ILL.

Freda were killed in an accident in 1937, although no documentation of the incident has been found. The same year Kaye went to Munich to try to convince Oskar to return to America, but Oskar decided to stay with the Goldstein family. Otis sent a letter from Munich to Paul II and Bessie: *37 Munchen Freitag 8:20 AM. Sold 2 paintings ($l and $5 bills with puns) to Mr. Kisselman.*[10] These were the only two money paintings Kaye ever sold.[11]

From his increasingly extensive output, Kaye clearly spent all his free time drawing and painting, mostly *trompe l'oeil* compositions featuring money—a central theme of his life's work. He painted whenever he could, on whatever material he could find—wood from old discarded furniture was often cheaper than canvas. With time he created larger, more detailed compositions on increasingly complex social and historical themes, often taking contemporary events as a starting point. Kaye was also doing etchings and remained very aware of contemporary artists including Burchfield, Benton, Browne, Curry, Hurd, Soyer and Wood, about whom he kept and annotated *Life* magazine articles, as well as reports of the 1937 Carnegie Show and the Frick Collection. [12]

During the Second World War, Kaye along with Paul Banks II and another engineer with connections in Washington, Charles Ashe, formed the civil engineering firm of JJ Byllesby & Co. at 14 S. LaSalle Street in Chicago (perhaps an allusion to H.M. Byllesby & Company, the

(from left) Otis Kaye, *Male Waist to Foot*, 1958, Red conte crayon on paper, 9⁹⁄₁₀ x 3⁹⁄₁₀ in., Private Collection, Illinois; Otis Kaye, *Standing Nude Woman*, 1950, Red conte crayon on paper, 7¾ x 3¼ in., Private Collection, Illinois

Chicago-based engineering firm and one of the large utility holding-companies of the pre-Depression era).[13] They had minor military contracts and when he was ten years old, Paul III sometimes cleaned the Byllesby offices on Saturdays for 35 cents. He remembers seeing blueprints for gyroscopes used in torpedoes that Byllesby developed, and pistols with red stars on the handgrips for Russia. Apparently Byllesby was successful, due in part to the work of Ashe, although neither he nor his wife were well-regarded by his two associates.[14]

Otis Kaye was a frequent visitor at the Banks home at 7729 S. Seeley on the southside of Chicago when Paul and he were in business together.[15] The engineers, Otis and Paul II and "Toddy" J. Toman, a chemist, would meet there

10 MSS, Archive, Otis Kaye Estate (Appendix 8 p. 170).

11 In 1998 two fake Kaye paintings were authenticated by Bruce Chambers as the paintings Kaye sold in Germany. Kaye's description of his paintings of a one dollar bill and a five dollar bill in his letter of 1937 proves that the *trompe l'oeil* paintings in question are false. These two fakes are nevertheless currently circulating in Europe as Kaye originals (*Fifty Dollar Bill* and *One Hundred Deutschmark Note*).

12 Several magazines with Kaye's annotations still belong to the Banks family: see Appendix 9 p. 184

13 The records from the 1940s appear to have been have been destroyed. Paul Banks III remembers talking about JJ Byllesby & Co. and seeing printed stationery. A handwritten draft letter written by Otis Kaye 6-4-42 lists Paul Banks as President and Otis Kaye as consulting engineer: MSS, Archive, Otis Kaye Estate (Appendix 8 p. 171).

14 A letter from Kaye to Paul Banks II 22 May 1944 is not highly complimentary to Ashe and his wife: MSS, Archive, Otis Kaye Estate (Appendix 8 p. 173).

15 Paul Banks II moved his family from their home on Ruble Street to a house on the south side of Chicago at 7729 S. Seeley Avenue after severing ties with his family due to a dispute about inheritance.

and discuss philosophy, science, and government, often complaining of rampant institutional corruption. Kaye continued to copy the work of artists he admired—a gridded clipping from this period of Gainsborough's *Blue Boy* bears witness to his practice.

His *trompe l'oeil* paintings of the 1940s became independent from the earlier American *trompe l'oeil* masters such as Harnett and Haberle, and he now only used other artists' paintings as references when he wanted to make a humorous or ironic point. Kaye's range of figurative imagery in other media—watercolor, etching, pastels—takes him beyond most *trompe l'oeil* practitioners of the time. During this period Kaye's cousin and partner's surname often figures in Kaye's obsessive punning, and Kaye repeatedly uses the fictional name "P. J. Sknab" in the signatures on his banknotes in recognition of the ways in which the Banks family supported him.[16]

Kaye lived at various times in Tremont, Illinois, about a three-hour drive southwest of Chicago, where Bessie Banks's mother Edith Hoffman and Bessie's three brothers Ed, Albert and Frederic (Fritz) lived in a farmhouse. Here Kaye had the opportunity to work alongside Fritz Hoffman, an accomplished printer. Kaye used the engraving skills he presumably learned in Germany in his youth to meticulously copy Rembrandt, Dürer, Goya, Whistler, the Impressionists, and Picasso from editions of the artists' work, and he often added his own wry visual twists in gouache. In most cases Kaye's copy is the exact size of the original, as they were made from publications of masterpieces of engravings, which Kaye then gridded (he never used photo-mechanical methods to create his etchings). He copied directly in reverse onto the metal or copper plates from which the prints were then pulled.

Assistance was provided by Hoffman, although his facility suggests Kaye had been familiar with the technique much earlier than 1925, the year of his earliest dated etching, *Woman with Mirror.*

Under the supervision of an exacting, demanding and often irrascible Kaye, Hoffman would pull a print from the inked plate. Kaye used a copper plate for copying Rembrandt's *The Stoning of St. Stephen* and cheaper zinc plates for copying Dürer's *Adam and Eve.*

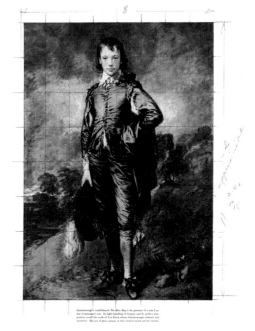

Gridding by Kaye on a reproduction of Gainsborough's *Blue Boy* in *Life* magazine, Otis Kaye Archive

Kaye is such an expert engraver that even when compared to the originals, a trained eye is often hard pressed to spot the differences. After the war Kaye and Banks sold JJ Byllesby, although they remained close friends until Banks's death in 1967. Kaye now devoted most of his time to painting, drawing and etching and stored his paintings in the Banks's garage, standing them in rows, wrapped in old sheets and newspapers taped tightly and in boxes. He frequented art studios in Hyde Park, and Paul Banks III recalls that one Sunday in the 1950s on their way to the Museum of Science and Industry, Kaye told Paul II to turn into a street where there were bookshops, art supply stores, and studios.

16 Kaye often refers to Paul Banks II as "Sknab" in letters: MSS, Archive, Otis Kaye Estate (Appendix 8 p. 173 and 180).

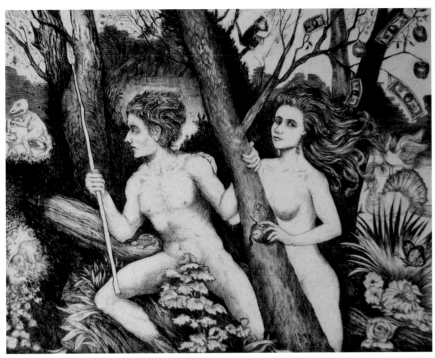

Otis Kaye, *Adam and Eve*, 1949, Etching, 12 x 15 in., Private Collection, Illinois

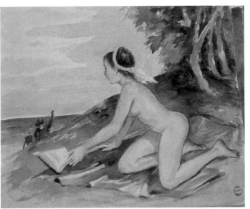

Otis Kaye, *Laura Mich. Dunes* (nude reading), 1960, Watercolor on paper, 19 x 24 in., Private Collection, Illinois

For larger works Kaye sometimes used the art facilities at St. Procopius College where a sister of Paul Banks II, Sister Laurencia, lived, to whom he had given several paintings, including a *Crucifixion*.

Since the 1930s, Kaye had always lived very cheaply, although for a while he had some money from the sale of JJ Byllesby. He did consulting, got room and board from relatives, and did odd jobs for them, as he was not only a trained engineer, but a competent handyman. He travelled cheaply in Eddy Hoffman's truck. After he lost his family in 1937, he seems to have been totally absorbed by art, witnessed by the range and number of his works. After the war he lived and worked in Chicago, Indiana and Tremont. He travelled west and wrote about it enthusiastically, made trips to Nahma and to New York. At the beginning of the 1960s, Paul II and Kaye took some of the landscapes and still life paintings that were stored in the Seeley Avenue garage to Margot Goldstein, Alma's cousin, who had a small gallery in downtown Chicago. Established in 1945, the La Borie Gallery was owned by Margot and her nephew Henri La Borie. Since it was still technically illegal to depict money, it was decided not to offer the money *trompe l'oeil* for sale, and in the end they were able to sell only a very few works.

Kaye, now in his seventies and still in robust health, frequently stayed in Dyer, Indiana with Ada Hoffman (Bessie's sister) and her husband

He pointed out some spots under a bridge on the Midway near the museum where he had worked with models. Now in his sixties, Kaye remarked that although the instructors had nothing they could teach him, working with the models was worthwhile, and—ever the sensitive artist—that there were some "beauties" among them. During this time Kaye was also experimenting with watercolor nudes, clearly painted from life. Some are dated and include the model's name, such as *Laura Mich. Dunes* (nude reading), *1960.*

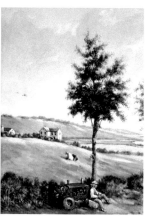

(from left) Otis Kaye, *Mountain Stream*, 1950s, Oil on board, 30 x 40 in., Private Collection, Illinois; Otis Kaye, *End of the Season*, detail, 1960, Oil on board, 20 x 24 in., Private Collection, Illinois

Frank Riordan, who was a carpenter. Otis gave Ada some landscapes and pastels and for Frank he created designs for small home engineering projects. Not recognizing the fragility of the pastel medium, Ada once inadvertently dusted a still life into oblivion. In 1966, Kaye promised the large oil painting *Heart of the Matter*—which makes direct reference to Rembrandt's *Aristotle Contemplating the Bust of Homer*—to Paul Banks III [cat. no. 32] as a wedding gift, along with his drafting tools. Kaye was not present at the wedding, but offered the gifts later. Kaye presumably saw the Rembrandt in Chicago, where it was shown at the Art Institute's *Century of Progress* in 1933, although he could have also seen it in New York in 1961 when it was shown at the Metropolitan Museum.

Throughout his life Kaye remained obsessed with *trompe l'oeil* currency and continued to depict currency in every medium. The money paintings became increasingly complex and reflect Kaye's ideas on American life and major social issues. He also painted many landscapes in the Tremont, Illinois area: farm scenes with an artist—probably himself—in the corner of the composition, sometimes sketching and often wearing a signature red shirt. He also did lakeshore watercolors in Michigan, Indiana and Wisconsin and made a sketchbook during his travels in the American West. He did portrait sketches that later appeared in his etchings and paintings, and continued to experiment with pastels in drawings that include hot dogs and beer mugs along with his trademark currency. As his eyesight began to fail in his eighties Kaye took longer to create his highly detailed *trompe l'oeil* oil paintings but continued to work in watercolor and pastel, using oils for large landscapes. One rural scene includes a blind man sitting under a tree, probably a self-reference.

Paul Banks II passed away in 1967, when Kaye was 82, and Kaye sent a note of condolence to Bessie Hoffman in which he speaks of plans to return to Germany.[17] Kaye did not return to Chicago, but sometime after 1969 he acted on his long-standing plan to travel to Germany, with the idea of returning to Dresden, in the then Warsaw-pact German Democratic Republic (East Germany), a plan he had formulated before Paul Banks II's death.[18] In 1975 Bessie Hoffman got word from the Goldstein family that he had died in Germany, at the age of 89 or 90, having fulfilled his wish to return to the country of his birth.[19] We do not know if Kaye ever made it to Dresden.

17 Otis Kaye to Bessie Hoffman Banks 29 May 1967: MSS, Archive, Otis Kaye Estate (Appendix 8 p. 180).

18 An undated letter written to Paul and Bessie Hoffman mentions his intention to "settle" in Dresden: MSS, Archive, Otis Kaye Estate (Appendix 8 p. 179).

19 Letter: June 19, 1975 *Dear Mrs. Banks, It may be of interest to you that my relatives in Europe have recently informed me of the demise of Otis Kaye. That is all the information I have at this time. Sincerely, Margot Goldstein.* MS, Archive, Otis Kaye Estate.

WHAT HAPPENED TO THE PAINTINGS?

As early as the 1950s, Kaye and Paul Banks II brought the etchings and plates from Tremont to Paul II's basement on Seeley Avenue. Many were water damaged. There were also boxes of *Life* magazine with annotations by Kaye on various topics including the work of other artists. There were books and miscellaneous papers in addition to the artwork. Most of Kaye's personal effects were later discarded because of mildew. The very few surviving letters and notebook pages provide the only remaining autograph documentation of Otis Kaye's life. Paul Banks II was aware of the uniqueness of all of Kaye's paintings and believed some day they would be valued, if not as art, at least for their technical mastery, and he made a conscientious effort to preserve them and advised his son of the need to care for them. Kaye's paintings were moved from the Banks's home garage on Seeley Avenue in Chicago to Oak Lawn storage when Bessie Hoffman moved to the suburbs. Watercolors, pastels, oil paintings and etchings and plates were stored in a large private commercial storage shed and in the homes of Bessie Hoffman and Paul Banks III, who were both living in Oak Lawn, Illinois. Family members, for the most part, did not hang the money paintings, as they were not considered sufficiently decorative. Some said they were strange, putting too much emphasis on money. As for the nudes, they wanted no part of them at all, calling them shameful. When Otis Kaye's death was reported, the Banks family became the stewards of Kaye's entire legacy.

HIDDEN IN PLAIN SIGHT:
OTIS KAYE AND TROMPE L'OEIL IN AMERICA

Mark D. Mitchell

To look at a still life by Otis Kaye is to enter a world of pregnant details. Seduced by the painting's semblance of reality, its beckoning illusionism, the viewer moves in to examine object after object, scrap after scrap, discovering clues, texts, and felicitous arrangements that portray pithy morals and bitter truths indiscernible from afar. Kaye's paintings require close looking, which they reward with recognition, delight, and revelation. That is the art of Otis Kaye: enticement and marvel.

Although *trompe l'oeil* (eye-fooling) painting had a long, if intermittent, history in America by the time Kaye began to work in the style around 1920, it had surged after the nation's centennial in 1876 to become a widespread practice for the first time. Led by professional painters William Michael Harnett, John Frederick Peto, and John Haberle, among others, the artists appealed to viewers' admiration for technical mastery and topical subjects, particularly money. By 1920, however, *trompe l'oeil*'s popularity had waned. With solitary dedication, Kaye nevertheless sustained his artistic avocation in private over four decades, well into mid-century, and addressed an astonishing range of American history. His art aligned with his predecessors' and harmoniously extended their practice into a new era with personal insight and, eventually, his own distinctive form, the calligram.

RESEMBLANCES

Kaye, an engineer by profession, must have appreciated *trompe l'oeil* painting's "clean design," the term he used to admire the art of

regionalist painter Grant Wood in 1937.[1] His first paintings from the 1920s are generally modest in size and focused on paper money, similar to the basic configurations that accompanied the emergence of *trompe l'oeil* aesthetics during the 1870s. William Michael Harnett's *Still Life–Five Dollar Bill* of 1877 (fig. 1) had marked the beginning

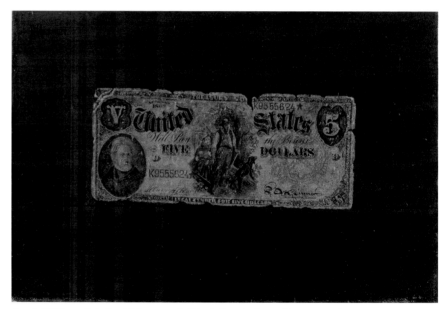

fig. 1: William Michael Harnett, *Still Life-Five Dollar Bill*, 1877, Oil on canvas, 8 x 12⅛ in., Philadelphia Museum of Art, The Alex Simpson Jr. Collection, 1943

1 "Fine, clean design" Kaye wrote in the margin alongside an image of Wood's *The Midnight Ride of Paul Revere* (1931, The Metropolitan Museum of Art) in his copy of *Time* (20 December 1937), p. 25. Otis Kaye Archive.

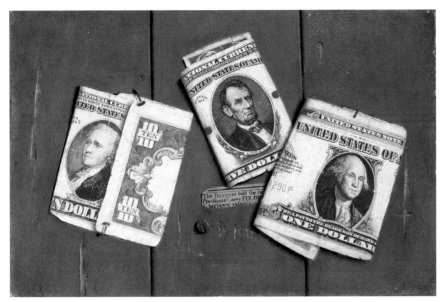

Otis Kaye, *Folding Money*, c. 1929, Oil on panel, 6 x 9 in., Private Collection, Illinois

Transcribing the visual information on flat bills as shown in Kaye's early *Folding Money* (c. 1929) and *Does History Make the Man* (1935) offered an excellent entry point to *trompe l'oeil*. The directness of both Harnett's and Kaye's formulations was a key to their appeal. The near-white bills adhere to dark surfaces, the contrast enhancing their illusory separation. The worn notes are so familiar in daily life as to escape initial scrutiny, further conspiring to mask the illusion. The bills' age also explains at first their softened features and the slight blurring of their engraved lines.[4] The format offered a basic test for both artist and viewer, even though it had become familiar for *trompe l'oeil* painters and their audiences alike during the decades between Harnett's and Kaye's compositions, with many permutations.[5] Of those, however, the firmness and evenness of Kaye's visual description in both *Folding Money* and *Does History Make the Man* aligns more directly with the work of Haberle and Jefferson David Chalfant, than with Harnett's selective detail or Peto's relatively soft focus. Despite their differences, Harnett's *Still Life–Five Dollar Bill* remained a

of the *trompe l'oeil* era, attracting government attention for possible forgery in 1886 when it went on public display. The ensuing controversy captured the popular imagination and virtually guaranteed that other artists would follow suit. They did. Kaye was just one of many to begin their own experiments in *trompe l'oeil* by closely emulating the format of Harnett's pioneering composition, their shared foundation.[2] Despite a tightening of the law on forgery in 1909, Harnett's *Still Life–Five Dollar Bill* likely remained on exhibit in New York City, where it was accessible to Kaye, until 1918.[3]

2 Charles A. Meurer, who painted well into the early-20th century, remembered that his first encounter with Harnett's *The Old Violin* (fig. 9) was formative to his artistic development. Alfred Frankenstein has plausibly suggested that a similar exposure to Harnett's work, in particular, may have inspired nearly all of the artists from that era. Alfred Frankenstein, "'After the Hunt'—and After," *Bulletin of the California Palace of the Legion of Honor* 6.4–5 (September 1948), n.p.

3 The revision of the US Criminal Code (9 March 1909) is often cited as the cause

of the cessation of money-themed *trompe l'oeil* painting. It threatened fines and up to fifteen years imprisonment for anything "in imitation of, or purporting to be in imitation of" American currency. Section 149.

4 Kaye generally relied on more contemporary bills than most of his peers. A message scrawled across a print of a one-dollar banknote documents at least one source for the artist when he remarked to his printmaking collaborator Fritz Hoffman, "Saw $500 $1000 n A Bank Exhibit in Chgo. I made dwgs!" Otis Kaye to Fritz Hoffman, undated, MSS, Otis Kaye Archive (Appendix 8 p. 176).

5 It was a particular favorite of Kaye's closest peer, the New York painter Nicholas Alden Brooks. Kaye reportedly owned two of Brooks' compositions related to Harnett's originary painting, one of which, *Full of Old Curiosities* (1890, private collection), nearly reproduces Harnett's composition using the same Andrew Jackson five-dollar note (though a later series), which embellished the composition with a small ticket stub and a news clipping. Bruce Chambers first described a possible meeting between the artists around 1904–5, when Kaye was in New York, and reported that Kaye owned two of Brooks' paintings, though he does not cite evidence of their provenance (Bruce W. Chambers, *Old Money: American Trompe l'Oeil Images of Currency* (New York, Berry-Hill Galleries, 1988), pp. 85–86). James Bradburne and Geraldine Banks challenge Chambers' account in their essay for this catalogue.

touchstone and was influential throughout the period leading up to Kaye's own turn to *trompe l'oeil*. It offered a direct link to the beginning of the movement as Kaye began to formulate his *trompe l'oeil* vision.

Kaye's early works vary significantly as he explored the potential of *trompe l'oeil* aesthetics and the influences of earlier American masters of the form. His *Breakout* (1930) records a supposed prison break by Kaye and includes the names of Harnett, Peto, and Haberle, his confraternity of law-breaking illusionists.[6] Such fanciful fiction is more characteristic of the satires of Victor Dubreuil during the later 1880s and 1890s, however, than of the works of the artists enumerated in *Breakout*. As Edward Nygren has observed, there was no one monolithic approach to *trompe l'oeil* in America during the late-19th century, but there was a shared divergence from convention and a collective resistance to authority.[7] On the other hand, using currency and stamps as vehicles to portray American history, as Kaye often did in his reflections on national history and events, was something of a tradition by Kaye's time. Its fullest manifestation was in Haberle's *The Changes of Time* (fig. 2), in which successive eras of currency and postage stamps layer on top of one another as accretions of time within an illusionistically "carved" wooden frame depicting the full lineage of American presidents. These works present history as manifested in official currency and postage, through successive presidential administrations, types of currency, and years of printing. George Washington and Abraham Lincoln appeared with particular frequency in Kaye's early work, pillars of the American story. In his early art, Kaye demonstrated familiarity with and facility in a wide range of his predecessors' practices as well as with American *trompe l'oeil*'s longer conceptual history.

6 On *Breakout*, see Chambers, pp. 88–90, pl. 25.
7 Edward J. Nygren, "The Almighty Dollar: Money as a Theme in American Painting," *Winterthur Portfolio* 23.2/3, (Summer/Autumn 1988), pp. 149–50.

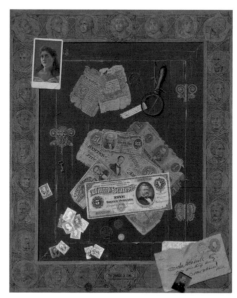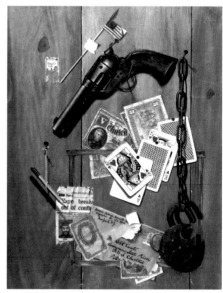

(from left) fig. 2: John Haberle, *The Changes of Time*, 1888, Oil on canvas, 23¾ x 15¾ in., Oil on canvas, Middleton Family Collection; Otis Kaye, *Break Out / Crash Out*, 1950, Oil on canvas mounted on board, 24 x 20 in., Private Collection

Deceptions, as *trompe l'oeil* paintings were known in the 18th and early-19th centuries, had a distinguished history in America that later artists such as Kaye embellished. Charles Bird King painted his quasi-autobiographical *Poor Artist's Cupboard* (fig. 3) around 1815 as a lament for artists' low standing in America, using *trompe l'oeil* still life as a vehicle for social criticism. As in Kaye's work, the painting's astonishing realism leads the viewer into detailed examination of its objects, including printed notice of the forthcoming sheriff's sale at which the artist's belongings will be auctioned to satisfy his debts. The artist's slim ration of bread and water as well as books on such edifying subjects as the *Advantages of Poverty* and *Pleasures of Hope* inventory the hardships of a painter of considerable ability, which is confirmed by the quality of the painting itself. Kaye's art is often similarly autobiographical,

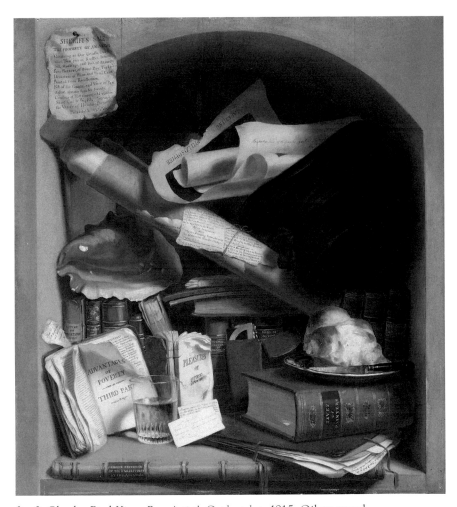

fig. 3: Charles Bird King, *Poor Artist's Cupboard*, c. 1815, Oil on panel, 29¹³/₁₆ x 27¹³/₁₆ in., Corcoran Gallery of Art, Washington D.C., Museum Purchase, Gallery Fund and Exchange

and rarely fails to include his name interspersed with coins or nail heads forming the "o" of his first name or engraved in the furniture. His impressive *D'-JIA-VU?* includes both forms of his name and charts the artist's own, as well as the nation's, financial struggles during the Depression. As an amateur, Kaye painted for a limited audience— himself and his family—rather than for public exhibition or sale, making personal meaning and inside humor his primary registers. For Kaye, as for King, *trompe l'oeil* offered a way to record his experience.

PRESERVING RELICS

Historical anachronism was a signature of *trompe l'oeil* during the later 19th century. The artists painted old things, often from the antebellum or Civil War periods, as seen in the present of the 1870s or after. By the 1920s, the *trompe l'oeil* idiom itself appears old-fashioned, even nostalgic, primarily identified with the artists of Harnett's generation. Although Kaye too embraced the Civil War as a subject at times, the historical horizons on which he focused his art were typically later, and the dividing lines of time in his experience were World War I, the Great Depression, and, eventually, World War II. The earlier era recollected in many of his paintings was closer to 1910 than 1860. Despite the differences in subject matter, however, Kaye's art, and that of his peers of the late-19th century, similarly addressed earlier periods as remembered through historical objects that had weathered the passage of time, as had the artists and the nation itself. All were survivors.

Custer's Gun is one of several of Kaye's works to revisit an earlier historical moment, to which it adds direct emulation of an earlier American *trompe l'oeil* painting as well: Harnett's iconic *The Faithful Colt* (fig. 4).[8]

8 An intermediate, alternate version of the theme between Harnett's and Kaye's is Jefferson David Chalfant's *Old Flintlock* (1898, Private Collection).

(from left) fig. 4: William Michael Harnett, *The Faithful Colt,* 1890, Oil on canvas, 22½ x 18½ in., Wadsworth Atheneum Museum of Art/Art Resources, NY; Otis Kaye, *Custer's Gun,* 1950, Oil on canvas mounted on wood, 18 x 13 in., The Hevrdejs Collection

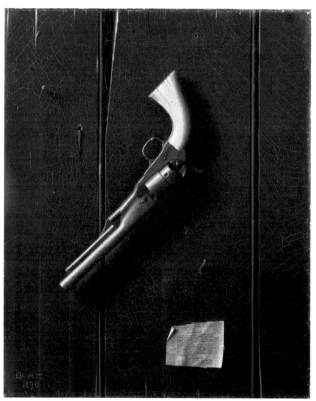 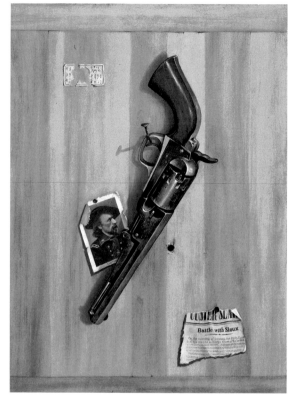

Both works portray a Civil War-era Union revolver made by Colt as though suspended precariously from a nail. Interest in Harnett's art had revived with astonishing speed during the later 1930s, beginning with the purchase of *The Faithful Colt* in 1935 by the Wadsworth Atheneum in Colt's hometown of Hartford, Connecticut. The painting was subsequently lent to several prominent exhibitions around the country and reproduced in catalogues, where Kaye likely saw it before painting his version in 1950. The ostensible owner of the gun in Harnett's composition could have been one of the many thousand Union veterans to have carried a similar pistol into battle. Kaye, however, includes additional details: that the owner of his Colt is the dashing and immediately recognized figure of George Armstrong Custer, along with a newspaper clipping that records Custer's death at the Battle of the Little Bighorn in 1876. Kaye eulogizes Custer, transforming Harnett's quiet, tense weapon, its trigger resting on the nail, into a memorial for an admired hero, complete with a bullet hole in the simulated wooden panel. Years after the Civil War's end, both Custer and his Union revolver were themselves anachronisms, much like Kaye and *trompe l'oeil* in 1950.

Kaye did more than record historical objects and imagery, however. He also animated their interactions with a sardonic humor that was generally absent from, or at least veiled in, the earlier *trompe l'oeil* artists' work. For Kaye, history was personally interpreted, whereas earlier works such as John F. Peto's *Reminiscences of 1865* (fig. 5) typically provided a more evocative and elegiac record of national memory. In Peto's painting, Abraham Lincoln's life dates are illusionistically "carved" into the green cabinet door above his portrait. Old signs and cards once adhered to the door have been torn off, leaving only their corners, marks of their absence. The painting is a shrine to the

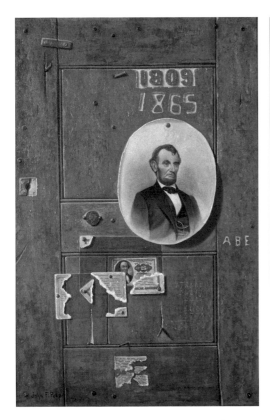

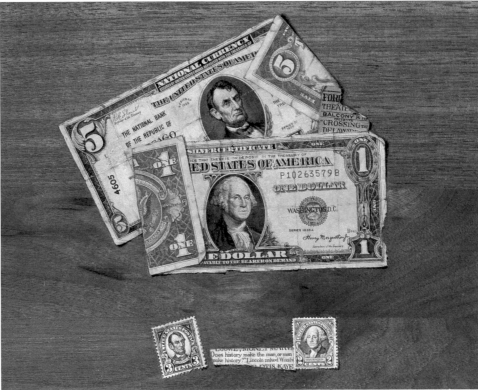

lamented "Abe," a father figure whom Peto revered.[9] Kaye had lost his father early in life, and his art demonstrates a similar preoccupation with national leaders. Kaye's idiom, however, is at times less historical than sophomoric, setting the likenesses of Washington and Lincoln imagery on currency into conversation with one another in *Does History Make the Man* Kaye enjoyed dangling questions before the viewer, here on a piece of newsprint at the bottom, leaving the answers open.

Kaye was not the only *trompe l'oeil* painter influenced by 20th-century events. World War I also inspired Charles A. Meurer, who was twenty years Kaye's senior, to return to *trompe l'oeil* after a decade-long hiatus. Like the Civil War, World War I was in many ways a grinding, bitter experience that challenged Americans' convictions about the nobility of war. Memorializing military service in the 20th century, Meurer painted *A Doughboy's Equipment* (fig. 6) in 1921, shortly after the war's

9 John Wilmerding, *Important Information Inside: The Art of John F. Peto and the Idea of Still-Life Painting in Nineteenth-Century America* (Washington, D.C.: National Gallery of Art, 1983), pp. 196–204.

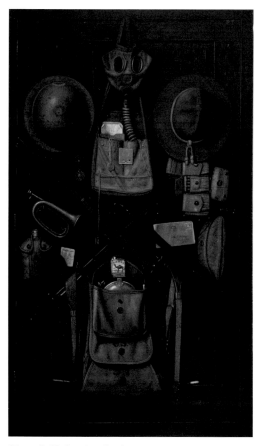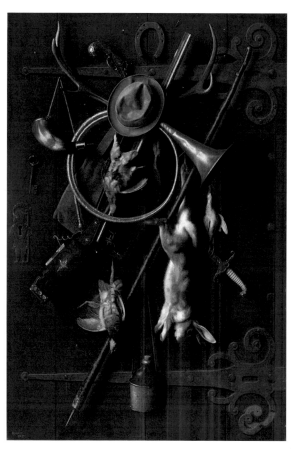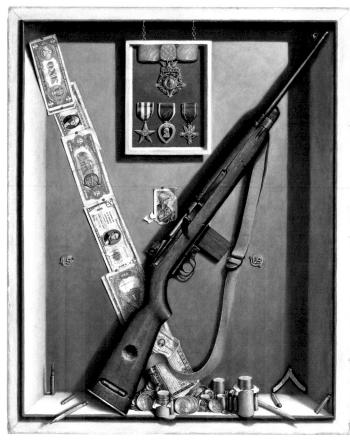

(from left) fig. 6: Charles A. Meurer, *A Doughboy's Equipment*, 1921, Oil on canvas, 68 x 40 in., Collection of the Butler Institute of American Art, Youngstown, Ohio Gift of Elmer G. Engel 1959; fig. 7: William Michael Harnett, *After the Hunt*, 1885, Oil on canvas, 71½ x 48½ in., Fine Arts Museums of San Francisco; Otis Kaye, *Soldier's Valor*, 1950s, Oil on wood panel, 36 x 30 in., Private Collection, Illinois

end.[10] Like Kaye, Meurer updated precedent, revisiting Harnett's famous life-size door mounted with gear on the theme of *After the Hunt* (fig. 7) Harnett's most ambitious work. Meurer adapted Harnett's example to celebrate the conclusion of the war by hanging up an infantryman's gear and rendering it at the size and complexity of a historical epic. A cigarette still smokes on the lower panel, setting the painting in the present time, with a Croix de Guerre medal and newspaper clipping describing the Armistice that place it at the war's end. World War I prompted Meurer

10 Alexander Pope's *Emblems of the Civil War* (1888, Brooklyn Museum) and George Cope's *Union Mementoes on a Door* (1889, Private Collection) also prefigure Meurer's work and, as their titles suggest, apply Harnett's formulation to Civil War subjects.

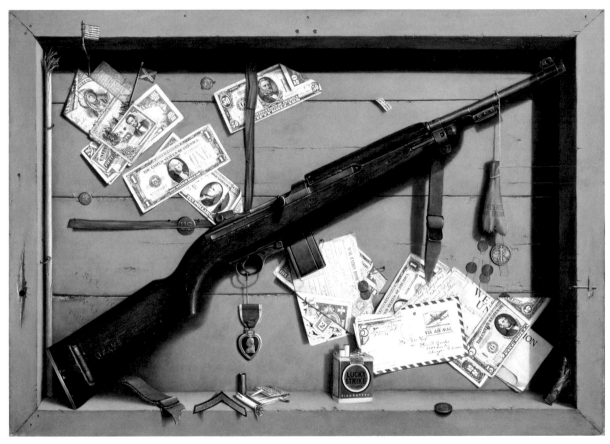

Otis Kaye, *Land of the Free, Home of the Brave*, 1944, Oil on panel, 25½ x 36¼ in., Private Collection, Atlanta, Georgia

cost in money against their cost in lives. Kaye described his feelings in a letter to his cousin, Paul Banks II, as he worked on *Land of the Free, Home of the Brave*: "a large painting about this damn war. In it I try to relate all American wars by their common factors: a rifle and money. You know I think greed for the power of wealth is the basis of war—hidden behind cheap philosophies."[11] Historical currencies stand in for the various American wars in *Soldier's Valor*, creating a parallel national history that crossed the World War II-era carbine to simulate the American infantry's insignia of crossed rifles. Rolls of coins resemble magazines of bullets. Kaye's military paintings are not memorials, like Meurer's, but protests.

Revisiting the historicism of late 19th-century *trompe l'oeil*, Kaye found inspiration during a period of personal disillusionment—an apt term—with federal power and its structures of authority. In his paintings, he redirected the nostalgia and elegy characteristic of his immediate predecessors' works in a new direction, conscientious, anti-authoritarian critique, that was unconstrained because private. Perhaps the wars of his own time and his family's German and Slavic roots created ambivalence about America's adversaries and the popular narrative propagated by the government. Despite his

to return to *trompe l'oeil*, and it also corresponded closely to Kaye's first known practice of the form. Kaye's war-themed paintings *Land of the Free, Home of the Brave* and *Soldier's Valor* were both created later, in response to World War II. Unlike Meurer's memorial, they are allegories of America's relationship to war though time, setting their

11 Otis Kaye to Mr. and Mrs. Paul Banks, 5 November 1944, MSS, Otis Kaye Archive (Appendix 8 p. 174).

skepticism about war and the American financial system, Kaye's personal correspondence records avid patriotism. With sharp irony and incisive wit that were deeply rooted in the tradition of American *trompe l'oeil*, Kaye opened a new avenue for the purposeful application of *trompe l'oeil*, for which he would develop his own distinctive form.

CALLIGRAMS

Kaye's most ambitious paintings read as commentaries. Through a host of devices—including juxtaposition, rebus, text, and calligram—the artist transformed illusionism into storytelling. One idiom in particular, however, he took considerably beyond any precedent and is arguably his most distinctive contribution to America's *trompe l'oeil* tradition: the calligram. In poetry, a calligram is the organization of a poem's words into an image that relates to the poem's subject. A historical form, calligrams were revitalized in the 20th century by the French poet Guillaume Apollinaire in 1918.[12] Kaye adapted it to still life, arranging his objects into shapes such as a heart, a dollar sign, a baseball home plate, or even a chart of the stock market. Kaye's calligrams offer overarching visual themes for his larger compositions, effectively introducing the subject that is then revealed more fully in its details. While the inclusion of a calligram may characterize Kaye's most ambitious paintings, it remained just one tool among others.

Within the somewhat rigid, literal idiom of *trompe l'oeil* painting, in which the illusionistic immediacy of objects is the work's primary impression, the use of literary devices permitted additional layers of meaning beyond the inclusion of printed text. Kaye was not the first to employ such tools, but he advanced them considerably. Some, such as the rebus—using objects to stand in for words—had longer histories,

12 See Guillaume Apollinaire, *Calligrammes* (Paris: Mercure de France, 1918).

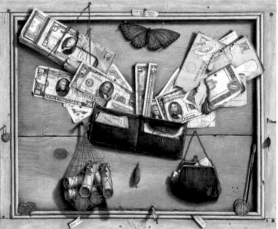

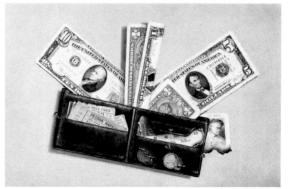

(from top) fig. 8: Ferdinand Danton, *Time is Money*, 1894, Oil on canvas, 16¹⁵⁄₁₆ x 21⅛ in., Wadsworth Atheneum Museum of Art/Art Resources, NY; Otis Kaye, *Easy Come, Easy Go (Version 1)*, 1935, Oil on panel, 21 x 25⅝ in., Manoogian Collection; Otis Kaye, *Easy Come, Easy Go (Version 2)*, 1950, Oil on panel, 10½ x 15½ in., Private Collection

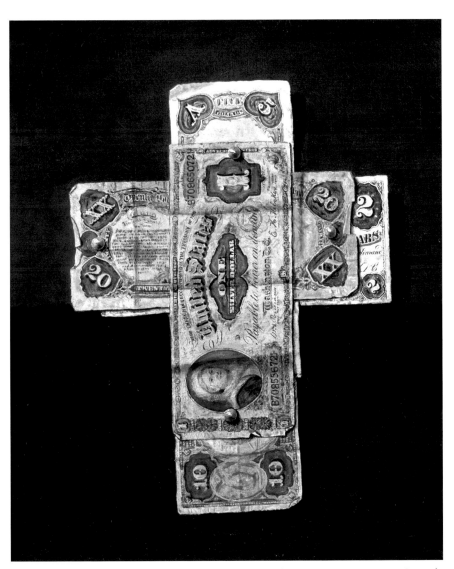

fig. 9: Victor Dubreuil, *The Cross of Gold*, c. 1896, Oil on canvas, 14 x 12 in., Crystal Bridges Museum of American Art, Bentonville, Arkansas

including in Ferdinand Danton's 1894 *Time is Money* (fig. 8). The artist employed an alarm clock for "time" and a stack of bank notes for "money," while the word "is" appears to be carved into the wood in between them. Just to be sure, the artist also transliterated Benjamin Franklin's famous aphorism onto a slip of paper at the bottom to ensure comprehension. Kaye often worked similarly, as in his two versions of *Easy Come, Easy Go.* Both paintings showing money flying into a wallet then coming back out again, with slips of paper painted at the bottom of the composition to narrate its message. In the 1946 version, the cash comes back out in the form of securities, so it is not spent, but instead poorly invested. The charred bits of the certificates represent their worthlessness. This version also incorporates a butterfly, whose shape echoes the form of the money coming and going from the wallet as well as the principle of wealth's fickleness, perhaps Kaye's signature theme. Kaye absorbed the earlier model, and also greatly embellished it.

Victor Dubreuil's *The Cross of Gold* (fig. 9) is one of the very few historical precedents for Kaye's calligrams, and also effectively introduces the fascination with money that prevailed in America during the late-19th century and corresponded to the ascendency of money painting. Dubreuil's painting manifests the political metaphor and rallying cry of William Jennings Bryan's failed 1896 presidential campaign, "You shall not crucify mankind on a cross of gold!" Dubreuil depicted several different forms of currency—including two denominations of silver certificates (the central one, from 1891, featuring a portrait of Martha Washington), two legal tender notes, and a national currency bank note—representing different types of currency that had been used since the Civil War crucified with golden tacks against an indeterminate backdrop of brown, black, and green. Bryan's campaign was a battle against the Gold Standard, in which all printed money would be

backed by actual gold bullion and redeemable for gold upon request, that was successfully adopted by his opponent William McKinley in 1900. Scholar Edward Nygren has called Dubreuil's painting "the most overt example of an artist's reflecting on a contemporary issue."[13] Bryan's appeal sought freer access to capital across the country to encourage development, a populist stance that echoed the accessibility of *trompe l'oeil* paintings, which were exhibited in unexpected venues for art, such as bars and stores, as well as art exhibitions.[14] Although Dubreuil's painting was more metaphor than calligram, it nevertheless offers historical perspective on Kaye's practice.

In perhaps the first significant study of Kaye's art, Henri La Borie characterized his paintings as "a mirror of the artist's mind."[15] His most ambitious *trompe l'oeil*, *D'-JIA-VU?*, resonates with La Borie's characterization. Kaye invested himself in it so richly and so pervasively that it may best be characterized as an autobiography, and a psychological one at that. Painted from the perspective of 1937, *D'-JIA-VU?* traces the Dow Jones Industrial Average's performance over the preceding eight years, since the onset of the Great Depression with the Crash of 1929. Punning on the Dow Jones's commonly abbreviated initials, DJIA, Kaye depicts

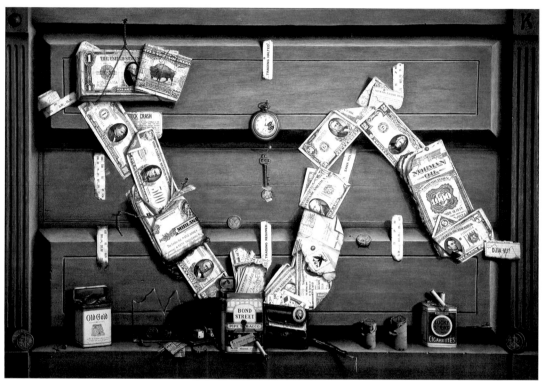

the anxiety, both personal and national, of 1937 as fears of a second crash loomed in a moment of *déjà vu*. In the painting's complex arrangement of correspondence and stock certificates, the artist's own name appears again and again as the owner of now worthless stock. His name and initials appear repeatedly in the composition, most prominently in the carved upper left and right corners of the wooden surface to which the objects are affixed or on which they rest, spanning the composition and also punctuating its story. As he often did, Kaye here associates investing with gambling by including playing cards and chips (the latter labeled "Wall St. Poker Co." in the lower left corner), in a bitter, or perhaps just wry, account of his own financial

13 Nygren, p. 131.

14 Kevin M. Murphy, "The Poor Artist? American Art in an Era of Financial Panic, Depression, and Speculation," in Leo G. Mazow and Kevin M. Murphy, *Taxing Visions: Financial Episodes in Late Nineteenth-Century American Art* (San Marino, Calif.: The Huntington Library, Art Collections, and Botanical Gardens; State College, Penn.: Palmer Museum of Art, 2010), pp. 52–55.

15 Henri La Borie, *Otis Kaye: The Trompe l'Oeil Vision of Reality* (Oak Lawn, Ill.: Soutines, Inc., Fine Art Investments, 1987), p. 3.

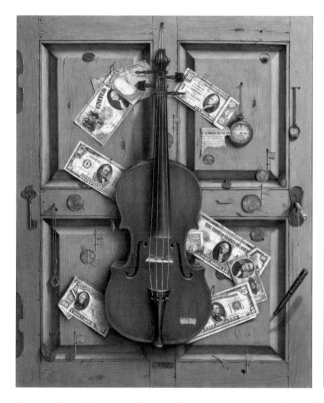

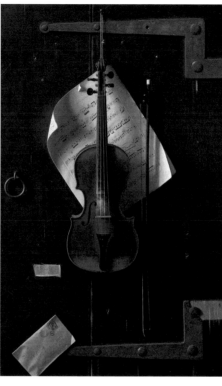

(from far left) Otis Kaye, *D'JIA-VU?*, 1937, Oil on panel, 27 x 39½ in., Cordover Collection, LLC; Otis Kaye, *U.S. Musical Notes*, 1946, Oil on panel, 30 x 24¾ in., Manoogian Collection; fig. 10: William Michael Harnett, The Old Violin, 1886, Oil on canvas, 38 x 23⅝ in., National Gallery of Art, Washington, Gift of Mr. and Mrs. Richard Mellon Scaife in honor of Paul Mellon 1993.15.1

works of the period, however, Kaye directly adapts earlier works of American *trompe l'oeil*. *U.S. Musical Notes*, for example, revisits a well-known icon, William Michael Harnett's *The Old Violin* (fig. 10).[17] Harnett's 1886 masterpiece fascinated his viewers, who famously wore out the rug in front of the painting at its first exhibition in Cincinnati.[18] Kaye, however, transformed Harnett's iconic violin into a different sort of emblem, a dollar sign, punning on his painting's titular notes as both musical notes as well as banknotes. The coins with matchstick flags resemble musical notes, replacing the sheet music in Harnett's original composition.[19] Even *The Old Violin* was at least partly about collectibles, the

losses. Brief description only grazes the surface of the symbolism of *D'JIA-VU?*.[16] The painting exhibits an astonishing, obsessive level of interlocking historical, cultural, and personal references that were likely only fully explicable by the artist himself. As a self-portrait, the painting is perhaps more thorough and insightful about Kaye than a conventional portrait could be.

D'JIA-VU? has no precedent in *trompe l'oeil*, though its scale and historical complexity rival Haberle's *The Changes of Time*. In other, less personal

16 For the beginning of a fuller analysis, see James M. Bradburne, ed., *Déjà Vu All Over Again: The Riddle of Otis Kaye's Masterpiece* (Florence, Italy: Fondazione Palazzo Strozzi, 2009).

17 Like Harnett's *Faithful Colt, The Old Violin* inspired a number of imitations and variations, including Jefferson David Chalfant's *The Old Violin* (1888, Delaware Art Museum).

18 One of those lingering in front of the painting was Charles A. Meurer, who credited the encounter for launching his own distinguished *trompe l'oeil* career.

19 *U.S. Musical Notes* is one of the few works of art that Kaye described in his own words, which deepen understanding of the layers of symbolism at work in his more complex compositions. In a letter to Paul and Bessie Banks, he records his discussion of the painting during a visit with his cousin Sister Mary Laurencia Bancak, a nun, at her convent in Lisle, Illinois: "Sister was delighted when I showed her 'Musical Notes' & was quick to see the dollar sign the bills make in conjunction with the violin. But of course she missed the cross that the wood makes behind violin. / Tony pointed out to her the coins & flags that have numerical and musical equality. He intervened in time. She doesn't like anyone to play around with religion—as you well know!" Otis Kaye to Mr. and Mrs. Paul Banks, 194[?], MSS, Otis Kaye Archive (Appendix 8 p. 172).

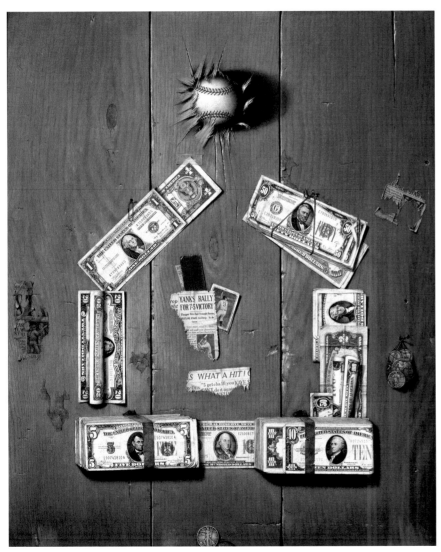

Otis Kaye, *What a Hit!*, 1932, Oil on canvas, 30 x 25 in., The Hevrdejs Collection

market for historic objects. Harnett's violin was admired as a rare 17th-century Cremona instrument, and he encouraged audiences to admire it with his emphasis on the wood's visceral texture. Kaye focused his rendering on the monetary value of works of art, in this case of Harnett's famously valuable painting, rather than their subjects. During the 1950s, the value of art would become a regular theme of Kaye's work. *U.S. Musical Notes* pointed the way.

Like news-oriented Americans generally, Kaye gravitated to the exemplary, the sensational, and the extreme for his subjects, memorializing them in objects that never stray far from the ever-present theme of money. Even America's national pastime was not immune from Kaye's acerbic interpretation. In *What a Hit!* Kaye portrays an astonishing home run by Babe Ruth at Wrigley Field in Chicago, where Kaye lived, during the 1932 World Series. Ruth hit the ball so hard, that it was thought to have broken the fence, as the newsprint in Kaye's painting records. The Yankees had been losing, down 5 to 4, and Ruth's two-run home run got them the lead, the win, and eventually the series. Kaye's outline representation of home plate composed of banknotes represents the big money at stake in baseball even then. The famous Chicago Black Sox bribery scandal in 1919 had tainted the game in the eyes of many fans, and Kaye's *What a Hit!* depicts skepticism of Ruth's amazing, improbable second home run of the game. Was the fix in? In Kaye's eyes, it always was. Money was the refrain of American life, history, and identity, as well as art.

ARTISTIC EXCHANGE

From its beginnings, American *trompe l'oeil* had a conceptual turn. Raphaelle Peale's *Venus Rising From the Sea–A Deception* (fig. 11) depicts a painting by the British artist James Berry of a nude Venus that Peale has

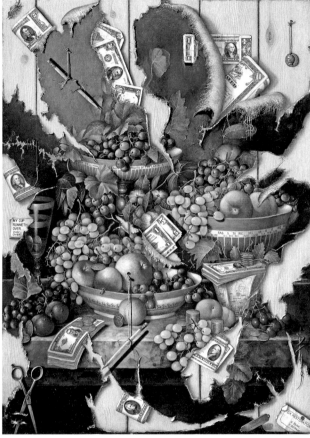

(from left) fig. 11: Raphaelle Peale, *Venus Rising from the Sea- A Deception*, c. 1822, Oil on canvas, 29⅛ x 24⅛ in., The Nelson-Atkins Museum of Art, Kansas City, Missouri; Otis Kaye, *My Cup Runneth Over*, 1950s, Oil on canvas mounted on board, 39 x 29¾ in., Private Collection, Illinois

mid-19th-century American still lifes of fruitful abundance. In his engagements with art's past, he set other artists' works into illusionistic interaction with still life objects, much as Peale's did. Kaye's paintings, in other words, did not create variations on historical artworks, but rather simulated those artworks themselves and placed them in conversation with more prosaic things, particularly money. His late works thereby broadened in scope to address historical art's presence and value in his own time, much as his earlier work had done with historical objects. Whereas Peale feigned concealment of a female nude and tempted the prurient viewer's hand to draw back the kerchief to peek at her, Kaye did the opposite. He simulated peeling back the canvas on which the historical artworks were painted to expose their true nature.

ostensibly hidden with a handkerchief suspended in front of the painting. Both the Venus and the handkerchief are illusions. During his later career in the 1950s, Kaye embarked on a series of works, both paintings and prints, that employ a related idea. In works such as *My Cup Runneth Over*, Kaye revisited various moments in art's history, in this case

Aging and damaged art are also themes in Kaye's late works, depicting injuries and wear to painted canvases as objects that need to be fixed. Like Haberle's *Torn-in-Transit with Woman's Photograph* (fig. 12) from the late 1880s, in which we see behind a torn shipping wrapper, Kaye's paintings, such as *Custer II / Going Out of Business*, depict artworks whose edges are

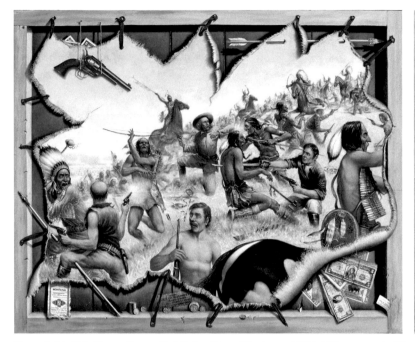

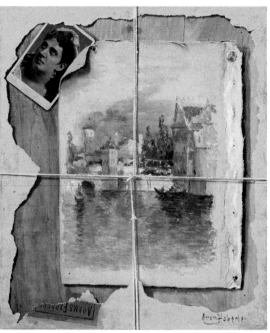

depicting single banknotes of both American and foreign currencies, skirting very close to counterfeiting. The money prints, in particular, were a fairly daring endeavor, even in private, because he would have little defense if investigated. At both ends of his practice—art and money—Kaye sharpened his stick, and at times split it in two, pursuing each to its logical conclusion.

When The Metropolitan Museum of Art in New York purchased Rembrandt's portrait of *Aristotle with a Bust of Homer* in 1961 for a then record price of over two million dollars, the acquisition attracted widespread attention, including from Kaye. The event

(from left) Otis Kaye, *Custer II / Going Out of Business*, 1958, Oil on panel, 48 x 60 in., Private Collection, Illinois; (fig. 12) John Haberle, *Torn-in-Transit with Woman's Photograph*, 1888–1889, Oil on canvas, 14 x 12⅛ in., Memorial Art Gallery of the University of Rochester, Marion Stratton Gould Fund

torn away and peeling back. Kaye depicts the actual artworks peeling back, rather than paper that simply covers Haberle's landscape. Both paintings depict the indignities to which artworks are subjected as they are handled, shipped, and occasionally damaged. Kaye's large scene revisits the life of Custer and his death at the Battle of the Little Bighorn that he apparently developed from a group of similar compositions he saw reproduced in *Life* magazine in 1948.[20] Notably, while at work on scenes like *Custer II / Going Out of Business*, Kaye also pursued his money pictures, including prints

offered an ideal subject, binding art, money, and news. His approach to the event built on that of many of the works already discussed, especially *U.S. Musical Notes*, as well as a series of prints depicting historical artworks shown with currency.[21] The resulting composition, *Heart of the Matter*, peels back segments of Rembrandt's famous composition to reveal an underlying arrangement of money, including a stack of cash located directly behind Aristotle's heart.[22] In this, the latest dated

20 Kaye kept annotated copies of *Life* over the decades from the 1930s to the 1950s, including the issue with "Speaking of Pictures... Artists Had a Field Day with Custer's Famous Stand," *Life* (21 June 1948), pp. 12–14, on which he drew extensively, apparently planning his own approach to the subject. Otis Kaye Archive (Appendix 9 p. 186).

21 The latter were the focus of an exhibition at the Federal Reserve Bank in 2002. See Mary Anne Goley, "Otis Kaye: Trompe l'Oeil Master of Appropriation," in *Otis Kaye (1885–1974)* (New York: Gerald Peters Gallery, 2002), n.p.

22 James Maroney observed that "elaborate voids" are a distinguishing characteristic of Kaye's art in the larger American *trompe l'oeil* tradition. Cited E. Jane Connell, "The Eye of

work in the exhibition, Kaye draws together the threads of his earlier works to reveal an inner truth: that Rembrandt painted his poetic vision of one great intellect contemplating another on commission. It was not made for beauty or poetry, Kaye proclaims; it was done for money. After decades of creating art from the shadows without hope of financial reward, Kaye may well have envied the financial successes of others, even those long dead, in his present day. *Heart of the Matter* offers Kaye's final reflection on the intersection of art and money, combining an event of the moment with a theme for the ages.

SUMMING UP

Otis Kaye was a culminating figure in the history and evolution of *trompe l'oeil* painting in America from its golden age in the later 19th century until the mid-20th century. He adapted and combined the techniques and inventions of his predecessors as well as introduced his own variation—the calligram—that further enhanced the tradition's range. By expanding on the ability of objects to elaborate ideas and interact with one another, Kaye fulfilled William Michael Harnett's stated goal to tell stories through still life. Like Harnett, Kaye had ambition. He pushed still life's scale and complexity, especially in the number and interaction of the symbolic details that fill his most intricate compositions. Kaye's vision, however, extended beyond realism to truth telling. He developed compositions that delved into the nature of financial markets and the economy, as well as into the meaning of art and its significance to society. Unknown as an artist in his lifetime, Kaye nevertheless left behind an astonishing record of accomplishment that synthesized the long history of *trompe l'oeil* painting in America and contributed something new.

the Artist: Images of the Creative Process," in William Kloss, *More than Meets the Eye: The Art of Trompe l'Oeil* (Columbus, Mo.: Columbus Museum of Art, 1985), p. 51, n. 6.

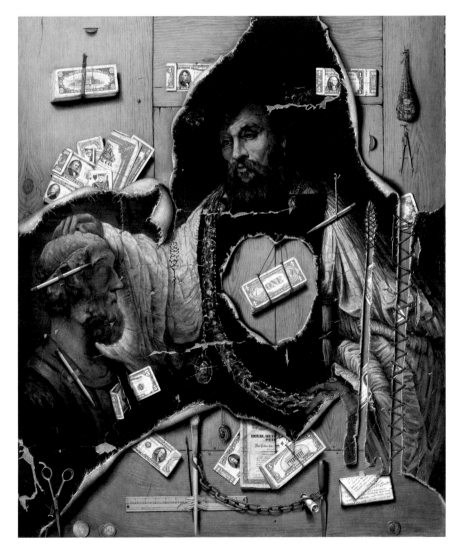

Otis Kaye, *Heart of the Matter*, 1963, Oil on canvas, 50 x 42½ in., Private Collection, Illinois

KAYE, MONEY, AND MORALITY
James M. Bradburne

For the love of money is the root of all evil: which while some coveted after, they have erred from the faith, and pierced themselves through with many sorrows.

1 Timothy 6:10

Every work of art asks us to answer the question, why do I exist in this way? Often art historians use the artist's life to help them solve the riddles posed by a work of art.[1] In Kaye's case, his biography gives us little to go on.[2] Moreover, in Kaye's case the situation is often reversed—one repeatedly finds clues to Kaye's biography in his works.[3] Kaye is often described as the last in a tradition of money *trompe l'oeil* artists—but this is wrong on all counts.[4] Kaye's extensive output in nearly every major medium (except sculpture) goes well beyond the bounds of money as a subject and *trompe l'oeil* as a technique, and other artists have continued the tradition of money *trompe l'oeil* since.[5] So how can we best understand the work of Otis Kaye, and through it the character of Otis Kaye as a person?

First and foremost, Kaye saw himself as an artist. Probably trained as a technical draftsman and engraver in Germany, Kaye was most at home with detailed and exact copying—a skill that has attracted posthumous

Otis Kaye, *Jake's Ladder Service*, 1950, Watercolor and gouache on paper, 10¾ x 14 in., Private Collection, Illinois

attention of different kinds.[6] Nevertheless, he sketched from life, *en plein air* and worked with live models at various times in his career, albeit with a less sure hand than he brought to copying a Goya engraving or a $1,000 banknote. Second, Kaye had a lively, ironic and penetrating sense of humor and his paintings are studded with jokes, allusions, witticisms, visual puns, and wisecracks. For Kaye, art could be the carrier of complex messages, and with the exception of a few nudes, landscapes and still lifes, his works are all deliberately intended to convey a deeper philosophical meaning. Third, for Kaye, the love of money was not OK. It is this last aspect of Kaye's character

1 Art history can be said to have begun with Giorgio Vasari's *Lives of the Most Excellent Italian Painters, Sculptors, and Architects, from Cimabue to Our Times* (Le Vite de' più eccellenti pittori, scultori, e architettori da Cimabue insino a tempi nostri), first published by Lorenzo Torrentino, Florence, 1550.

2 See *The Life of Otis Kaye* in this catalogue, pp. 12–19.

3 For instance *D'JIA-VU?* (cat. 5) and *Amor Vincit Omnia* (cat. 26) to name only two.

4 Bruce Chambers, *Old Money*, Berry Hill Galleries, NY, 1988, p. 85.

5 For example Kevin Boggs.

6 Mark Shell argued, citing only Kaye's engraving skills as evidence, that Kaye was a counterfeiter in the pay of Nazi Germany: 'Or, perhaps OK did not seek to make his work known because he counterfeited money in more commercially, or militarily profitable ways than by selling *trompe l'oeil* money-paintings. These ways would include counterfeiting as a means to make his personal fortune as a tactic to help the Axis powers in the 1930s (fig. 26). These ways were and are illegal, secretive by their very nature. And, indeed, this very painting *Handel with Care* violates the laws laid down by the US Department of the Treasury and the Secret Service forbidding the construction of life-size, living-color imitations of paper money. Even in the 1990s the Secret Service defines intentional likenesses of paper money like those in *Handel with Care* as "genuine counterfeits" and still confiscates such artworks and imprisons their artists and dealers.' Marc Shell, "OK; Or Handel with Care", paper for the Symposium on Experimental Scholarship, (New Haven: Yale University, 1995), p. 26.

that provides one of the most important keys to understanding Kaye's work as an artist, and the starting point for any detailed investigation of his most important works. By recognizing that underlying all Kaye's work is his belief in the corrupting power of money and his deep distrust of capitalism, his paintings can be read more carefully and the meaning he invested in them discovered more readily.

Born to a German father, Kaye presumably was exposed to Lutheranism early in life. Luther was keenly aware of the ambiguities of money and moneymaking and, just as Christ's expulsion of the moneylenders from the Temple informed later Christian doctrine, Luther's attack on papal indulgences kicked off the Protestant Reformation in 1517. Seven years later Luther made his criticisms of the market explicit in *On Usury*.[7] Kaye's mother Freda Kozlik is said to have been born in Slovakia, and from her he may also have been exposed to the teachings of Jan Hus who preceded Luther by a half a century. Hus's followers were known simply as Hussites, and in 1450 a breakaway group founded the Bohemian Brethren, a group of radical pacifists who taught that Christians should follow the law of love, and believed there should be no rich or poor, since a true Christian relinquished all property and status. In 1910, Kaye married Alma Goldstein, from a well-to-do Jewish family in Munich. As

the Old Testament makes very clear, Judaism also censures moneylending and usury, albeit only to co-religionists.[8]

When Kaye returned to America from Germany the country was facing the challenge of taking advantage of its newfound economic predominance. One of the key issues of the early part of the century was the gold standard. Germany had abandoned it in 1914, and could not effectively return to it because war reparations had cost it much of its gold reserves, which eventually led to the German hyperinflation of the 1920s. Kaye's German relatives would have kept him well informed of the troubles facing the German middle class during the decade. The US did not suspend the gold standard during the war. The newly created Federal Reserve intervened in currency markets and sold bonds to "sterilize" some of the gold imports that would have otherwise increased the stock of money. Although by 1927 many countries had returned to the gold standard, the United States, which had been a net debtor country before the War, had already become a net creditor by 1919.

Few Otis Kaye works survive from the 1920s,[9] but they already show the hallmarks of Kaye's more mature work. Influenced by the great *trompe l'oeil* artists of the time—William Michael Harnett, John Haberle, John F. Peto and N.A. Brooks—whose works were still immensely

7 "Therefore it is not enough that this business [the creation of monopolies] should be rescued by canon law from the reproach of usury, for [...] we find that it is not directed toward love, but toward self-seeking. *Money won by gambling is not usury either, and yet it is not won without self-seeking and love of self, and not without sin; the profits of prostitution are not usury, but they are earned by sin; and wealth that is acquired by cursing, swearing and slander is not usury, and yet it is acquired by sin.* [...] If there were no other reason to regard this buying of income as usury or as wrong dealing (especially in such a case as I have mentioned), this one reason would be enough, viz., that it is a cloak for such manifest and shameless avarice, and allows men to do business without risk." (Martin Luther, *On Trading and Usury*, June 1524, from the *Works of Martin Luther*, Philadelphia, A.J.Holman: 1915 vol. 4 p.63) In the beginning of the treatise he says he has been 'urged and begged' to expose some of the financial malpractices of the time. These requests probably sprang from the discussion of monopolies, which occurred at the Diet of Nuremberg early the same year.

8 Deuteronomy 23:20-21: *Thou shalt not lend upon interest to thy brother: interest of money, interest of victuals, interest of anything that is lent upon interest. Unto a foreigner thou mayest lend upon interest; but unto thy brother thou shalt not lend upon interest; that the Lord thy God may bless thee in all that thou puttest thy hand into, in the land whither thou goest in to possess it.*

9 Surviving from the 1920s are the following paintings: *Hidden Assets, Three Bills and Theater Stub, The Only Constant Is Change, Watch Yer Money, Money to Burn, Money to Burn II, Learn About Money, Key to Success, Key to Success a Novel, Key to Success III, Dollar and Half/ Washington...Half Dollar, In Gold We Trust*; a drawing, *Bella*; and gouache Chicago scenes: *Buckingham Fountain, Marshall Field, 47th Ashland, Hyde Park and Englewood Stations*, and the *Art Institute*. There is also one etching, *Seated Nude with Mirror*.

popular and circulated as chromolithographs and prints,[10] Kaye took up some of the standard tropes of *trompe l'oeil*,[11] and used them to comment on the debate surrounding the gold standard. These include *In Gold We Trust* (1928), and *Folding Money* (1929, cat. 1), which Kaye uses to comment on the introduction of paper money on the eve of the stock market collapse. Kaye borrowed another practice from earlier *trompe l'oeil* painters, later developing it extensively—the hiding of puns and clues in the printed material he depicted, including bank notes, stock certificates, coins and newspaper clippings. Kaye read widely and visited museums regularly, and the references in his paintings suggest he had more than a passing knowledge of art, social and cultural history.[12] In the 1920s Kaye also experimented with other media and other subjects, including his wife Alma, who is presumably the subject of the engraving *Seated Nude with Mirror* (1925). According to family history, the Kayes moved to Philadelphia, then possibly to Pittsburgh, finally

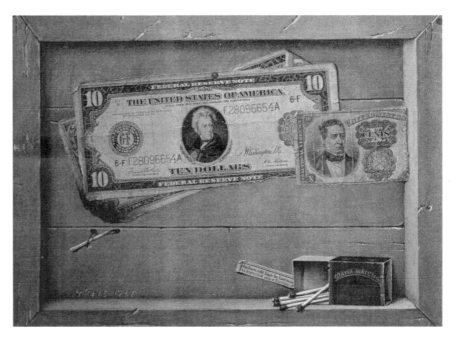

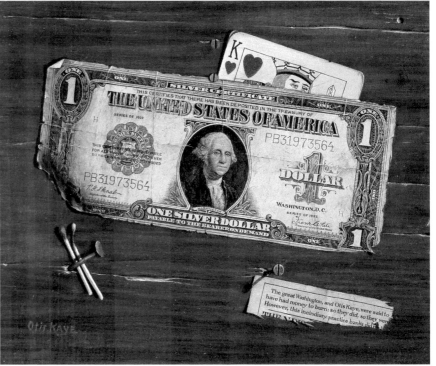

10 An article from *LIFE* magazine, August 29, 1949, clipped by Otis Kaye describes the art scene of the 1890s through the 1920s: "For the first time in the history of the country, the art of painting spread out to the general public. The great expositions held in Chicago, St. Louis and San Francisco not only were a means of displaying the mechanical advances of the nation but also served as gigantic art galleries... The still lifes of William Harnett attracted such crowds that rails had to be put up to stop the curious from touching his painted objects to see if they were real."

11 These include Kaye's earliest known painting, *Hidden Assets* (1920), *The Only Constant is Change* (1923) and *In Gold We Trust*, which all show the reverse of a canvas stretcher, a device made popular by the earlier generation of *trompe l'oeil* artists. Kaye's references to earlier models remains a constant in his early work, and the use of the slate blackboard in *Learn About Money* (1928) explicitly recalls John Haberle's *Leave Your Order Here*, while *Love of Money* (1925) is a rack painting, a device used by William Harnett in his *The Artist's Letters* and by John Frederick Peto in many similar paintings. The letter rack *trompe l'oeil* has a long history on both sides of the Atlantic which includes Cornelis Gijsbrechts's *Turned over canvas* (1670) and Edwart Collier's *Letter Rack* (1684) of which Kaye was almost certainly aware.

12 Otis Kaye and his wife loved music, and in the background of his painting *The Sweetest Notes* (1929) appears a relatively obscure Beethoven score, *Rage [for] a Lost Penny*, (Chambers, op. cit., p. 92.)

settling in Chicago in the aftermath of the Great Crash where the Kayes took advantage of the hospitality of Kaye's cousins, the Banks family.[13]

As paintings such as *Money to Burn* (1927) and *Money to Burn II* (1928) suggest, Kaye experienced the boom at first hand, and is said to have invested significant sums (possibly borrowed from his wife's family) but was then hard hit by the bust. Economic historians usually attribute the start of the Great Depression to the sudden devastating collapse of US stock market prices on October 29, 1929, known as Black Tuesday. Even after the Wall Street Crash of 1929, optimism persisted for some time.[14] The stock market turned briefly upward in early 1930, returning to early 1929 levels by April, before collapsing again. In many ways, the losses Kaye sustained in the Crash of 1929 made an impact on his family, his work and ultimately on his marriage. Above all, it confirmed his deep belief in the corrupting power of money, and of the moral turpitude of bankers, traders, stockbrokers, salesmen and gamblers of any kind. The amorality of the markets and the huge suffering brought about by the collapse of the stock market left a scar that marks all Kaye's output from 1929 onwards; thereafter Kaye's works increasingly criticized speculation as mere gambling. What caused the Great Depression? Some economic

historians such as Barry Eichengreen continued to argue that keeping the gold standard prevented the Federal Reserve from expanding the money supply to stimulate the economy, fund insolvent banks and fund government deficits. Others such as Milton Friedman placed the blame for the severity and length of the Great Depression at the feet of the Federal Reserve and blamed the major economic contraction in 1937 on the tightening of monetary policy that resulted in higher cost of capital, weaker securities markets, reduced net government contribution to income and higher labor costs. As can be read from his paintings of the time, for Kaye the reason was clear—the self-interest of the rich and powerful and the complicity of the government regardless of the suffering and loss for individuals.

After a further seven long, difficult years of deflation and high unemployment, the market once again looked like it was about to recover in 1937—a false dawn documented in detail by Kaye in his masterpiece *D'-JIA-VU?* (1937, cat. 5). The depth of Kaye's disillusionment is palpable, and has been extensively described in a separate account,[15] but a quick survey of other Kaye paintings of the 1930s—such as *What a Hit!* (1932, cat. 3), *Washout* (1933) and *Easy Come, Easy Go* (1935, cat. 4)—shows Kaye's ironic take on financial risks of all kinds—by markets, governments, speculators and gamblers. After the final collapse of his marriage in 1937 (it was already faltering in the early 1930s), and possibly as one of the reasons for it, Kaye devoted himself almost entirely to art.[16] From the late 1930s, during the Second World War and in the two decades following it, Kaye's output was substantial, and he continued to paint obsessively, despite

(opposite page from top) Otis Kaye, *Money to Burn (I)*, 1927, Oil on canvas mounted on panel, 9¼ x 12½ in., Private Collection; Otis Kaye, *Money to Burn (II)*, 1923–28, Oil on canvas mounted on board, 8 x 9½ in., Private Collection, Photograph by Joseph Bartolomeo Courtesy of Shannon's Fine Art Auctioneers

13 See *The Life of Otis Kaye* in this catalogue, pp. 12–19.

14 'I see us free, therefore, to return to some of the most sure and certain principles of religion and traditional virtue—that avarice is a vice, that the exaction of usury is a misdemeanour, and that the love of money is detestable, that those walk most truly in the paths of virtue and sane wisdom who take least thought for the morrow.' John Maynard Keynes, "The Future," in *Essays in Persuasion*, (New York: Harcourt, Brace and Company, 1932), pp. 371-2.

15 J. Bradburne and L. Sebregondi, eds., *Déjà Vu All Over Again. The Riddle of Otis Kaye's Masterpiece*, (Florence: Alias, 2009).

16 Kaye's wife returned to Germany sometime in 1932, taking their two children with her.

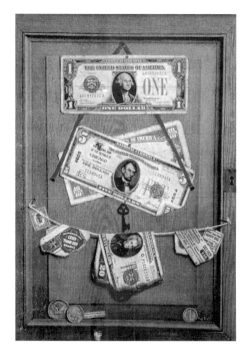

Otis Kaye, *Washout / Hang the Wash*, 1933, Oil on panel, 16 x 12 in., Mongerson Gallery

not intending his works for sale.[17] As can be seen from his increasing ambition in the following years, art provided Kaye with a means to wrestle with the issues of his time, while providing an outlet for his restless creativity, his voracious reading, and his continuing mastery of the artist's craft.

In the 1940s Kaye was a frequent visitor of his cousin Paul Banks II when they were in business together. Three engineers, Kaye, Banks, and 'Toddy' J. Toman, a chemist, would meet and talk long into the night. They would discuss philosophy, science, and government, and often rant over examples of institutional corruption in organizations like the Red Cross.[18] They also argued the existence of God, but generally agreed on the abuses of organized religion. Paul Banks III, the son of Kaye's business partner, remembers hearing the men's discussions as a small boy:

'What I remember is mostly philosophy and the church, especially the church. God, corruption. They argued with each other. My mother had to throw them out a couple times, and said: okay that's enough. They'd smoke up the house, and once they started drinking they'd get really loud. But then they'd go off into a different language. When they'd first start out they'd talk about conditions of the time. They were talking about the war, and corrupt agencies that were gaining money for war efforts and most of it would be side tracked to somebody else's pocket. I remember them saying that there was no God. I used to ask my mother and she would say, no, they have these crazy ideas about things. And she would say, don't pay them too much attention. [...] His [Kaye's] wife was Jewish and my mother was Lutheran. My grandmother demanded that my mother turn Catholic. The Kayes had the same problem because she [Kaye's wife] was Jewish and at the time they were living on Ruble Street which was all a Czechoslovak neighborhood and they just didn't fit in. Kaye evidently had trouble with his wife. You know, you can be married for a while and then you say, well, you come over to this side or I'll come over to that side. My parents had the same problem, but my mother didn't care too much. My grandmother used to call her the German Lutheran and I'm sure she called her quite a few other names too.'[19]

17 According to a letter by Kaye, two works were apparently sold during a visit to Germany in 1937, but these were an exception. MS, Otis Kaye Archive (Appendix 8 p. 170).

18 During the Second World War and Korean War, reports that the American Red Cross charged troops token fees for 'comfort items' such as toothpaste, coffee, donuts, and cigarettes abounded and provoked a strong reaction in many quarters. The stories were in fact true, although the practice was based on a government directive that noted that as Allied soldiers were being charged for these items, Americans should be charged as well to 'ensure an equitable distribution among all service personnel of Red Cross resources.' Although the practice was quickly discontinued, the rumors of abuse persisted.

19 An interview with Paul Banks III by the author recorded at the family home 8 March 2010.

It is likely that the men also did some gambling. Paul Banks III remembers his father going out at night and returning late, hastily getting money from his locked desk and dashing out again. They always dressed in suits and ties and smelled of cologne when they went out on the town. They would have gambled in private clubs in Chicago. A Kaye etching of a strip show at Minsky's, *Striptease* (1950), is not merely a documentary record of Chicago's seamier side, but a comment of what people will do for money.[20] Kaye's work in the decades following the war increased in its ambition, its range of subject and media, and its complexity. References to the corrupting power of money continue to appear frequently but Kaye's messages become more varied and more overtly philosophical. Kaye begins to tackle larger scale paintings, with historical themes such as *Custer II / Going Out of Business* (1958, cat. 27), and landscapes, with mixed success. Occasionally he creates works that are simply representational—nude studies, portraits, engravings, drawings in red chalk, watercolors—but these are exceptions. Even the simplest nude may lie on a bed on which coins are to be found, perhaps suggesting the story of Danaë, or an exaggerated mountain landscape may reveal a nude model scampering away from a contemporary satyr in the corner, as the red-shirted Kaye looks on. Kaye experimented extensively with watercolors, which variously depict falling banknotes (*Money Does Grow on Trees*, 1953, cat. 19), a nude bathing in a river with barrels of money (a tip of the hat to the late-19th-century *trompe l'oeil* artist Victor Dubreuil), fishermen tempting salmon with banknotes, or the artist and a friend calmly drinking cognac while roasting in the fires of Hell among many other themes.

Otis Kaye, *Striptease*, 1950, Etching, 8⅛ x 5⅞ in., Private Collection, Illinois

Some of his more complex *trompe l'oeil* works are autobiographical, such as *Amor Vincit Omnia* (1950, cat. 24) or biographical, such as *Land of the Free, Home of the Brave* (1944, cat. 8), others more overtly polemical, such as, *Pass the Bread! Jack* (1949, cat. 11) and *Soldier's Valor* (1953, cat. 16). Still others such as *Custer's Gun* (1950, cat. 14) and *U.S. Musical Notes* (after 1946, cat. 10) take their starting point from known *trompe l'oeil* models, which Kaye then makes his own by adding his own critical commentary. Kaye is not afraid to invent his own models as well, and used baseball in 1932 (*What a Hit!*, cat. 3) and again in 1954 (*Will you play ball?*, cat. 20) to moralize about a 1919 baseball scandal in which the Chicago White Sox were accused of having deliberately lost to the Cincinnati Reds. In the 1950s Kaye began to create mixed media works—gouache, watercolor, colored pencil, graphite—in which he works over engravings by well-known masters. Thus in Kaye's *The Almighty Dollar Yad* (after 1948) Rembrandt's alchemist stares out not at Cabalistic anagrams praising God's power, but at a Liberty half dollar. In his nod to Dürer, *Eden Bonding* (1950), the apple is replaced by a gold coin. Reworked by Kaye, Picasso's early *Frugal Repast* becomes *Before Taxes* and *After Taxes* (1956, cat. 21, 22)—a commentary on

<hr />

20 Chicago's center of vice was located outside of the 'Loop' and the Rialto Theatre, owned by a member of the Minsky family, was one of the most popular vaudeville houses. It opened at 336 South State Street in 1917 and soon provided strip shows for all male audiences.

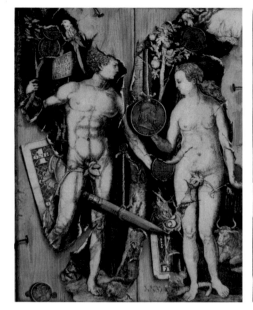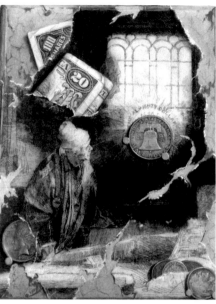

(from left) Otis Kaye, *Eden Bonding Company*, 1950, After Albrecht Dürer *Adam and Eve* (1504), Etching and gouache on paper, 9¾ x 7¾ in., Private Collection, Illinois; Otis Kaye, *The Almighty Dollar Yad*, after 1948, After Rembrandt van Rjin, *Faust in His Study, Watching a Magic Disk* (1652), Etching and gouache on paper, 8³⁄₁₆ x 6½ in., Private Collection, Illinois

poverty, a theme he also treated in engravings during the Depression. Like many of his generation, Kaye's morality transcended party politics, and paintings such as *Checks and Balances* (1959, cat. 29) show he could be as scathing about Communism as he could about the failings of the stock market. Some of Kaye's works, such as *Fate is the Dealer* (1957, cat. 25) and *The Uncommon Man* (1958, cat. 28) attempt to stretch criticism beyond its natural limits to become philosophy, albeit with mixed success. No matter what the medium or the subject, Kaye was unable to resist making his works social commentaries; even when his point is not explicitly moralistic or critical, it is there nonetheless.

What was Kaye like? According to Paul Banks III, Kaye—'Uncle Otis'—was 'stern, with kind of a deep voice—greying hair, but energetic. I remember Toddy [J. Toman] as being very slow and deliberate and my father kind of in between, but this guy was just like, it's got to be this way. It's almost like people say today, "my way or the highway".'[21] Was Kaye himself religious? Do his repeated references to the corrupting power of money find their root in faith? Probably not. In fact, all the evidence points to Kaye's distaste for organized religions of any kind. At most, Kaye was perhaps a Mason, prepared to believe in a generic Supreme Being unfettered by confessional belief. Although he clearly held strong beliefs about social justice and morality, Kaye was not doctrinaire about religion.[22] His beliefs were probably similar to those of many other Americans of the 1930s and 1940s, such as Ed Ricketts, as described by John Steinbeck: "He had no religion in the sense of creed or dogma. In fact he distrusted all formal religions, suspecting them of having been fouled with economics and power and politics. He did not believe in any God as recognized by any group or cult. Probably his God could have been expressed by the mathematical symbol for the expanding universe. Surely he did not believe in an after life in any sense other than chemical. He was suspicious of promises of an after life, believing them to be sops to our fear or hope artificially supplied."[23] As Paul Banks III remembers, Kaye and his father, like Ricketts and Steinbeck, 'believed in science, they were all science. And that's really the thrust of it.'[24]

21 Paul Banks III in an interview with the author recorded at the family home 8 March 2010.

22 Kaye teases his cousin on his atheism in a letter to Paul Banks II and Bess Hoffman. MS, 194?, Otis Kaye Archive (Appendix 8 p. 172).

23 John Steinbeck on Ed Ricketts, in *The Log from the Sea of Cortez*, (New York City: Viking Penguin, 1951), p. li

24 An interview with Paul Banks III by the author recorded at the family home 8 March 2010.

So what is the moral of the story? What picture does Kaye leave us? Who *was* Otis Kaye? Profoundly moral but not deeply religious. Self-absorbed, opinionated and cantankerous; a loner with a deep philosophical bent. Ironic and wry, with a dry and penetrating sense of humor based on careful observation of humankind's frailties, which clearly included his own. Perfectionist and exacting, but not without a deep underlying humanity. Above all, Kaye was an artist, who used his technical skills to address—although not resolve—the dilemmas he confronted during a long, complicated and not cloudless life. Kaye never sold a painting in America in his lifetime—they were just stacked one against the other in the Banks's garage and occasionally on the walls of friends and family, in one case in a nunnery.[25] Far from being manifestos, meant to stir the hearts and minds of others, they were part of a continuing dialog with himself, perhaps in the hope that in the end, everything would be OK.

25 A *Crucifixion*, a rare religious work, which Paul Banks II's sister, Sister Laurencia, hung in her cell.

CRITICAL RECEPTION—OTIS KAYE'S LEGACY

James M. Bradburne

In the 1980s, over a decade after Otis Kaye died, the Banks family first thought about selling some of Kaye's work. Bessie Hoffman decided to try selling a few of the works her husband, Kaye's closest friend and cousin Paul Banks II, had collected and admired. Henri La Borie, who ran the Chicago gallery La Borie Gallery with his aunt Margot Goldstein (Kaye's wife's cousin), suggested that Paul Banks III see James Maroney in New York. Maroney was working as a private dealer at that time, and was former head of the American Paintings Department at Sotheby's, an expert who would be able to determine if the paintings were saleable. In February 1985 Paul III brought three paintings to Maroney: *Three Bills and a Theater Stub* (unsigned), *Trompe l'Oeil for Bessie Hoffman* (signed N.A. Brooks) and *Hidden Assets I* (dated 1920 and signed O KAYE). Paul Banks III remembers the visit very clearly. Maroney looked at the painting with no signature and said immediately, "Oh, that's a Brooks—but Brooks would not paint that well!" He looked at the painting signed N.A. Brooks and then the last, signed Otis Kaye. Paul explained that the paintings were in his parents' collection. Maroney said Otis Kaye must have painted them or bought Brooks's paintings.[1] He bought *Three Bills and a Theater Stub* for $5,000 and put it in the Sotheby's June 1985 Auction as Lot 33A: "Attributed to Otis Kaye (19th/20th Centuries), oil on board, 11x13 Est. $4,000–$6,000." It sold for $9,625. Otis Kaye was totally unknown, and the painting was sold entirely on the basis of its technical excellence and artistic quality.

Just before the Second World War, Edith Halpert's *Nature-Vivre* exhibition at the Downtown Gallery in New York City in 1939 helped revive the vital American *trompe l'oeil* tradition that had had its heyday in the late 19th and early 20th centuries. Afterwards, in 1953, Alfred Frankenstein's book

Otis Kaye, *Three Bills and a Theater Stub*, c. 1920, Oil on board, 11 x 13 in., Private Collection

After the Hunt: William Harnett and Other American Still Life Painters, 1870–1900 created new impetus for the rediscovery of the American still life tradition, and in particular, money *trompe l'oeil.* Of course there is no mention of Kaye, who was an unknown engineer working in Tremont, Illinois. As Kaye's work came onto the market in the 1980s, the only way it could be understood—and sold—was to place it in the context of the earlier tradition that began with William Harnett, John Haberle and John Frederick Peto, and included N.A. Brooks and Victor Dubreuil. To make sense out of his work, it was important to proclaim Kaye as 'the last of William Harnett's true followers,' as he was described in the 1985 Sotheby's auction catalogue.

1 Interview with Paul Banks III by the author recorded at the family home 8 March 2010.

Otis Kaye (signed N.A. Brooks), *Trompe l'Oeil for Bessie Hoffman*, 1962, Oil on panel, 21 x 12 ¾ in., Private Collection, Illinois

One example serves to illustrate how Kaye's legacy was shaped by guesses that soon took on the authority of facts. This is of course not uncommon when biographical details are as scarce as in Kaye's case; however, the imperatives of creating a convincing narrative often prove surprisingly resistant to fact. After the 1985 Sotheby's sale, James Maroney was convinced there was a market and purchased *Trompe l'Oeil for Bessie Hoffman* and *Time Is Money*, both signed N.A. Brooks. The story of Otis Kaye and N.A. Brooks began to take on a life of its own, and has largely shaped how Otis Kaye's life has been viewed. The same

fall, *Trompe l'Oeil for Bessie Hoffman* was included in the exhibition *More Than Meets the Eye: The Art of Trompe l'Oeil*, at the Columbus Museum of Art (December 7, 1985–January 22, 1986), the first time Kaye's work had been shown in a museum. The catalogue included the following description for the painting: "Otis Kaye, attributed to, American active 1880-1917 *Trompe l'Oeil for Bessie Hoffman* ca. 1917 James Maroney New York."[2] Not only did this suggest that Kaye was painting five years before he was born, it made him a near contemporary of a pantheon of better known *trompe l'oeil* painters—clearly an historical error. William Kloss, the exhibition's guest curator, writes in the introduction: "Political and social interpretations do not apply to the handsome *Trompe l'Oeil for Bessie Hoffman*, now attributed to Otis Kaye, a 20th-century artist who often emulated Brooks's manner and style and even Brooks's signature—not to forge the work for fraudulent purposes, but to introduce another level of deception for the connoisseur's enjoyment. To paint regressively in a style and with a subject matter of a generation earlier suggests a nostalgic or provincial temperament—perhaps both."[3] In a note to her catalogue essay *The Eye of the Artist: Images of the Creative Process*, the museum's curator E. Jane Connell elaborated Kaye's relationship with Brooks even further.[4]

2 E. Jane Connell, "The Eye of the Artist: Images of the Creative Process," *More Than Meets the Eye: The Art of Trompe l'Oeil*, (Columbus Ohio: Columbus Museum of Art, 1986), p.61.

3 William Kloss, "More Than Meets the Eye: The Art of Trompe l'Oeil," *More Than Meets the Eye: The Art of Trompe l'Oeil*, (Columbus, Ohio: Columbus Museum of Art, 1986), p.29.

4 "Although this picture is signed N.A. Brooks NY, it has been reattributed to Otis Kaye, about whom little is known except that he once lived in Illinois and painted in the first half of the 20th century. Kaye's signature paintings depict events from the lives of American historical figures such as Custer and Lincoln. His trompe l'oeil pictures are about paper and

Trompe l'Oeil for Bessie Hoffman was also included in the show *Old Money* (November 11–December 17, 1988) presented by Berry Hill Gallery and curated by Dr. Bruce Chambers. Berry Hill Gallery had purchased a number of Kaye paintings from the Banks family, and several of these paintings were included. The catalogue and gallery focused on firmly linking Kaye to the past tradition of *trompe l'oeil* in America: "Otis Kaye, the last of the great *trompe l'oeil* money painters was born in 1885, just a year before Harnett quit painting currency." Chambers continues: "[...] Kaye and his mother arranged to enroll Kaye in engineering school in Dresden, Germany, beginning in 1905. In the intervening year, they lived in New York, where Kaye became interested in art. While he did not attend art school, he did seek out the advice of more experienced painters, including Nicholas A. Brooks. Kaye even purchased two of Brooks's paintings, both of which—*Fifty Dollar Bill on the Bank of Augusta* and *Full of Old Curiosities*— are in this exhibition." This is a new twist—Kaye has now not only studied and copied Brooks, he met him and bought two of his paintings, the same ones that were in the show.[5]

money and are similar in style to those ascribed to N.A. Brooks. Perhaps Kaye revered the work of Brooks to the point that he signed this picture with Brooks's name. We do not know where Kaye would have seen examples of Brooks's work. There are however marked differences between the paintings of Kaye and Brooks. According to James Maroney in a discussion with this author, Kaye shows a penchant for painting paper with rather elaborate voids, such as the ten-cent note in the center of his picture and the ten-cent stamp on the letter which is not consistent with paintings by Brooks. Kaye also gives the portraits on currency notes a unique caricaturish quality (compare the bills in Kaye's picture to the one in *Full of Old Curiosities* by Brooks." Connell, *More Than Meets the Eye: The Art of Trompe l'Oeil*, note #6, p.51.

5 Chambers continues: "Two of Kaye's paintings are not signed Otis Kaye, but are signed N.A. Brooks. One of these is entitled *Time Is Money*, and the other is the remarkable *Trompe l'Oeil for Bessie Hoffman*, dating sometime after 1922. N.A. Brooks's name appears just below the clipping at left center but the painting is executed in Kaye's unmistakable style and bears the name of his cousin's wife on the envelope at the lower right. Why would Kaye forge Brooks's name to his own paintings? The answer lies under our nose, in the clipping: '*To the critic the artist replied, "Imitation was the highest form of compliment to art, man or nature." One critic rose to complain of mere deception; however, he quickly sat down when the painter offered him a brush.*'

By 1993, in the catalogue for *A Private View: American Paintings from the Manoogian Collection*, an exhibition held at the Yale University Art Gallery (April 3–July 31, 1993), the curator Alison Tilghman writes of *Time is Money*: "Kaye had met the *trompe l'oeil* artist Nicholas A. Brooks in 1904, the same year he acquired two of his paintings. When he began to paint a dozen years later, Kaye taught himself by copying Brooks's work."[6] In the Berry Hill catalogue of American Paintings published a decade later, the entry for Kaye's *Holding the Bag* elaborates on the now entrenched N.A. Brooks myth: "Kaye became

Otis Kaye (signed N.A. Brooks), *Trompe l'Oeil for Bessie Hoffman*, detail, 1962, Oil on panel, 21 x 12¾ in., Private Collection, Illinois

interested in art and sought out the advice of several painters, including Nicholas A. Brooks. Kaye even purchased two of Brooks's paintings."[7] The Banks family never confirmed the story, and reported only what they heard from Kaye himself after he moved to Chicago, or could prove with the documents Kaye left with the family.

The presence of this clipping not only explains the signature of Brooks, Kaye's "mentor"; it also strongly suggests that Kaye knew of the existence and meaning of Haberle's *Imitation*, and may even have been aware through Brooks, of Fullerton's shenanigans at the Old Curiosity Club." Bruce Chambers, *Old Money*, (New York: Berry Hill Galleries, 1988), p.88.

6 Alison Tilghman, *American Paintings from the Manoogian Collection*, (New Haven: Yale University Press, 1993), p.59.

7 Bruce Weber, *American Paintings XI*, (New York: Berry Hill Galleries), p. 20.

Unfortunately, the Banks family did not begin to keep a record of the artworks—or of their recollections of Kaye—until the family began to sell Kaye's works in the 1980s. By then, Paul Banks II, Kaye and most of his friends were dead; Paul Banks II's wife Bessie was in her 70s; and most of Kaye's papers had been thrown away in earlier years. The most enduring witness to Kaye and his life remains his artwork. In the past few years, both paintings Kaye had playfully signed N.A. Brooks, originally thought to have been painted in the early 1920s, have been re-assigned dates in the 1960s on the basis of internal evidence.[8] Nevertheless the earlier speculation remains embedded in essays and catalogues and proliferates on the Internet, taking on a separate life of its own. With time it acquires the aura of fact, and spawns new and more fantastic conjectures.

Bruce Chambers, whose 1988 exhibition helped launch interest in Kaye, wrote effusively, prolifically and enthusiastically. However, one may argue that Chambers did not delve into the documentary evidence as thoroughly as one may have hoped. The discovery of the sparse but very real documentation would have helped Chambers avoid the mistakes he committed in trying to establish Otis Kaye as the inheritor of the mantle of Harnett, Haberle and Peto—and N.A. Brooks.

A second factor in shaping contemporary misconceptions of Kaye's work is that only a single genre of his *oeuvre*—*trompe l'oeil* money paintings—was considered saleable. As a consequence, the vast variety of Kaye's output—pastels, watercolors, engravings, mixed media—has gone largely unrecognized. In 1987, Henri La Borie organized a small exhibition of Kaye's work, which featured a selection of his output that fell outside

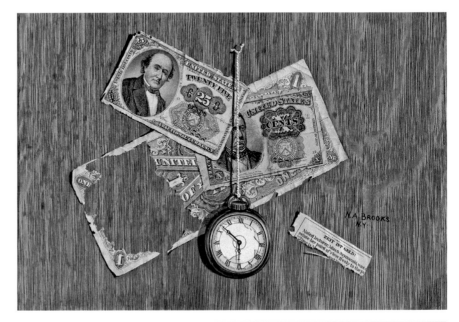

Otis Kaye (signed N.A. Brooks), *Time is Money*, 1962, Oil on panel, 9 x 12¾ in., Private Collection; detail below

8 The two paintings signed N.A. Brooks are the only works Kaye painted directly onto wood, which appear to be from the same panel. A clipping in *Time is Money* refers to Miss Szymanski, the maiden name of Geraldine Banks, Paul Banks III's new wife, whom he married in 1966.

the easy-to-sell money *trompe l'oeil* genre. For the first time the public was shown Kaye's engravings of nude figures, large oil paintings, and charcoal sketches. Mary Ann Goley and the exhibitions she curated in 2002—*The Art of Appropriation,* at the Federal Reserve (February 6–April 5) and *Otis Kaye* at the Peters Gallery in New York (April 24–May 24) which shared many pieces and the catalogue essay—were instrumental in presenting Kaye's wide variety of work in different media to a broad public, and clearly demonstrated how Kaye's work went beyond the confines of the money *trompe l'oeil* tradition to which he is habitually assigned. Her work is the first to analyze Kaye's art seriously, paying meticulous attention to the coins and currency he uses, and to the wide variety of sources he uses as inspiration—Dürer, Vermeer, Rembrandt, Goya, Picasso and other major artists of the past four centuries, which he copies to perfection, always adding something in the service of making a political, polemical or merely humoristic point. Goley's work remains the most serious scholarship available, although it is not clear whether her characterization of Kaye's work as 'the art of appropriation' does full justice to the intelligence he brings to bear on his *trompe l'oeil.*

Marc Shell, a MacArthur Fellow and the Irving Babbitt Professor of Comparative Literature at Harvard, for reasons of his own, spoils his otherwise delightful, erudite and poetic essay in *Experimental Scholarship,* "OK: or Handel with Care" (1996), on the nature of *trompe l'oeil* in general and Kaye's *Handel with Care* in particular, with the suggestion that Kaye was planning to flood the American market with fake bills during World War II to help Nazi Germany, as a kind of misplaced revenge for having lost his money in 1929. While consistent with the fanciful literary spirit of the essay, it seems an odd conclusion to draw about someone who had a Jewish wife, and who quite possibly lost his own son in the Shoah.

Two major exhibitions have contributed to new scholarship on *trompe l'oeil* in the past decade, the National Gallery's *Deceptions and Illusions* (October 13, 2002–March 2, 2003) and the Palazzo Strozzi's *Art and Illusions* (16 October, 2009–24 January, 2010), which featured a section on American *trompe l'oeil,* and had as its centerpiece Kaye's masterpiece *D'-JIA-VU?* (cat. 5). A small book accompanied this second exhibition, *Déjà Vu. The Riddle of Otis Kaye's Masterpiece,* as part of the Palazzo Strozzi's series *Conversations,* in which the work was discussed by a group of experts including Mark Mitchell and James Bradburne in the collector's home.[9]

We still do not know the baptismal name of the artist we know as Otis Kaye. So what's in a name? There is no doubt that the paintings by the artist calling himself Otis Kaye would be just as sweet whatever name he chose to use. There is equally no serious doubt that the person calling himself Otis Kaye was the artist responsible for the paintings attributed to him, less doubt in fact than for many more famous artists, whose work was often done by assistants, copied by admirers and forged outright. In the case of Kaye, every one of his known paintings—with the exception of two *trompe l'oeil* paintings sold in Germany in 1937 and a few non-money paintings sold by the La Borie Gallery in the 1960s—belonged to the Banks family until after Kaye's death, which makes attribution simple and straightforward. Either the painting was sold by the Banks family or it was not a Kaye. On the other hand, while attribution is less problematic, the fact he never sold any of his *trompe l'oeil* works during his lifetime, despite some half-hearted attempts, means that for his entire life as an artist, he was unknown, unrecognized by the public, the critics and the press.

9 James M. Bradburne, ed., *Déjà Vu all over again: The Riddle of Otis Kaye's Masterpiece,* (Florence: Alias, 2009).

Kaye flew under the radar, and as a consequence never had to reply to gallerists, critics or journalists to explain his own background or the origins of his art. Critical reception had to wait until after his death, and even now Kaye's works are mostly in private hands, having been bought at auction in the 1980s and 1990s—only a handful have found their way into museums such as the New Britain Museum of American Art. Notwithstanding the importance of American art and the work of Harnett, Haberle and Peto in the collections of the LACMA, the Metropolitan, the National Gallery and other smaller American museums, it may still be some time before any significant number of Kaye's works are purchased by museums or left to them.

THE RIDDLE OF OTIS KAYE

James M. Bradburne

It should come as no surprise that a *trompe l'oeil* artist's life—when looked at carefully—turns out to be an illusion, at least in part. Beyond his paintings themselves, in which the eye is regularly fooled and the mind teased with multiple allusions, hidden meanings and wordplay, Otis Kaye himself remains a mystery, and his biography full of unsolved riddles. A simple search on the Internet reveals a seeming wealth of information about the artist who called himself Otis Kaye. Nevertheless, relatively little work is needed to discover that much of what we currently 'know' about Otis Kaye is largely based on speculation, hearsay or outright fantasy—speculation by academics, personal accounts by family members, and stories invented by art dealers to create a market for Kaye's works. This means that from an academic perspective even the simple sentence '*Otis Kaye was born in Dresden, Germany in 1885. When he was about three years old, his parents moved to America near his cousins in Chicago, the Bancak family.*' is far from unproblematic.

So what do we really know about the artist who for all his adult life called himself (at least in America) Otis Kaye? What puzzles remain to be solved by future biographers? First of all, while it is certain he was born, and reasonable to assume he was born around 1885, lacking a birth certificate and a death certificate, Kaye's exact age remains speculation. We also know enough—in principle—to find out his baptismal name, as he was certainly a son of Freda Kozlik, who was certainly the sister of the Anna Kozlik who married Paul Bancak in 1905. Although an extensive search of the records has not yet turned up the name of a son with the first initial O (perhaps Oskar?) born to a woman named Freda (or Frieda) with the maiden name Kozlik, in

theory the document is somewhere waiting to be discovered. With this happy discovery we would learn the surname of Kaye's presumed father Werner, and be able to—among other things—find Kaye's father's death certificate, confirm the dates of Kaye's leaving and returning to America, his enrollment at technical school in Germany, his marriage to Alma, the baptism of his two children (if they were in fact baptized) and presumably discover a host of other information that would turn up if Kaye in fact conducted his legal existence (paying taxes, renting apartments, forming businesses) using his baptismal surname. Everything would become much clearer.

Or would it?

In all likelihood, Otis Kaye returned to America with his family at the end of the First World War, leaving a devastated Germany behind. His first works can be dated to the 1920s, including sketches and gouaches. In addition to unambiguously signing himself Otis Kaye, from the outset he shows a lively sense of humor and delights in wordplay; in the titles of his works (some of which bear similar titles to classics of *trompe l'oeil*), in the fragments of newspaper clippings that routinely appear in his paintings, in the signatures on bank notes and stock certificates, and in the ingenious use of his initials, OK. This obsession with his name leads one to speculate—with no hard evidence whatever to support the conjecture—that perhaps a piece of the puzzle is actually staring us in the face. What if Otis (which although rare in German could in fact be his name, although Oskar is more likely) used, for whatever reason, the initial of his mother's maiden name, Kozlik, as his surname—'Otis K' becomes Otis Kaye. Certainly the punning on his initials found in his paintings suggests more than a mere fascination

with the homonym of Martin "Old Kinderhook" Van Buren's initials. Kaye need not to have adopted his new name until his return to America after the First World War, and his Chicago cousins—whom he only met in the late 1920s—surely would have accepted the use of his mother's initial without much fuss. After all, they too had simplified their surname to Banks from a surname variously recorded as Bancak, Bancsak and Banclik, and Kaye lamented his father had not done the same.[1] Similarly, although there were many Kozliks already living in the Chicago area, Kozlik was not an easy name to spell either. How much easier just to use 'K'!

Kaye's baptismal name aside, more importantly, where did he learn to paint currency with such astonishing skill? While it is certain that Kaye was prodigiously talented, painting bank notes and stock certificates with the accuracy Kaye's work displays suggests that Kaye's natural talent was sharpened by formal technical training, which strengthens the belief that Kaye did indeed study engineering in Germany, and possibly even at Dresden's *Gewerbeschule*. We can say with some certainty where Kaye found the models for his etchings, and even some of his paintings, as the few documents that have survived suggest that he was an avid collector of art publications of various kinds. He would also have had access to the collections of the Chicago Art Institute and other Chicago and New York museums. We also know he sketched from life—at the zoo, using live models from the art school, on his many trips into the countryside. But what about the bank notes? Where did he find the models (and there are some 'beauties') to use for $1,000 bills? Here the answer seems relatively straightforward. Kaye was a naturally gifted artist and a technical draughtsman with a trained eye—he did the same thing he did with all

of his art, he observed carefully, and made sketches, and even writes to his friend and printer Fritz Hoffman in triumph when he makes a find.[2] With his technical training it would not have been difficult to return to the easel and painstakingly reconstruct the bank note.

Kaye's personal life also raises some questions for future biographers, more troubling than his chosen *nom de plume*. There is little doubt that Alma Goldstein was from a Jewish family, like her cousin Margot, although we have no way of knowing if her parents had converted to Christianity. We do not know if Otis and Alma were married in a church or a synagogue, or whether their children where baptized. We do know, as they would not have foreseen when they married around 1910, that the Nazi government would take power in 1933, and that as of 1935, with the passage of the new race laws, their children would certainly be defined as Jews, and set apart for derision at least, extermination at worst. Germans by birth, German-speakers who lived in a German community, Kaye and his wife would surely have been aware of the dangers presented by the rise of Nazi power. So why did Alma return to Germany after 1932? If she returned to America, why did she go back again? Even if she returned to Germany to be with her children—which Kaye did not—why did Oskar not return to America with his father in 1937 after the death of his mother and sister, when there could have been little doubt of what the future held in store for a Jewish 24-year-old?

Then there was JJ Byllesby. From the accounts of the family, and in particular Paul Banks III, who cleaned the offices for pocket change and recalls seeing technical drawings of gyroscopes and guns, there is no reason to doubt that his father and Otis Kaye were involved in the

1 Otis Kaye letter to Paul Banks II: "And you were right to push him to make the name change legal. I wish my father had done it." 1944 MS, Otis Kaye Archive (Appendix 8 p. 173)

2 Note on a printed $1 Bill in red ink: *Fritz great job on this. Saw $500 $1000 n A Bank Exhibit in Chgo. I made dwgs. How about a try?* Undated MS, Otis Kaye Archive (Appendix 8 p. 176)

war effort. But both the name and the address of this small engineering firm with three associates raise questions. H.M. Byllesby was one of the inventors that helped Westinghouse develop Thomas Edison's electric light in the late-19th century. H.M. Byllesby & Company operated until the 1930s as engineers, financiers and managers and operators of public utilities. The company's home offices were at 231 South LaSalle Street, Chicago. Byllesby himself died in 1924, and afterwards the company was involved in several dubious monopolistic activities, attracting the attention of the federal anti-trust officers. While the name may well have been a Kaye-inspired joke, the fact that the name, business and address are so similar makes one wonder if there wasn't a deeper logic behind the choice, perhaps a tongue-in-cheek reference to a major stock market manipulator—the very sort that Kaye excoriated in his money *trompe l'oeils?*

Finally, putting aside nostalgic reasons, why—and how—did Kaye return to Germany to die? As a German, he may have held a German passport. If he was a naturalized American (under his baptismal name) he may have held an American passport (required since 1941 for foreign travel) albeit probably by renouncing his German nationality. In either case, he could have travelled to Germany given the ease of transatlantic air travel (the Boeing 747 entered service in 1970). But would he have been able to travel to Dresden as he clearly hoped? The German Democratic Republic was under Soviet control as a member of the Warsaw Pact, and it is hard to imagine an 80-something year-old German-American being allowed to enter the GDR without eyebrows being raised. The Stasi kept separate files on foreigners entering every major East German city and have no record of the arrival of an American

calling himself Otis Kaye. So did he return to Dresden? Did he make it to Berlin? If he made it to Bonfeld to say hello to Bessie Hoffman's family, no letter survives. Only a short note, from his ex-wife's cousin, many months afterwards, to say that Otis Kaye had died. An end as mysterious as his beginning. All lives are unexpectedly difficult to document, but few are mysteries. Kaye's life, on the other hand, remains as enigmatic as his paintings, the artist himself a *trompe l'oeil.*

FOLDING MONEY

c. 1929, Oil on panel, 6 x 9 in.
Signed: [O]tis KAY
Private Collection, Illinois

In *Folding Money*, Kaye first used the
technique of pictorial colloquy. Against a
cool gray wood panel, a folded ten-dollar bill
features Alexander Hamilton, the founder
of America's financial system. Joining him is
Abraham Lincoln on a 1929 five-dollar bill.
George Washington on a one-dollar note
completes the trio. A pink paper clipping
in their midst reads: *The Treasurer told the
Am[erican] / Presidents: 'Carry FOLDI[NG] /
MONEY ONLY.'* All three bills are folded
to feature the portraits of the presidents as
if in conversation. The expression "folding
money," referring to paper currency rather
than coins, originated in the late 1920s, just
about when Kaye created this composition.

GB

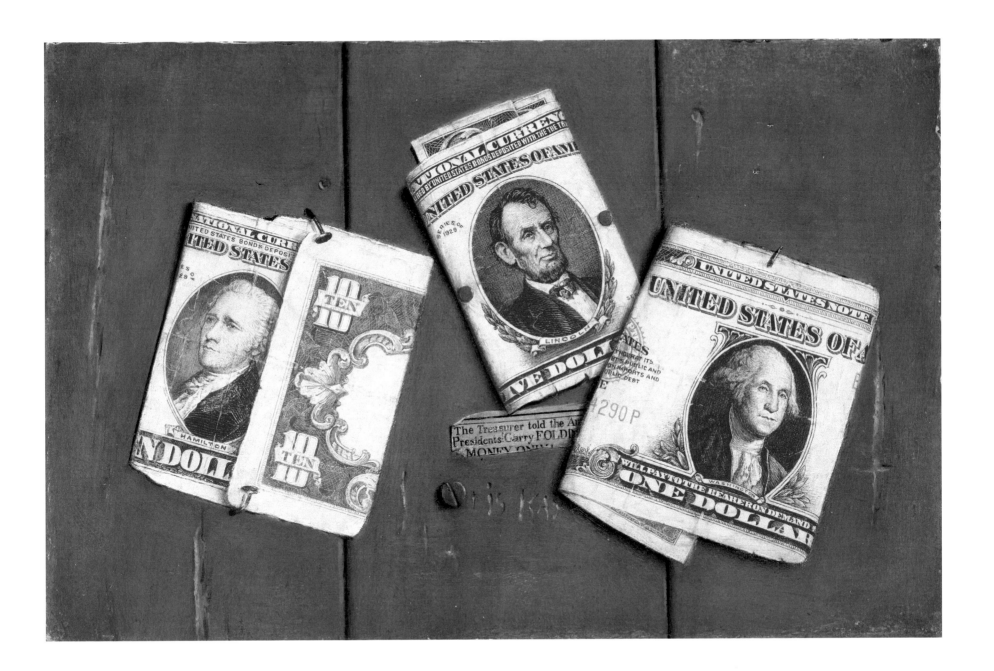

OTIS KAYE'S COIN COLLECTION / MONEY COSTS

1930, Oil on panel, 9½ x 6½ in.
Signed: OTIS KAYE
D. Brent Pogue

Labeled with a scrap of paper and a thumb tack, *OTIS KAYE'S / COIN COLLECTION* is comprised of little more than a dozen worn and well circulated coins: a nickel and a dime, a penny, a Standing Liberty quarter, a Walking Liberty fifty-cent piece and a silver dollar. Only two gold coins sparkle in the dark and weathered wood cabinet: an ancient Greek heroic likeness and a 1926 golden Indian Head eagle ten-dollar piece, coinage treasures that span time. Although a skeleton keyhole is present in the cabinet door, no screen or glass protects the collection. It is not their commercial value that moved Kaye to select these coins but his attraction to their design and to the challenge of replicating them in two dimensions so meticulously that the viewer might be tempted to snatch them up from the shelves. Kaye, in his usual ironic style, attached the admonition *MONEY COSTS*—his invitation to ruminate on the true worth of money in all its ramifications.

GB

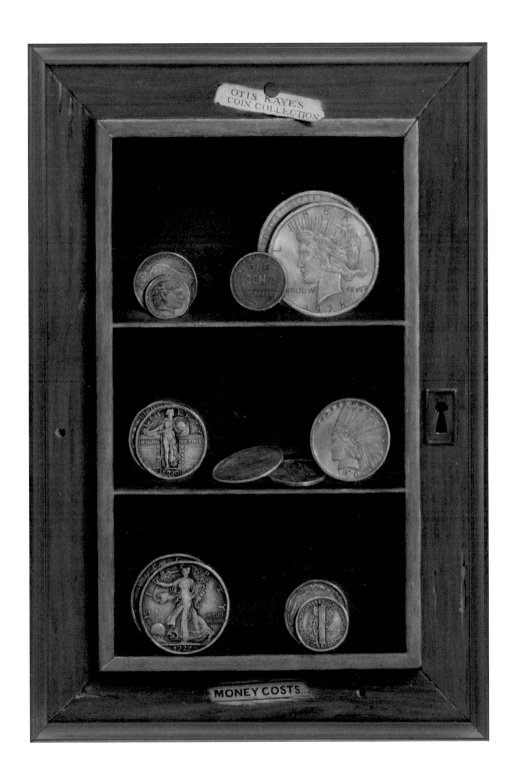

OTIS KAYE'S
COIN COLLECTION

MONEY COSTS...

WHAT A HIT!

1932, Oil on canvas, 30 x 25 in.
Signed: [O] KAYE
The Hevrdejs Collection

What a Hit! calls to mind the saying "Play Ball!" but take care, for the viewer must play by Kaye's rules. Once again, he conjures two realities: his own imagined setting and the real world.

At the top of the painting, a baseball crashes toward us, propelled by a powerful force through the wood panel (presumably a ballpark fence). Kaye keeps the space to the exact minimum of the picture plane, and the viewer is outside the ballpark, thrilled by the action. Then he brings us back inside with the assemblage of pasted and tacked objects—Kaye's reality—that tempts us to move closer to touch the items.

Dollar bills form the perimeter of home plate and represent bets placed on the game. In his news clip, Kaye writes, *Bets, / big and small were placed near / home plate as fans chanted, "five / get you 10 / can't do it / again."* Small black-and-white news photos show Babe Ruth, #3, at bat, with the headline *YANKS RALLY / FOR 7-5 VICTORY / Slugger Hits Ball Through Fence; / FUTURE STARS Unlikely to do / Same.* A red Wrigley Field admission ticket fixes the event in baseball history. During the 1930s

Kaye lived in Chicago and may even have attended the third game of the 1932 World Series. The ticket is issued for *WRIGLEY / CUBS vs. YA[NKEES] / OCT. 1 1932.*

Ruth's home run became a sensation when reporter Joe Williams wrote this headline in the late edition of the New York World Telegram the day of the game: "RUTH CALLS SHOT AS HE PUTS HOME RUN NO. 2 IN SIDE POCKET." Whether the Babe really called his hit or not, the newspapers gave the story life and readers assumed it was true. Ruth's home run ball actually landed in extra bleachers set in the street outside the ballpark. Kaye presents a more exciting image.

Flanking the outer sides of home plate are dark photos of what are probably forgotten older-generation players relegated to obscurity by Ruth's stellar performance. At bottom center, a half-dollar coin makes the "O" of Kaye's signature. A torn newspaper clipping provides us with the title *WHAT A HIT! and a taunt for the artist: Otis "5 getcha 10, you KAYE / CAN'T do it again.*

GB

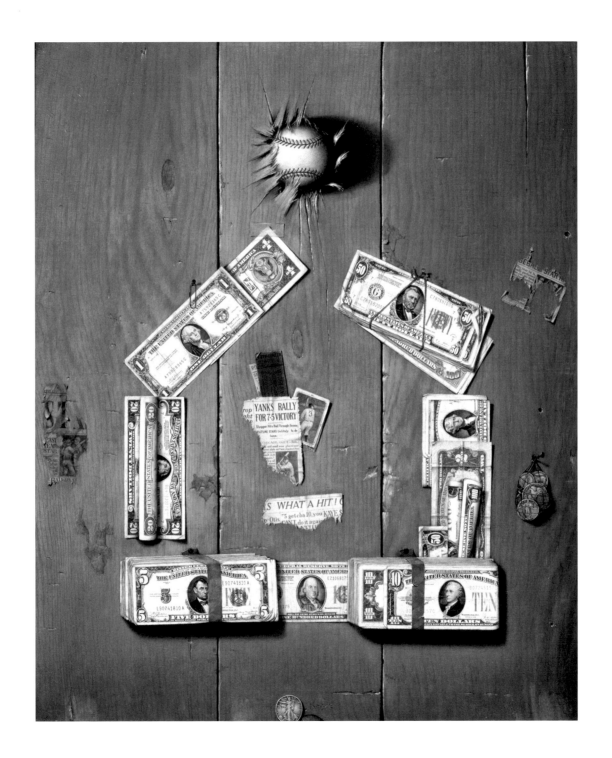

EASY COME, EASY GO

1935, Oil on panel, 21 x 25⅝ in.
Signed: O. KAYE
Manoogian Collection

If *Easy Come, Easy Go* were music instead of a painting, it might sound like Vivaldi's *Spring*. The warm sepia-colored wood background repeats the color of the monarch butterfly that would flutter away in the balmy air if Kaye had not pinned it down for his purpose: to mimic its shape with money.

The large wings are modeled by the fanned out currency and envelopes at top left and right, while the smaller wings are echoed by the net holding rolls of coins and the black purse. A blue payroll envelope postmarked *CHICAGO / OCT 26 / 7PM / 1935* is stuffed with money and surrounded by fanned-out bills of various denominations. The Queen and King of diamonds represent wealth, and the "Q" and the "K" also stand in for Kaye's initials—Kaye is betting his all. In the wallet are tickets from the Peoria lottery, the Pekin Sweepstakes and, of course, a racetrack.

Centrally placed, the folded one-dollar bill captures our attention momentarily, inviting us to ponder the results of Kaye's folly. Inside the open change section of the wallet appear an IOU and burned ticker tape. At right, further financial losses are affirmed by the yellow *UTILITY SECU[RITY] / COMPANY / MARGIN DEPT* envelope and burned defaulted stock certificates, along with sundry overdue notices and a menacing blue *FINANCE CO.* envelope, all from Chicago.

Kaye summarizes his ordeal in the black purse, which holds a Joker and a Two of Diamonds, a pair of dice displaying craps, and pennies poking through the holes. At bottom left and right, the words *EASY COME* and *EASY GO* appear on what seem to be paper slips from fortune cookies.

A final gesture at lower right is a smiley face adjacent to a paintbrush tucked between two Walking Liberty half dollars. Kaye seems to tell us money may come and go, but that he is at liberty to keep painting.

GB

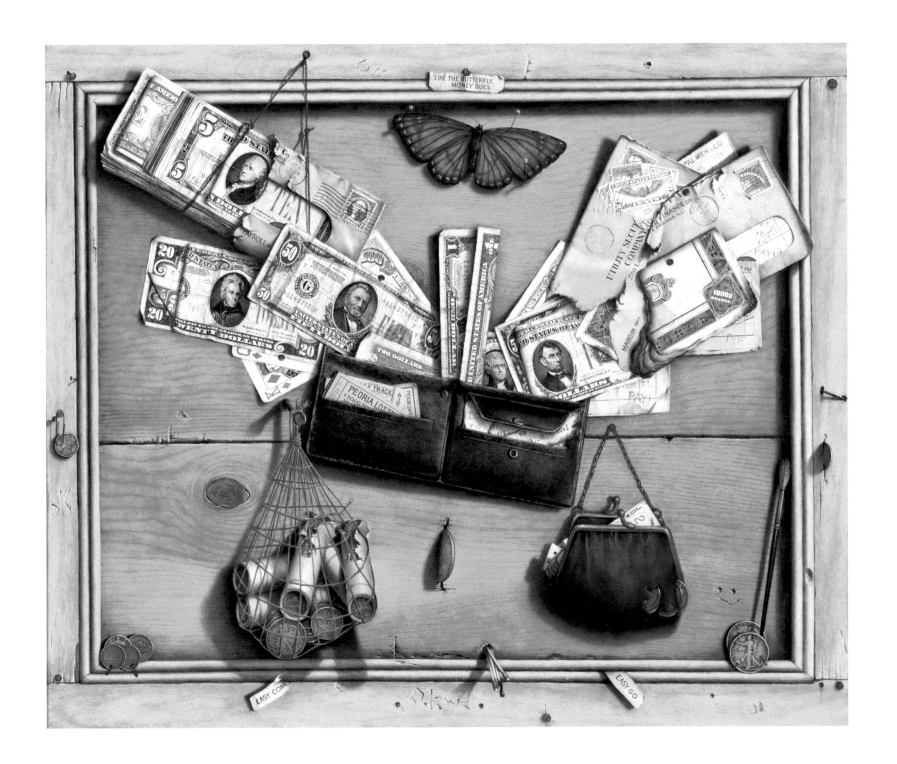

D'-JIA-VU?

1937, Oil on panel, 27 x 39½ in.
Signed: Otis Kaye
Cordover Collection, LLC

With meticulous realism and intricate documentation, Otis Kaye's *D'-JIA-VU?* records the national malaise of 1937 as the United States again teetered at the brink of a stock market crash after eight years of the Great Depression. Capitalizing on the phonetic resemblance between DJIA (the abbreviation of Wall Street's primary index, the Dow Jones Industrial Average) and the French *déjà* ("already"), Kaye's painting traces the Dow Jones's performance during the preceding eight years in a chart composed of currency and bonds, and culminates with the question *D'-JIA-VU?* (Have we already seen this?).

The complexity of *D'-JIA-VU?* renders it difficult to summarize and bears deep scrutiny. The market's decline is charted by shrinking values of bills and stock certificates, while the ensuing fluctuation includes bonds, an alternative investment. Tobacco containers mark time with the felicitous names Old Gold, Bond Street and Lucky Strike. At bottom, cards and dice reflect the gamble of stock trading alongside a campaign pin for Franklin Delano Roosevelt, whose New Deal had initiated the market's recovery. The artist's initials and name appear repeatedly in the papers as well as carved into the drawer fronts and moldings suggesting that *D'-JIA-VU?* is the artist's self-portrait in objects, an autobiography that paralleled national events.

MDM

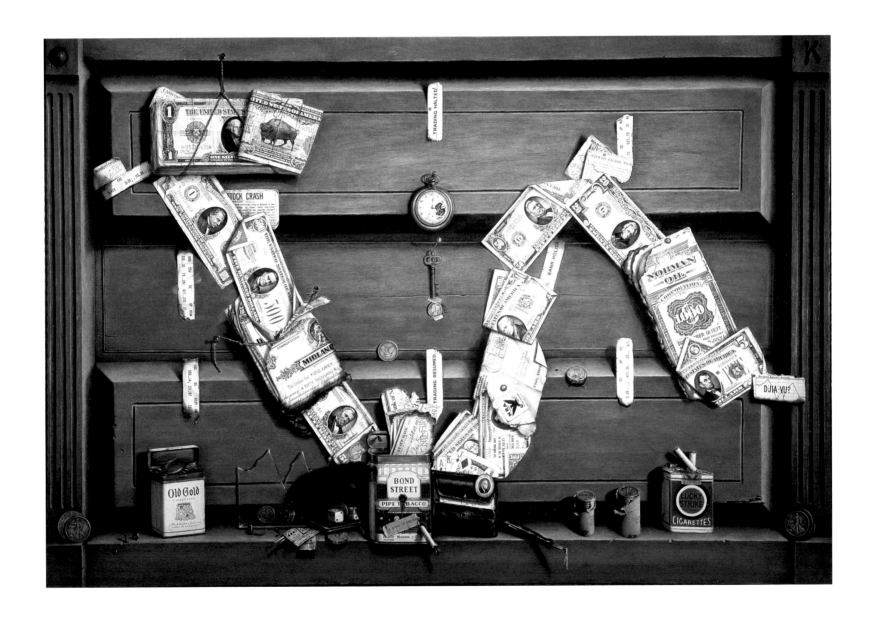

FACE IT, MONEY TALKS

1940, Oil on canvas mounted on board, 11 ⅛ x 15¾ in.
Signed: OK
Private Collection Care of Waterhouse & Dodd

There is no doubt the calligram here is a smiley face. Liberty coins twinkle in the eyes, the nose is formed by a title tag hanging from a penny wedged into the sunny yellow wood background. Currency forms the mouth, including a fifty-dollar bill with a mischievous curl. Two coin "dimples" in the lower corners complete the countenance. Kaye's major theme paintings are filled with irony and humor, but here amusement is the magic.

GB

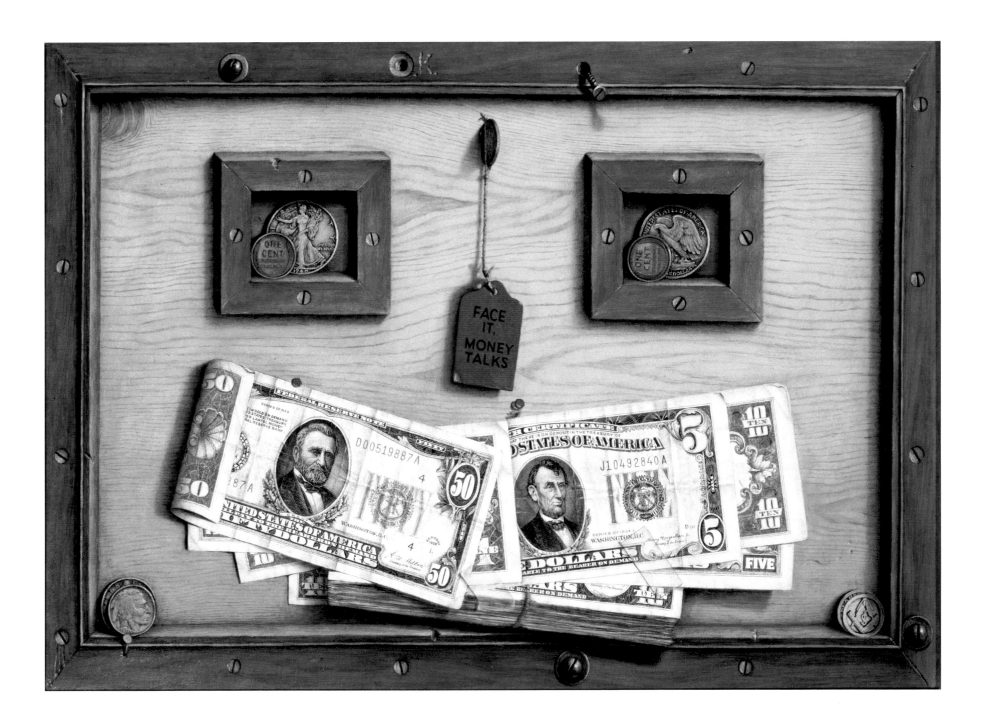

DOLLAR BILL

c. 1940, Etching with tempera on paper, $2^{11}/_{16}$ x 6 in.
Signed: Otis Kaye
Sheldon Museum of Art, University of Nebraska-Lincoln,
NAA—Gift of Carl and Jane Rohman

Kaye etched an exact duplicate plate for the
One Dollar Bill, Series 1935. On this print
from his plate, he painted the back of a
penny and the face of a 1940 dime in tempera,
thereby adding a new dimension to his
trompe l'oeil, combining etching and painting.

In 1909, Congress had passed a law
prohibiting all non-official copies of
money, but Kaye was not deterred. A bit
of an anarchist, he relished the challenge of
creating the face of the dollar bill in all
of its verisimilitude. We can assume he had
no intention of counterfeiting because he
never created a plate for the verso. He did
sign his name as Secretary of the Treasury.

GB

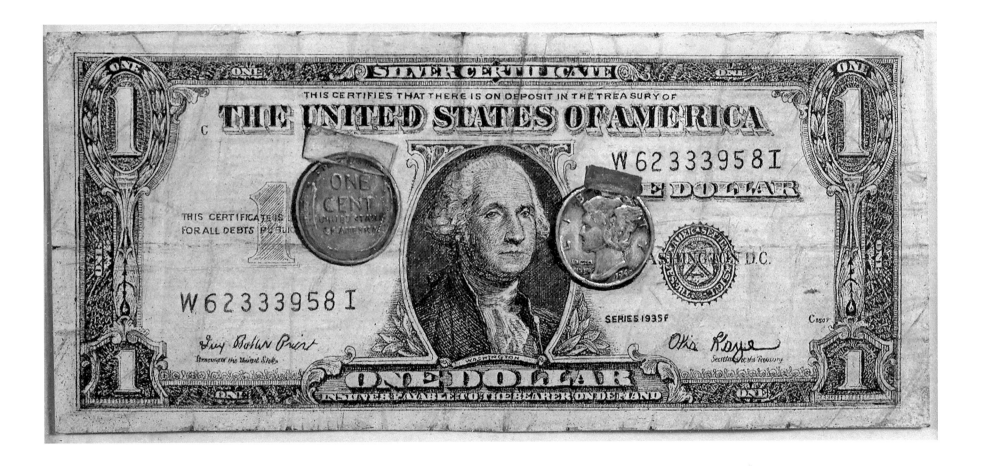

LAND OF THE FREE, HOME OF THE BRAVE

1944, Oil on panel, 25½ x 36¼ in.
Signed: O. KAYE
Private Collection, Atlanta, Georgia

Land of the Free, Home of the Brave presents a sequence of major American wars (via paper currency) as well as the story of one individual soldier's experience during World War II. The collective narrative begins at the upper left, where a broken yellow stick acts as a pole, adjacent to a red ribbon placed at right angles, boxing paper currency overlapped in star-like clusters. The blue horizontal planks of the background suggest the stripes of the American flag. The miniature early American flag and Union Jack reference the birth of the nation, and a colonial note is sounded with 19th-century paper money depicting an Indian (territorial expansion from Indian wars) and fractional currency from the Civil War period. The one- and ten-dollar notes lead us through World War I on an unbroken diagonal line passing under the trigger of the rifle, to the edge of the five-dollar and folded one-dollar bills and ending at the red, white, and blue airmail envelope and the Western Union Telegram.

At this juncture we encounter the individual narrative. In late 1944 Kaye met Bess Banks's nephew, Donald Hoffman, a soldier on his way to serve in Germany. Kaye was impressed by the earnest young man and moved by the unknown danger he was about to face. In 1945 the soldier's family was notified that he was missing in action, though he was later found wounded in a barn. All these elements prompted Kaye to compose what is somewhat of a memorial painting.

The rifle's opposing diagonal shifts from past wars to the individual soldier's tale. Kaye pinpoints how war almost destroyed a young life. A Purple Heart dangles from the trigger, pointing toward an empty shell casing whose bullet may have severed the gun's shoulder strap, injuring the soldier (private's stripe and burnt match)—a really unlucky strike (Lucky Strike cigarettes).

Clustered beneath the rifle are a ration book and currency stamped *HAWAII*, which was issued in case of Japanese invasion. There is a note from the soldier to Kaye asking for financial advice when he returns. The fragmented yellow bag from the Federal Reserve Bank of Chicago implies the financial losses of war, as do the ration tokens and ticket and the Walking Liberty half dollar. The miniature Statue of Liberty in the corner is a bit off balance, but she still extends her torch.

GB

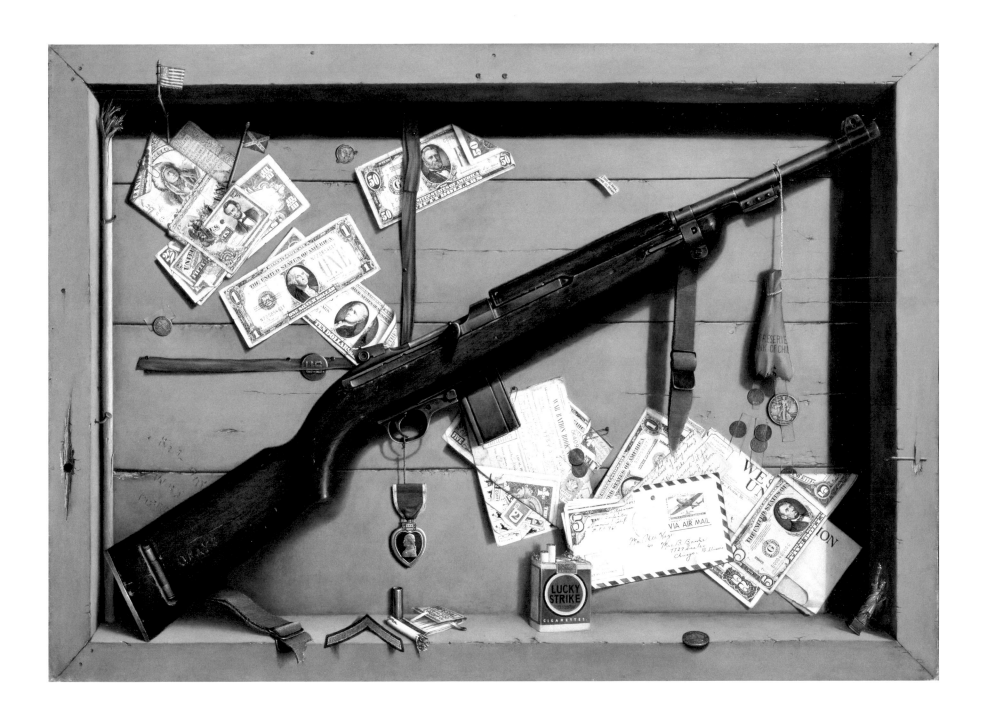

CHRISTMAS PIGGY BANKS

1946–49, Oil on panel, 6 $^{11}/_{16}$ x 9¾ in.
Signed: [O]tis KAYE
Collection of Walter and Lucille Rubin

Christmas Piggy Banks creates a visual pun on the five-and-dime, a popular type of American variety store that sold items for either five or ten cents, but in the painting, the nickel is replaced by a five-dollar banknote. Beginning in 1928, former president Abraham Lincoln's portrait was printed on the five-dollar bill, which Kaye depicted alongside a dime bearing the allegorical head of Liberty. The juxtaposition illustrates Lincoln's historical role as the emancipator of enslaved Americans. Kaye effectively used historical allusion to create meaningful depth behind his illusionistic surfaces.

A sale at a five-and-dime is a virtual oxymoron, yet one is advertised on the printed pink notice. The painting's small scale and modest backdrop echo the poverty of its subject, likely the artist himself, who lost much of his savings in the Stock Market Crash of 1929. In depictions such as this one, the hanging currency is often a wad of cash, but here the five-dollar note is revealed in its solitude by its dog-eared corner. *Christmas Piggy Banks* suggests autobiography in the artist's signature, which begins with the "o" of the coin as his first initial, and the framing elements to which the money is tacked that resemble the reverse of an artist's board.

MDM

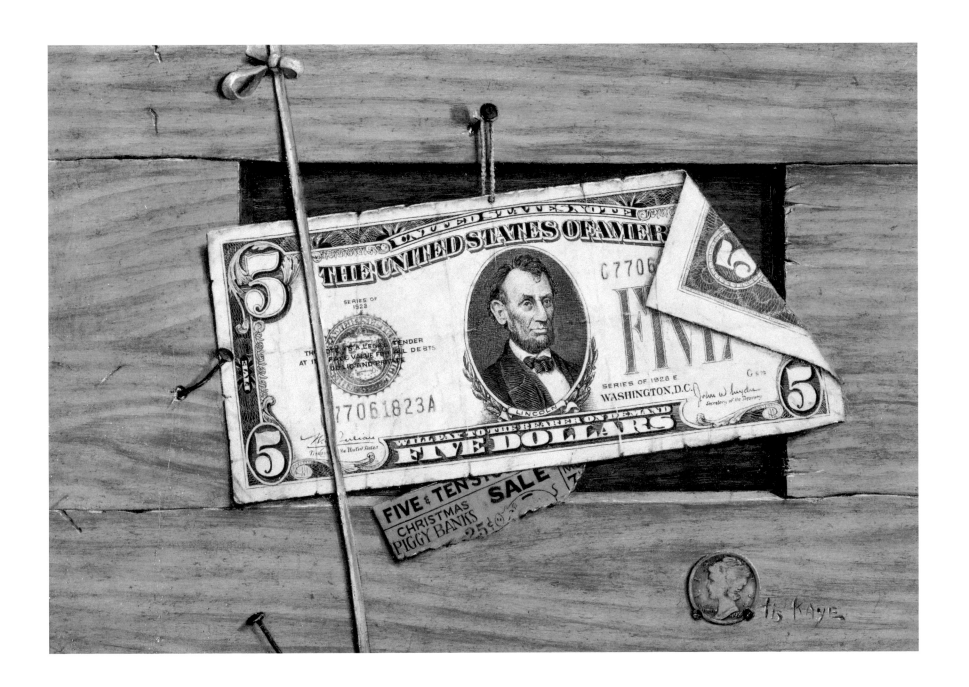

U.S. MUSICAL NOTES

after 1946, Oil on panel, 30 x 24¾ in.
Signed: OK
Private Collection

Backgrounds often form an integral part of a painting's meaning. In *U.S. Musical Notes*, Kaye has interwoven contrasting cool background forms with a warm central violin. The currency is positioned to create a large "S" over the background gray wood panel and behind the black fingerboard of the violin, making a large dollar sign. The vertical middle panel taken with the black fingerboard and the horizontal middle panel together form a cross.

Kaye wrote in a letter to his cousin Paul Banks on November 5, 1944: "...I think greed for the power of wealth is the basis of war—hidden behind cheap philosophies." In later correspondence he discussed this painting's composition: "Sister was delighted when I showed her "Musical Notes" & was quick to see the dollar sign the bills make in conju[n]ction with the violin. But of course she missed the cross that the wood makes behind the violin."

Beginning at the top of the violin Kaye provides a historical tour of power and wealth through *trompe l'oeil* bank notes: a revolutionary continental bill overlapped with a late 19th-century five-dollar greenback, a folded ten-dollar bill, and 1929 National Currency pointing to the newspaper clipping dated 1937. It is titled: *[TH]E SERMON ON THE MO*, a reference to the Sermon on the Mount or perhaps, the Money—the cross or the dollar sign. There is also a warning: *Rev. Otis Kaye said, "Stop fiddling / around chasing money..."* The remaining bank notes, along with a burned fragment of a stock certificate, continue downward through wars and economic disaster to finish the "$" symbol.

The composition is balanced by the placement of coins mounted against the door. Kaye has attached matches adorned with miniature American flags which resemble musical notes. The beguiling shape of the violin is repeated in the two brass hinges at the left of the painting and again in the door

lock opposite. Its key hangs at the left while in the keyhole a curled roll of paper money claims to be the *REALKE*—one of Kaye's frequent puns, money is the key to everything. On the lower bout of the violin there is a further message: *"The reality of wealth / is an illusion," Jesse Jam(es) / told S. Freud.*

Kaye claims his authorship with a visual riddle: dangling on a string tied to the money roll is a pen pointed toward the initials OK scratched in the wood.

GB

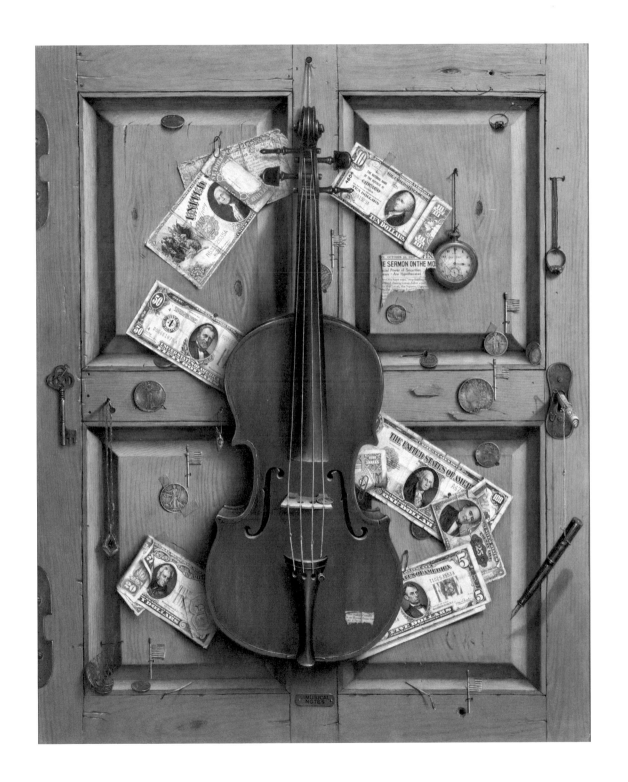

PASS THE BREAD! JACK

1949, Pastel on canvas, 29 x 21 in.
Signed and dated: O. KAYE 1949
Private Collection, Illinois

At first glance an arresting and powerful form, the head of an octopus with tentacles ensnaring all before it, seems ready to lurch out at the viewer. With further viewing, we recognize a stock ticker printing paper tentacles—stock ticker tapes—tempting us as they have tens of millions of people before us, with the illusion that money brings life. But only to a lucky few, Kaye indicates with the faces of the dice showing a roll of snake eyes.

Everything is laid before us, for the taking— the piles of cash that would be generated, ownership of stocks, bonds, gold and silver. The stuff of a good life is reinforced by the staff of life, the buns and bread (symbolic of money). All this is executed in pastel on canvas, a somewhat restrictive medium of choice for Kaye's *trompe l'oeil* work, but one he used regularly for other subjects. Here the soft edges of pastel painting and the selective red, white and blue color scheme, seem to say "win or lose, it's the American way."

GB

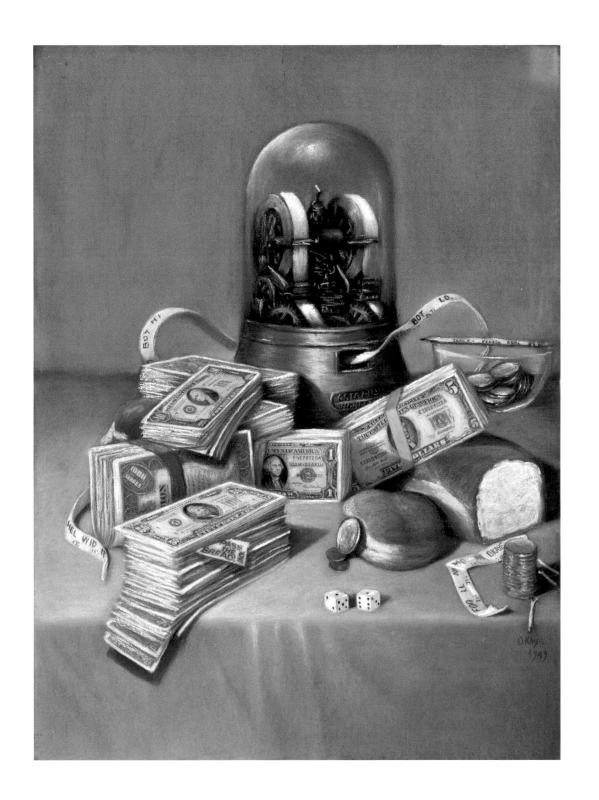

WE'RE ALL GOLD BUGS
1949, Oil on cradled wood, 7 x 12½ in.
Signed and dated: O. KAYE 1949
D. Brent Pogue

Within a *trompe l'oeil* antique gilded frame, Kaye presents four gold coins and a United States of America piece of paper currency accented by a jeweled gold pendant shaped like a winged bug.

The small white note in the upper left corner cautions, *We're all Gold bugs.* Kaye's erudition is shown by his choice of coinage: Alexander the Great, Caesar's Gold Aureus, a Spanish colonial Cob 8 Escudos or Doubloon, and lastly, America's Saint Gaudens 1910 twenty-dollar gold piece. A Series 1928 ten-dollar gold certificate is folded to point directly at the portrait of Alexander Hamilton, the first Secretary of the Treasury and founder of the country's monetary system.

The evidence that hoarding and honoring gold serves as a seemingly permanent expression of wealth and power is highlighted here. Kaye most often features tarnished, well-circulated coins and crinkled, folded currency—the money in men's pockets rather than the money of their dreams.

GB

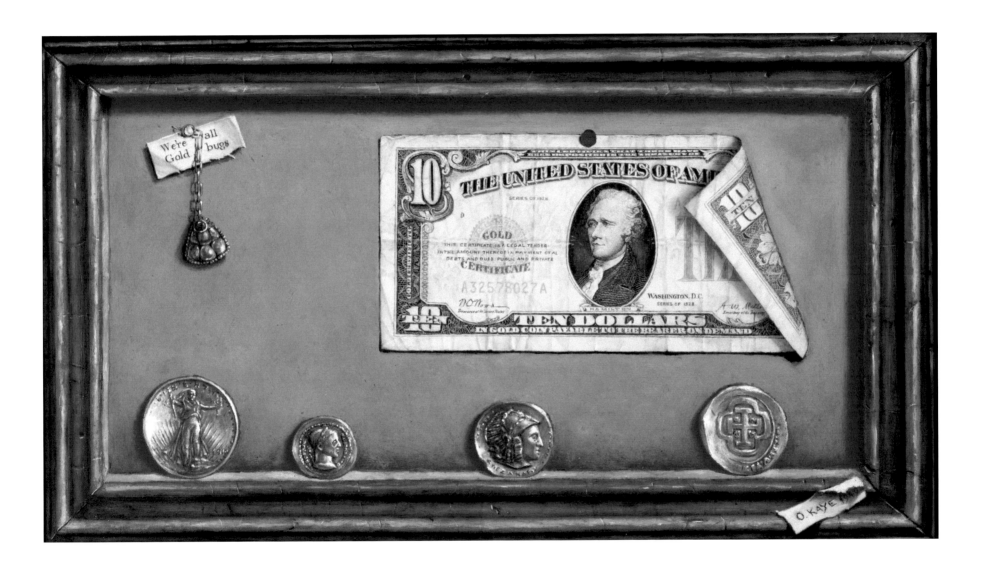

HIDDEN ASSETS

1950, Oil on panel, 14¼ x 20 in.
Signed: Otis Kaye
Private Collection

Hidden Assets is a superlatively painted multilayered conceit recalling the hazards of 1929 Wall Street, an experience firmly entrenched in Kaye's mind. Glued at the top left and right of a wooden stretcher are a five- and a ten-dollar bill. A canvas, tucked inside the stretcher, has been ripped open, revealing colorful stock and bond certificates that otherwise would have been concealed—hidden treasure.

Meager though they may appear today, their total value could have been of some significance for there are multiple 100 share certificates and bonds displayed. Especially interesting is the red bond certificate *STATE OF ILLINOIS / [UN]ITED PAWN CO / No. 711.* It was issued *[OCTOB]ER 1, 1929* and is *DUE / OCTOBER 1 1950 / [INTE]REST PAYABLE ?* Kaye's investments were probably considerable until the stock market crash on Black Tuesday, October 29, 1929.

If the *trompe l'oeil* canvas were undamaged we would see only two small bills, a pack of single dollars dangling from a tacked blue string, and a small cluster of change at the lower left—we would never be aware of Kaye's one-time treasure. Kaye concludes his narrative with the blue pencil inscribed, *DEAL SHARPE PENCIL CO.* It points to a label reminding us what we are looking at: *"Hidden Assets"/ by Otis Kaye / THE SOCIETY OF ANONYMOUS ARTISTS.*

GB

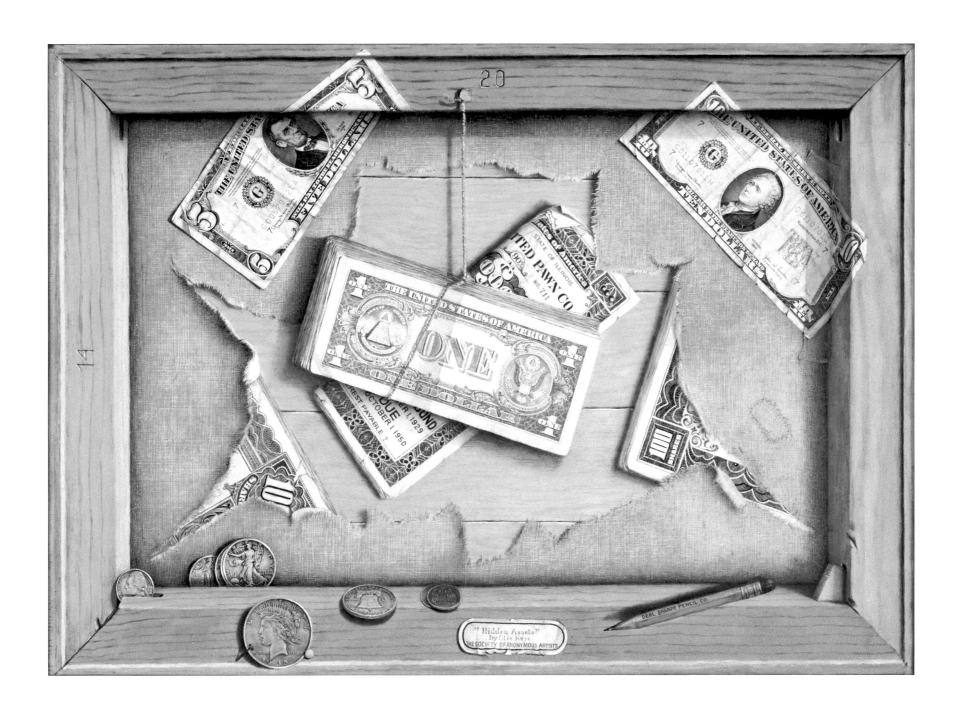

"Hidden Assets"
by Otis Kaye
THE SOCIETY OF ANONYMOUS ARTISTS

CUSTER'S GUN

1950, Oil on canvas, glued on wood, 18 x 13 in.
Signed: Otis KAYE
The Hevrdejs Collection

There is no sentimentality in *Custer's Gun*. It is direct and to the point. A menacing black pistol hangs over the black-and-white photo of the Civil War general. They are so closely connected they become a single image. The adjacent dark bullet hole in the plain wood, a drafting board, alludes to the weapon's intent. The gun, a product of military engineering, the field Kaye pursued during World War II, is a firearm. In the lower right corner, a torn newspaper item bears the headline *CUSTER SLAI[N] / Battle with Sioux / On the morning of Sunday, the 25th Cus[ter] / led his men to a charge. Most of the Indian / ...well armed.* Kaye has highlighted this text for us. The rest is illegible. The painting is a memorial to Custer, an officer who led his men into a bloody fight and died with them on the battlefield. Kaye had visited the West several times and was planning a large painting of the battle scene around 1950. He later painted *Custer II / Going Out of Business*, an introspective presentation on the Indian wars and the settlement of the West.

The artist's signature is found on a ticket in the upper left corner. Its enigmatic Asian script may be Kaye's nod to fortune's sway or another indication of his own inscrutable personality.

GB

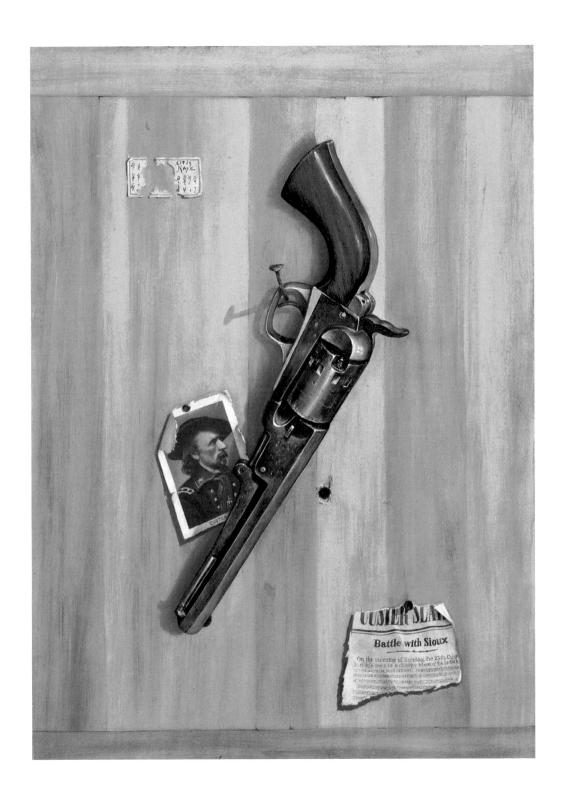

NICKEL DIME SECURITIES

1950, Oil on panel, 12½ x 18 in.
Signed and dated: O. KAYE 1950
Private Collection, Illinois

Kaye's composition is a pyramid of incredibly detailed currency and stock certificates fastened to a warm red wood panel. A one-dollar bill forms the pyramid's base, a five-dollar note with the tip of a ten is the left side, and the right is a blue stock certificate with a burnt edge. A blue business card dangles from a string to the right: *Nickel Dime Securities / A. Ponzi, president RA3-7376*. The name Ponzi is synonymous with pyramid schemes. The certificate reads: *100 SHARES / NUMBER 711 / N[A]TIONAL TEA / IN...UNDER THE LAWS OF THE STATE OF ILL / THIS [CERTIFICA]TE IS TRANSFERABLE IN THE CITY OF CHICAGO ONLY*. Its illustration is a Roman matron seated with a book and stock ticker. A ticker-tape band wrapping around the certificate says *U BOT TU HI*.

There is also a ticket promising that *ON THE LAST OF OCT. 1929 / $1.00 / NORMAN OIL CO / WILL PAY TO / THE BEARER / MAYBE IF WE / HAVE MONEY / $1.00 DOLLAR*. The date is significant, two days after the stock market crash of 1929. Two matches (one burned) tell us Kaye got "burnt" buying cheap nickel-dime stocks, but that your fortune is still in your hands.

GB

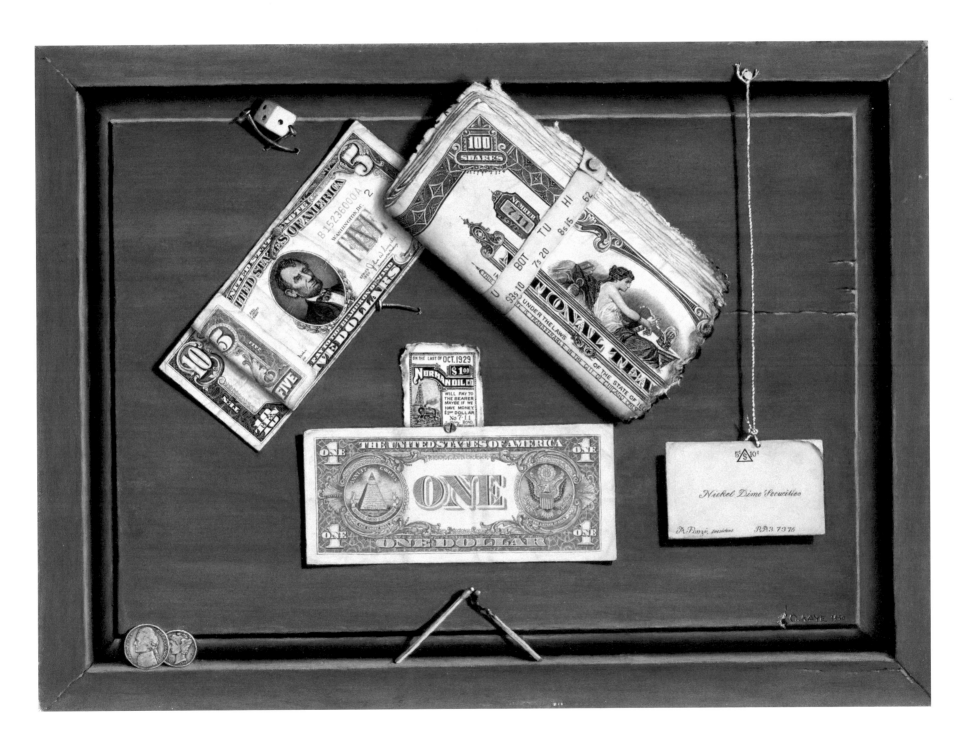

83

SOLDIER'S VALOR

1950s, Oil on wood panel, 36 x 30 in.
Signed: O.KAYE
Private Collection, Illinois

Soldier's Valor is more than a tribute, much like a memorial to all American troops who have fought throughout the country's history and simultaneously a passionate critique of War. Within the patriotic red, white, and deep ultramarine blue framework, the composition's intellectual thrust is the V extending the entire length of the panel and formed by the soldier's M-1 carbine rifle and the opposing line of currency. Yellow and green pencils extend over the framework diagonally creating one-point perspective depth. Kaye labels the pencils *SOLDIER'S* and *VALOR* making it clear the V stands for valor not victory. The painting's center is a sepia photo of an unidentified soldier fastened by a blood red pin and scrap of tape. His sacrifice is obvious in the bullet hole in the rifle butt which would ordinarily have been close to his chest. The bullet is echoed by the spent cartridge in the lower right corner of the painting.

Kaye's timeline of money is a pictorial history of war in America beginning (at the bottom) with the War of Independence 1776, represented by the four dollar currency dated *10th day of April, 1775* (the start of the war) and signed *Otis Kaye.* Next is the Civil War, a three-cent Fractional of March 3, 1861, followed by a one-dollar verso, series of 1914, marking the period of World War I. It is tangent to a five-dollar Lincoln, *NATIONAL CURRENCY, NATIONAL BANK OF THE REPUBLIC OF CHICAGO,* the 1929 issue that marks an economic war of sorts; money and power, comrades in war. The following two-dollar bill has a Liberty half dollar pinned to it, a probable reference to the liberty that could have been lost in 1941. Two one-dollar bills and one-dollar silver certificates, front and back, all reference World War II and date the painting to the 1950s.

Within the four-dollar currency, Kaye has written: *Gold Silver WAR[S] / COST MO[NEY] / young men pay the Bill.* The young men who pay the bill are given the medals exhibited in the blood red case, in the top center of the painting. The Silver Star is bestowed for valor in the face of the enemy in all branches. The Purple Heart, America's

oldest award, was first presented by George Washington to three Revolutionary War soldiers and then revived after the First World War. The Distinguished Service Cross, the second highest medal, recognizes exceptional gallantry and risk of life in combat with enemy forces, and the highest military decoration of all, the Medal of Honor, awarded for conspicuous gallantry, is most often presented posthumously.

The soldier's photo is stamped *UNKNOWN* in red. To the left is a soldier's US pin with part of the U missing: it reads *IS*–America IS Money, while the pin to the right reads *US* and the adjacent rifle symbolizes power: US is Power. Kaye seems to see little redemptive value in medals given for lives lost, and to place responsibility for ending wars with the United States.

GB

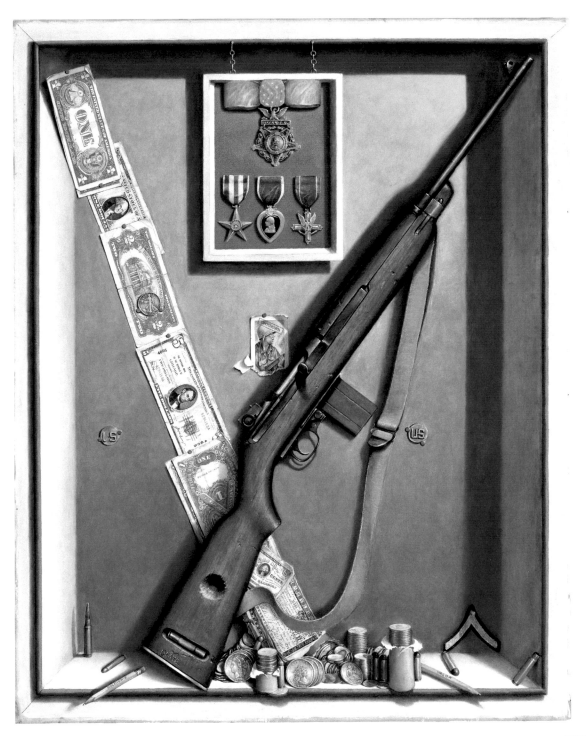

UNTITLED WITH HALF DOLLAR, QUARTER AND PENNY

1953, After James McNeil Whistler
(American, 1834–1903), *Rotherhithe* (1860),
Etching and gouache on paper, 13 x 9$^{3}/_{16}$ in.
Signed: O. KAYE
Collection of the Board of Governors of the
Federal Reserve System, Gift of the Whitehead Foundation

In addition to his oils, pastels, and watercolors, Kaye created a body of etchings of his own design. He refined his skills by making copper plate line for line copies of etchings by Dürer, Rembrandt, Goya, Renoir, and Picasso. Over this print from Kaye's copper plate of Whistler's *Rotherhithe,* he has painted a half dollar, quarter and penny in gouache. As he does in most of his works, he offers us multiple layers of objects to fool the eye and double meanings to challenge the mind. Is this a penny for the seaman's thoughts?

GB

UNTITLED WITH DIME AND PENNY

c. 1953, After Sir Anthony van Dyck (Flemish, 1599–1641),
Portrait of Franciscus Franck, Etching and
gouache on paper, 11 $^{11}/_{16}$ x 8 $^{3}/_{16}$ in.
Signed: [O] KAYE
Collection of the Board of Governors of the
Federal Reserve System, Gift of the Whitehead Foundation

In 1626, Van Dyck began a series of etchings
based on twenty-one of his famous portraits.
Kaye chose to replicate Van Dyck's etching
of *Portrait of Franciscus Franck* (c. 1630–45),
with all its subtle delineation. Kaye left his
signature on his plate and added a 1940
Liberty dime and 1953 Lincoln penny in
gouache—coins he often used to symbolize
freedom. Unfortunately, the plate for this
etching was destroyed in a cousin's
storm-flooded basement, where Kaye had
stored boxes of his belongings. He made
only this one print from the plate.

GB

FRANCISCVS FRANCK
ANTVERPIÆ PICTOR HVMANARVM FIGVRARVM.

Ant. van Dyck fecit aqua forti.

MONEY GROWS ON TREES

1953, Watercolor on paper, 21½ x 29 in.
Signed and dated: O. KAYE 1953
Private Collection, Illinois

Kaye worked in a wide variety of media.
Sometimes, more often later in life, he
turned from his highly detailed *trompe l'oeil*
paintings to the looser style of traditional
watercolors. He also explored the delicacy of
pastel colors and relished the freedom of the
medium. Autumn leaves and Kaye's allusion
to easy money combine here to form a casual,
whimsical scene in which money does grow
on trees and lies at your feet for the picking
in fall.

GB

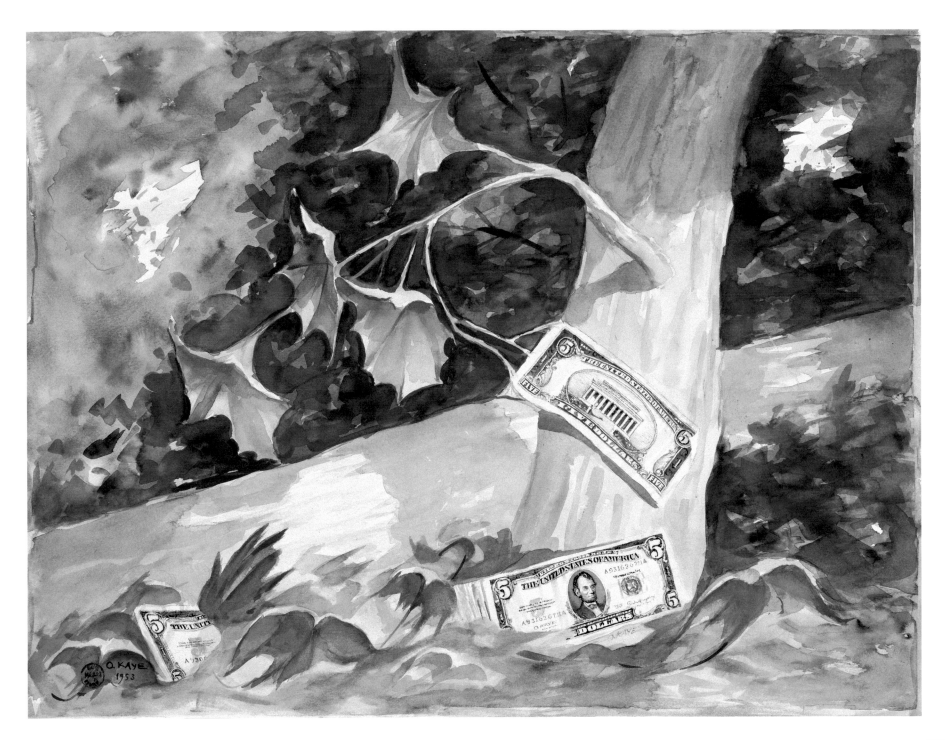

WILL YOU PLAY BALL?

1954, Pastel and pencil mounted on Masonite, 12¼ x 17¼ in.
Signed and dated: Otis KAYE 1954
Private Collection, Illinois

Will You Play Ball? is Kaye's all-American still life, containing a baseball, hot dog, beer mug, a stack of bills, coins, and a ticket for a ballgame. A small yellow ticket poses the question of the title.

True to character, Kaye challenges the viewer to uncover the narrative. The blue ticket is for seat 7, row 11 at the Chicago White Sox World Series game of 1919. The wad of cash signals the "Black Sox Scandal" of that season. Although the White Sox were heavily favored, they lost to the Cincinnati Reds. The gamblers' odds of 7 to 11 were interpreted as proof of their knowledge that the White Sox would throw the game. Even though acquitted, eight White Sox players were banned from baseball for life.

GB

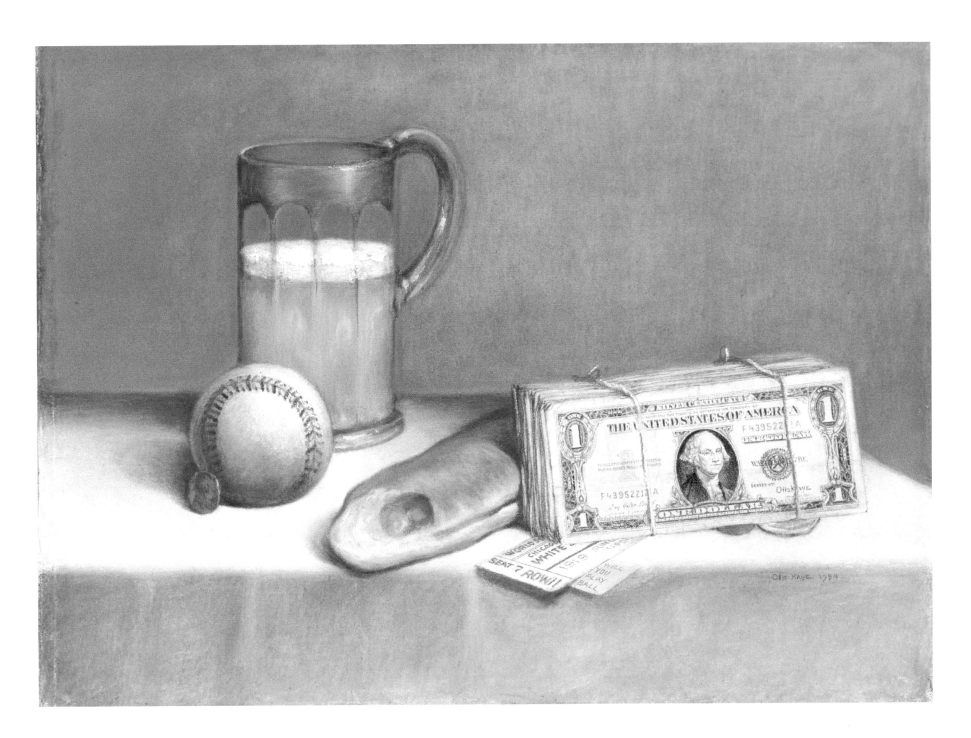

BEFORE TAXES

1956, Etching and gouache on paper, 18 x 15 in.
Signed: O. KAYE
Collection of the Board of Governors of the
Federal Reserve System, Gift of Rachel and Nathan Young

In the 1950s Otis Kaye made a number of masterful line-for-line copies of select etchings by Rembrandt, Dürer, Goya, Whistler, Renoir, Van Dyck, and Picasso. Then, in his ironic manner, he created a new narrative for each work. *The Frugal Repast* was transformed by Kaye's intervention from a despondent study of a man and woman living in poverty to a pair of contrasting portraits of one couple with means and another without.

In *Before Taxes*, Kaye kept a large section of Picasso's print exposed allowing the man and woman to be surrounded by portions of stock certificates, some titled—*MORE! / THAN 10000 / SHARES*—rolls and packs of currency and bills in large denominations. The woman holds shiny gold coins in one palm and dangles sparkling ruby and sapphire rings while the man has a sapphire and pearl tie tack in his scarf and numerous shimmering silver and gold coins. A yellow pencil is labeled *BON APPETIT CATER[II]NG CO. O. KAYE*. The woman looks bored while the man is vigilant, perhaps watching for thieves who covet their wealth.

GB

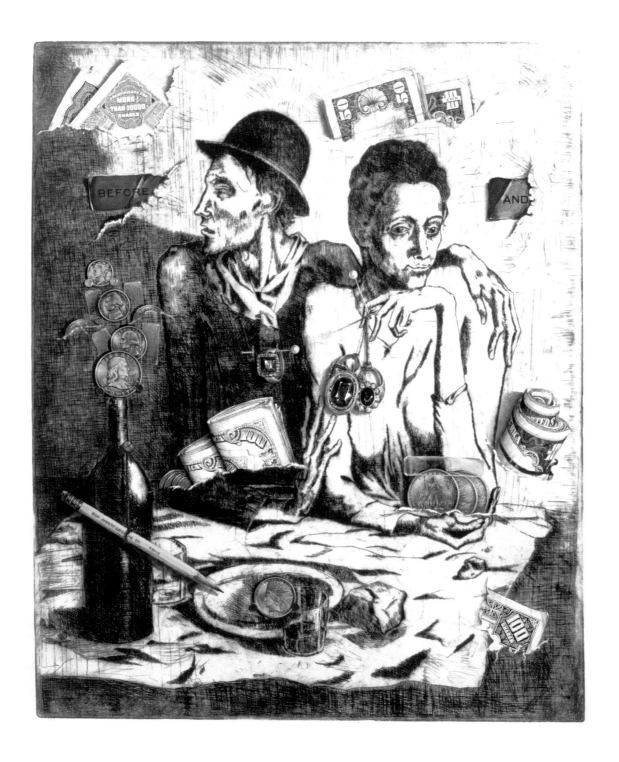

AFTER TAXES

1956, Etching and gouache on paper, 18 x 15 in.
Signed: [O] KAYE
Collection of the Board of Governors of the
Federal Reserve System, Gift of Rachel and Nathan Young

In this companion piece to *Before Taxes*, Kaye created a raw wooden plank for the background and reduced the space of Picasso's image, seeming to squeeze the couple closer together. Now they do not have gold or jewels. The woman instead holds a net bag of coins. The paper currency includes a one, five, ten, and twenty. The corner of a stock certificate reads *2 / SHARES / ONLY*. A lone Walking Liberty quarter marks the lower right corner as the "O" in Kaye's signature.

The coins and currency, jewels, and pencils are painted subtly but realistically in gouache. Not only did Kaye exhibit his master expertise in etching, but he also introduced another medium to his *trompe l'oeil.*

The male sitter here is watching out for a thief, perhaps, considering the title of the work, someone from the Internal Revenue Service. Kaye certainly was no defender of government, the church, or Wall Street. His notebooks reveal his level of distrust of all institutions, and he enumerates their failings from personal observation. After he lost his assets during the Depression, he lived frugally and painted as much as possible, perhaps believing the maxim "The taxman never forgiveth, the taxman only taketh away."

GB

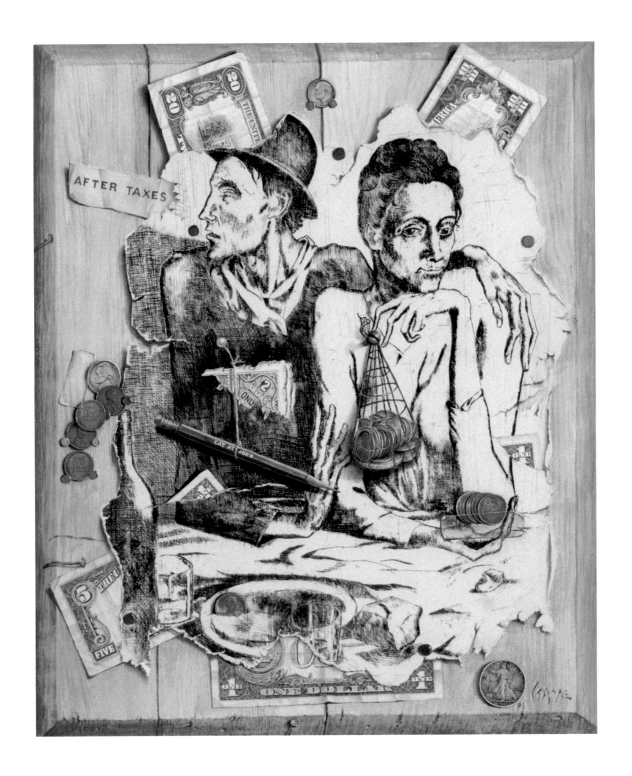

MY CUP RUNNETH OVER

1950s, Oil on canvas mounted on board, 39 x 29¾ in.
Signed: OK
Private Collection, Illinois

My Cup Runneth Over is quintessential Kaye *trompe l'oeil*. Abounding in the joys of life (nature's gifts of juicy peaches, plums, grapes, and wine) and the booming stock market's largesse (stacks of money), it seems to shout to the viewer: "Enjoy the fruits of thy labor!" Done with Kaye's eye-popping technique and laced with his characteristic tongue-in-cheek commentary, it is a Dutch Master's still life with wisecracks—*JACK CASS SECUR[IT]IES CO.* is present along with securities stock certificates from the *BANK OF RUPT COUNTY ILLIN[OIS].*

Kaye's reality games always go a step beyond expectations. Painted to be a wood panel behind a black canvas torn into rolling segments, his composition offers bowls of fruit on marble tabletops and fool-the-eye currency inserted through, behind, and in front of the painted canvas; attached to the painted wooden panels; and extending towards the viewer from urns, playing with different dimensions of space. Encrypted in the decorative borders of the Delftware are stock ticker-tape messages such as *RAG S TU RIC HES OR IS IT RIC HE* and *SELL HIGH ENJOY FRUITS OF THY LABOR BUY LO.* Designs are configured from dollar and cent signs, and stock tickers replace windmills. Discovering them is like participating in an archaeological dig.

An ancient coin labeled *SARDIS COIN CO. OK* dangles at the upper right. Sardis, the capital of the Lydian Empire, was one of the richest cities of the ancient world, located at the end of the Persian Royal Road. The Lydians are credited with having minted the first coins and the city was associated with the fabled King Midas, who bathed in its river to rid himself of the Golden Touch, a myth appropriate to the excesses of wealth and speculation in the painting.

Kaye's business card states *O.K. RESTORATION / U TEAR, / I REPAIR*—his boast that he can tear apart a painting then restore it. The dark modern shapes executed in pictorial opposition to the display of masterly details, delicate colors, and sensuous textures conjure a rich visual tension. Kaye's *Cup* is a slap at the promise of Psalm 23: "Thou preparest a table before me ... my cup runneth over."

GB

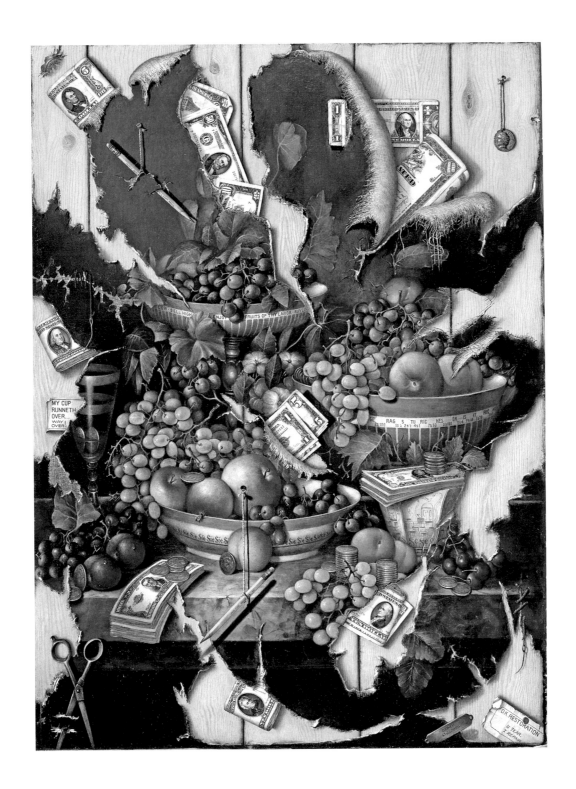

AMOR VINCIT OMNIA
1950, Oil on panel, 30 x 25 in.
Signed: [O]tis KAYE 1950
Private Collection, Illinois

Kaye's bittersweet valentine, *Amor Vincit Omnia*, has for its centerpiece a red gift box brimming with shiny silver and gold coins. Examining the treasure more closely, you discover that they are male and female heads facing off in the eternal struggle between the sexes.

Surrounding the heart are remarkable *trompe l'oeil* bills of various denominations. The painted currency includes a folded fifty-dollar Reserve Note series 1950, signed by Alma Goldstein (Kaye's wife) as Secretary Treasury and a ten-dollar bill forming wings at the center top. The ticker tape crossing the heart reads *HAP PY VAL IN TIN DAY JS*, but it also says *BOT HI SO LD LOW*. Kaye offers us his title, *Amor vincit omnia*, but the candy cane above a Standing Liberty piece of silver in the lower right corner could be read as an ironic question mark.

The composition is framed by a *trompe l'oeil* cabinet door with hinges and a heart-shaped keyhole. Below it the initials *AG OK*—for Alma Goldstein and Otis Kaye—have been carved and then crossed out. The letters are also etched inside the keyhole.

On the painted ledge below, Kaye included a blue envelope from A. Goldstein to Otis Kaye. In the envelope window is the rhyme *Roses are Red, Violets are Blue, Lost your Money. Lost Me too!* In a small torn photo, Alma is seated, looking out with a sadly puzzled expression. The postmark is *JUN 1, 6:30 PM 1937 ILL.* There is one penny in the envelope (for your thoughts?). Above the envelope two corners of stock certificates, burnt remains, are a reminder of how Kaye got burned in the great stock market crash. Dice on the ledge tally craps, bad luck.

Otis Kaye and his wife Alma separated in the 1930s; the reason is unknown. Alma is believed to have died with their daughter Freda in an accident in Germany in 1937.

GB

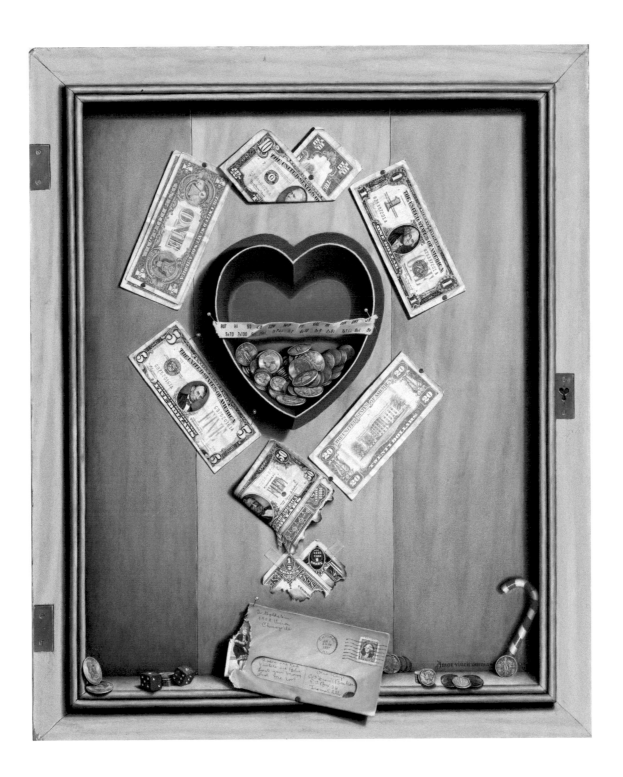

FATE IS THE DEALER

1957, Oil on panel, 48 x 72 in.
Signed: OTIS KAYE
Private Collection, Illinois

Kaye's career can be expressed by a single large late work, *Fate is the Dealer*. While not a *trompe l'oeil* like his many small paintings, the composition of this life size figurative panel recalls Caravaggio's well-known *Supper at Emmaus*.

But Kaye breaks with the convention of representing Christ at the center of the table. He offers us instead a blue-cloaked, faceless card dealer who may be all knowing, but if asked his name, might reply, "I am as I am," in a word, Fate.

This figure is in the center of a large triangle created by the left side of the young girl in a striped dress, carried up the shoulder of the woman in red, whose head is the apex. The right side of the triangle proceeds down her left arm in a straight line continued by the bag of money to the card held by the man in the red shirt. The edge of the green table completes the base.

The figure at the far left of the table has been identified as Johan Hoffman, a member of the family with whom Kaye lived from time to time. Hoffman was a German Lutheran, but the artist portrays him in a skullcap—presumably a Jewish *kippah*—with the air of an old man of presumed wisdom whose passive expression has seen the hopes of winners and losers of all faiths. The small objects beside him are symbols of his belief in God's intervention. A gold pyramid—a frequent reference in Kaye's work to the all-seeing Eye of Providence—boasts the name OTIS KAYE in place of the usual eye. A slip of paper with Hebrew letters provides a reference to the Old Testament Book of Daniel (5:1-6, 25-8), which recounts God's foretelling of the death of the Persian King Belshazzar after he blasphemously serves wine in gold vessels looted from the Temple in Jerusalem. The hand of God appears and writes in the air the letters which appear on Kaye's slip of paper—on the surface they seem to be measurements of money (two mina, a shekel and a peres, or half-mina), but the Prophet Daniel interprets them to mean "God has

numbered the days of your kingdom and brought it to an end; you have been weighed in the balances and found wanting." Kaye has included a gold shekel and three silver coins next to the text. However, a close look reveals a second reference, to Rembrandt's painting *Belshazzar's Feast* (1636-38, National Gallery London). In his painting, Rembrandt writes the words in columns rather than lines—as does Kaye—and mistakenly reproduces the last letter of the phrase as a zayin (ז) rather than a nun-sofit (ן), an error repeated here. Kaye is presenting a modern morality play.

Across from the pious gentleman is a middle-aged woman in a white dress with flowers. She mirrors his sentiments as she looks wistfully at the young girl in the foreground. She has chosen not to play or perhaps she has played and lost. At her shoulder is an old man silhouetted against an azure sky; he is looking out directly at his viewers. His eyes do not appear kind but they seem honest—and insightful. A yellow pencil and pocket slide ruler are all he needs—he is Otis Kaye himself, in a rare self-portrait. Next to

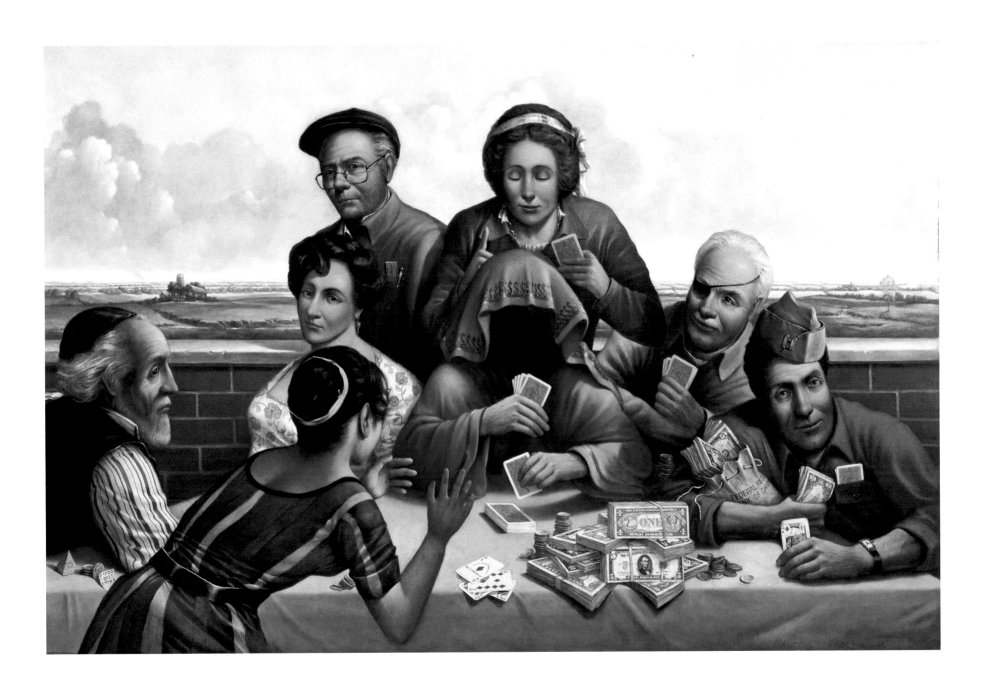

him, hovering over Fate, is a hopeful woman; wearing a red dress and a band in her hair—with a blue-and-white print reminiscent of simple Jewish prayer shawls or the Israeli flag—she may be Alma, Kaye's ex-wife. Her cards have not yet disappointed her; she is still a player, as is the old man in a yellow shirt with a patch over his eye. He is eager but has only a one sided view. His five cards may still produce a winner; it all depends on the card the dealer is about to play.

That card, however, does not perturb the man in the red shirt who has already won a bag of money marked *FEDERAL RESE[RVE] / [BA]NK OF CHIC[AGO]*. He represents power in Kaye's universe—tight-fisted, and confident of his strength. He shows the viewer the winning card the young lady in the striped dress needs to complete her royal flush. Suspiciously there are other cards in his pocket; he knows what it takes to be a winner. His cap suggests he's been in battle, and his wristwatch has a broken hand, suggesting his time too will end. The young girl in the foreground anxiously awaits the dealer's last card and the *trompe l'oeil* riches to come—as youth inevitably does, she seems to expect to win.

The drama's backdrop is the flat Illinois farmland near the Mackinaw River, a peaceful sky. On the right side the anvil cloud of a storm has passed. But on the left on the horizon there may be a tornado building.

The colors are basic red, blue, and yellow. The style is a blend of naturalism and *trompe l'oeil* with smooth, soft edges. The light comes from the right creating soft shadows, but the money goes beyond naturalism to *trompe l'oeil*, so expertly executed that the viewer is tricked by the stacks of currency, the cards and coins.

GB

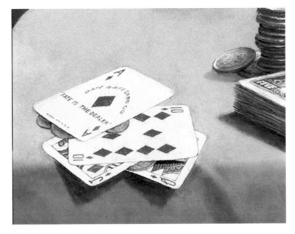

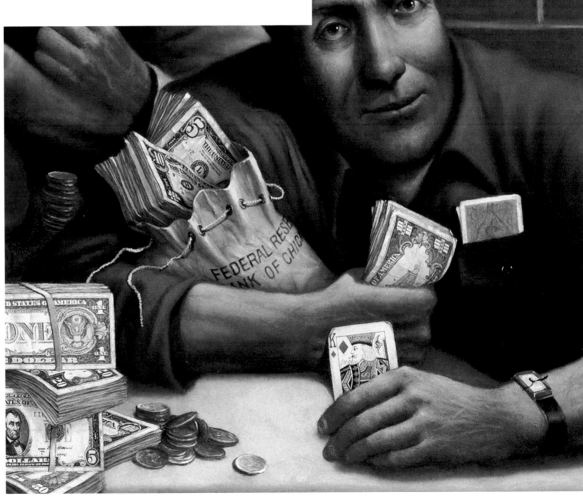

WIN, PLACE, SHOW

1958, Oil on panel, 20¼ x 14¼ in.
Signed: Otis KAYE
New Britain Museum of American Art,
Gift of the Otis Kaye Estate, 2012.49

No one thinks of George Washington, Thomas Jefferson, and Abraham Lincoln as jockeys, but in *Win, Place, Show,* Kaye takes the viewer to the smooth surface of the racetrack. Washington, on a meticulously painted one-dollar silver certificate, is in the lead. The two-dollar bill, a favorite at the track, is a close second. Behind by a nose, Lincoln, on a three-dollar note, seems pleased to appear on a brand new currency.

A worn and well-trod horseshoe makes its mark. Tucked behind it is a trio of tickets from Arlington Racetrack. A blue ticket reads: *PLACE / SUCKERBET / ARLINGTON / SPREAD YOUR / BETS TICKET.* A pink $2 WIN for 1st Race, May 26, 1953: *No. 5 / GOOD WITH LUCK ONLY / sucke[r].* And a yellow two-dollar ticket: *SHOW/ 1st / LONG SHOT BET TICKET CO.*

A photo of the grand bettor himself, Otis Kaye, is ensconced under the arch. During the 1950s Kaye lived in Chicago on and off and sometimes in Indiana on a friend's farm. He frequented nearby Arlington Race Track and Washington Park. When he executed this self-portrait, he was over seventy, had added a few extra pounds, had lost some hair, and was wearing glasses, but still painting convincing *trompe l'oeil* detail.

Kaye placed two Buffalo nickels on the ledge in front of his photo. On their backs and out of the running, they are a reminder of Kaye's many losing bets. There is, however, another nickel not too far out of his reach, still a contender. In the snapshot, Kaye is unsmiling but not scowling. Perhaps, he knows something we do not.

GB

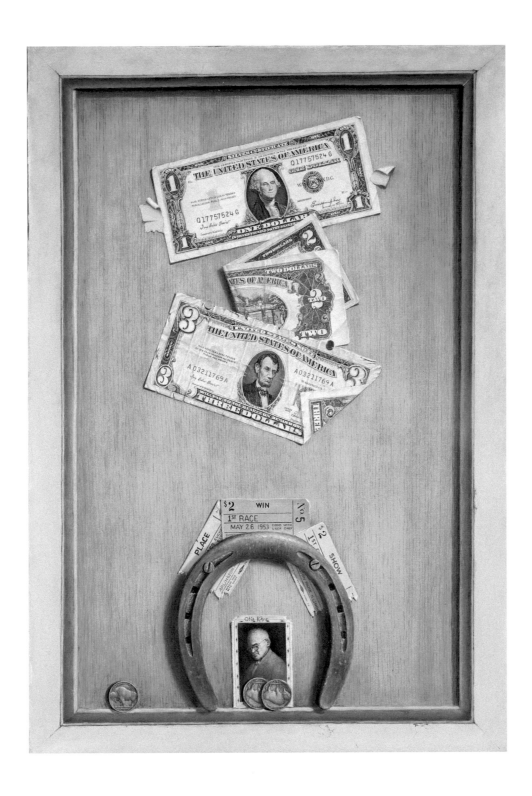

CUSTER II / GOING OUT OF BUSINESS

1958, Oil on panel, 48 x 60 in.
Signed: O.KAYE 1958
Private Collection, Illinois

The twisting turmoil of battle, on a theatrical scale with a cast of hundreds, is the subject of *Custer II / Going Out of Business*. The general is the focal point, the center of a pinwheel in which diagonals abound. The barrel of a pistol (upper left) begins a line that passes through the raised lance of an Indian on horseback then through the right leg and tomahawk of the warrior receiving a rapier thrust. The soldier wielding a sword and his arm blend with the line made by Custer's raised right thigh, and the shoulders of the Indian being shot, culminating at the horizon. Two short curved diagonals point from the torn canvas to Custer's head. A long diagonal created by the edge of the hill bisects the painting from the upper right and ends with the right arm of the fighter in yellow buckskin. A final line arises from the red strap pinned to the bottom frame moving up to the rifle held by the red-haired trooper and to Custer himself. Red bands radiate from every edge of the canvas, calling

attention to the explosive action. In contrast to the smooth *trompe l'oeil* surface, portions of the battle scene are painted in the broken brushstrokes of Impressionism.

In a letter dated 1950 to his one-time business partner and cousin in Chicago, Paul Banks II, Kaye tells of his trip out West. Along with watercolor sketches of the plains, he had already completed his painting *Custer's Gun* and done numerous drawings of soldiers and Indians. There is ample evidence of Kaye's continued musings about war. The grouped currency at lower right chronicles a brief history of American conflicts. The references may be indirect, but they are there nonetheless: Continental 1774, five-dollar Lincoln 1953 for the Civil War, 1907 and 1967 bills depicting a Sioux Indian Chief and Buffalo.

Above the money and the rolled back canvas, the largest Indian rides a horse branded

OK. Dangling at his side a red shield bears the inscription *NOVUS ORDO*, the Eye of Providence from the Great Seal of the one-dollar bill, the letters *alpha* and *omega*, and an unfinished game of tic-tac-toe. It is unknown if the last move will be an X or an O. A winning X might indicate the Indians' intentions to cross out Custer and begin their new order.

Kaye restates his theme of power and money on the white business card at bottom right: *INDIAN PAINTINGS / by / CHIEF BIG BUCKS AND / SON, SMALL CHANGE / Sec. SQUAW SQUAWK RA 3 7376 / FAMILY BUSINESS SINCE 1876*. However, the battle date—June 25, 1876—heralds not a new order of entrepreneurship, as the Indians intend, but their coming annihilation. This premise concludes with the *GOING / OUT OF BUSINESS* label at the bottom center. A double entendre, *BLANKETS BEADS ET AL / ALL ITEMS SLASHED* is followed by

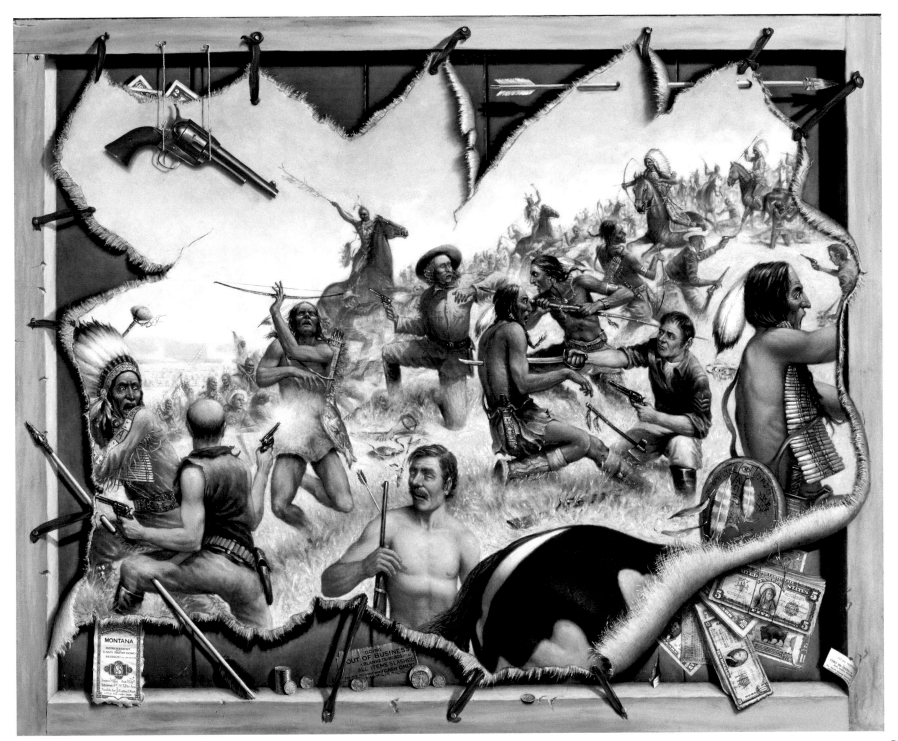

Kaye's fifth signature, *O.KAYE AKA CHIEF BIG BUCK "CASH ONLY."*

The coinage below the label continues the narrative. Indian head and Buffalo nickels and the Walking Liberty half dollar symbolize the disappearance of the Indian and buffalo from the American plains and the loss of their liberty.

In the far left corner is a bond tucked under the painting: *MONTANA / IMPROVEMENT / AND / LAND TRUST BOND* promises to pay 10% interest from June 1876 to October 1929. The payers are *G. Custer* and *O. Kaye* of the *LITTLE BIG HORN BANK*. This is a direct reference to one of the few documented land grabs.

The ferocious Indian Chief above the bond wears a war bonnet, which links the Battle of the Little Big Horn to history's past conflicts. The symbols painted on the headband: the Star of David, the Christian cross, the Star and Crescent, the Swastika, and Hammer and Sickle denote the Twelve Tribes of Israel's biblical expansion, the Inquisition, the wars of Islam and the Ottomans, World War, the Nazi holocaust, and the far-from-bloodless Communist Revolution. On the chief's yellow sleeve, Kaye has painted the alpha and omega, a reminder of man's continuous struggle with man.

GB

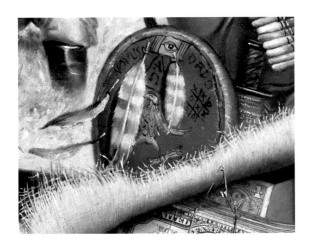

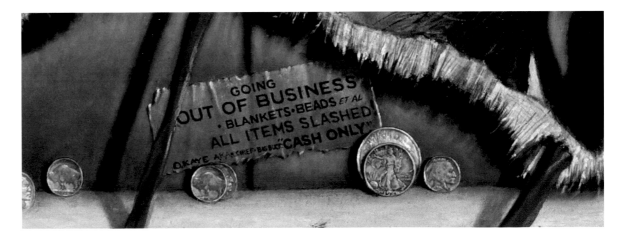

GOING
OUT OF BUSINESS
• BLANKETS • BEADS ET AL
ALL ITEMS SLASHED
O. KAYE AKA CHIEF BIG BUCKS "CASH ONLY"

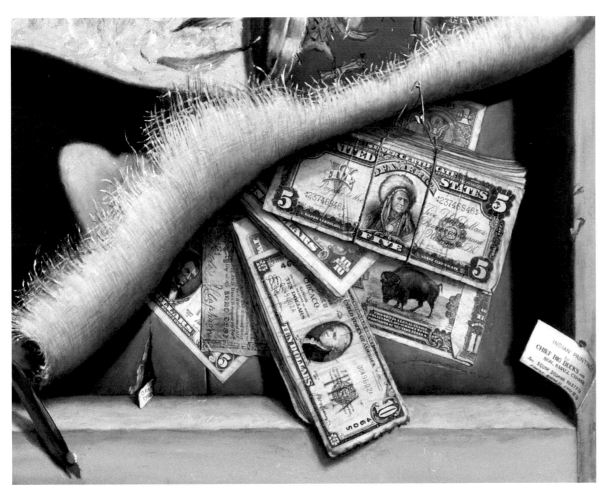

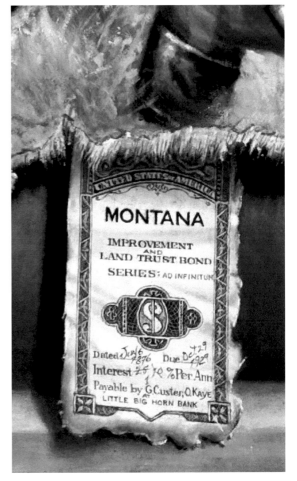

MONTANA

IMPROVEMENT
AND
LAND TRUST BOND

SERIES: AD INFINITUM

Dated July 6 1876 Due Dec 29 1929
Interest 75 10 % Per Ann
Payable by G. Custer, O. Kaye
LITTLE BIG HORN BANK

THE UNCOMMON MAN

1958, Oil on board, 30 x 40 in.
Signed and dated: O KAYE 58
Private Collection, Illinois

Kaye uses a curve to spark energy and rhythm in this snowscape. Although differing from his signature *trompe l'oeil* style, *The Uncommon Man's* subject concerns Kaye's classic conflict between man, power and money. There is an immediate tension between the man and machine caused by the recent avalanche piling snow high on the train tracks. The locomotive steams precariously close to the side of a hill (half of the curve is completed by the rising arc of snow at the mid-left of the painting). A lone figure motions the train to stop while he attempts to dig out a barrel of money. As if in defiance to this isolated man, the engine blasts out a curve of billowy white smoke. Our bet is wisely placed with the train as its number *711* (below the headlight and again along the carriage) suggests it is the winner.

The entire painting is a masterful exposition of color control. The cool tone of the snow is juxtaposed against a warm violet early morning sky. Nestled in a tight triangle in the lower left is a sleeping town, its inhabitants unaware of the catastrophe that has occurred or of another approaching between man and mechanical beast. Kaye seems to say that wherever there is money, man will try to get his share and inevitably there will be a greater power there to stop him.

GB

CHECKS AND BALANCES

1959, Oil on board, 34 x 31 in.
Signed and dated: O.KAYE 1959
Private Collection, Illinois

In *Checks and Balances*, Kaye allows us to eavesdrop on a contractual dispute between two historical figures, Rembrandt and Karl Marx. The composition is an exercise in canvas and cutlery similar to Kaye's *Heart of the Matter*.

Here is Kaye's inimitable irony on the blue, yellow, and violet checks pinned and taped to the left side of the painting. The top blue check written on *Acme Union Bank, established 1848* (the year of the Communist Manifesto), bears a portrait of Marx and his signature. It reads *Pay to order of Remb. V. Ryn / O Kaye $3.00 For Port.* but is stamped NO BALANCE.

Just below, a yellow *M.&E. MUTUAL TRUST BANK $5 REVENUE ANTICIPATION NOTE OF PRIMROSE, UTAH* is signed *Karl Marx–Fred E.* and includes the portraits of both Marx and Engels. Also stamped NO BALANCE, the lower border incorporates the message, *GENUINE ONLY IF WE SAY SO.*

HONEST AS THE DAY IS LONG is the slogan in the top border of a purple two-dollar check written on *THE COMMNUAL STATE BANK / UTOPIA, IOWA.* Kaye comically lampoons the fact that the economic efforts of Marx and Engels proved to be bankrupt fiscal policy. At right, American currency, similar in size and shape to the checks, offers an important counterpoint. A variety of bills along with two Walking Liberty half dollars emphasize the efficiency of a free-market economy.

In the correspondence, Kaye tells us that the Communist duo ordered a portrait from Rembrandt, but have not honored the full payment in cash, issuing worthless checks instead. Not surprisingly, Rembrandt angrily called them to task in his scripted note (top right, in brown ink): *Cut it out Karl! / You only bought / pieces of this work / with checks and no / balances—Why do / workers get no dis- / count! / Pay up! or my agent / Kaye will pick up. / Rembrandt / Amsterdam 1657.*

Rembrandt's irritation is emphasized by Kaye's use of a red-orange background supporting the Old Master's painting, which Marx has cut into tatters (scissors, lower left). The irregular, abstract positive and negative shapes in opposition to the monumentality of the board create a dynamic verve. The gold chain is recalled by the blue string and red paper that reads: *Remy – / We wonder is there a dis / -count for fellow artists and / writers? Karl & Freddy.*

In response, Kaye answers for Rembrandt and for himself. The yellow pencil points to his note pinned to an unfinished corner of the one-dollar bill: *YOU GUYS SETTLE / THIS YOURSELVES. / I'M TIRED OF PAINT- / ING MONEY. I QUIT! / NOW! / OKAYE 1959.* This seems a reasonable answer by two capable artists to two notorious radicals—the inevitable clash when two worlds collide.

GB

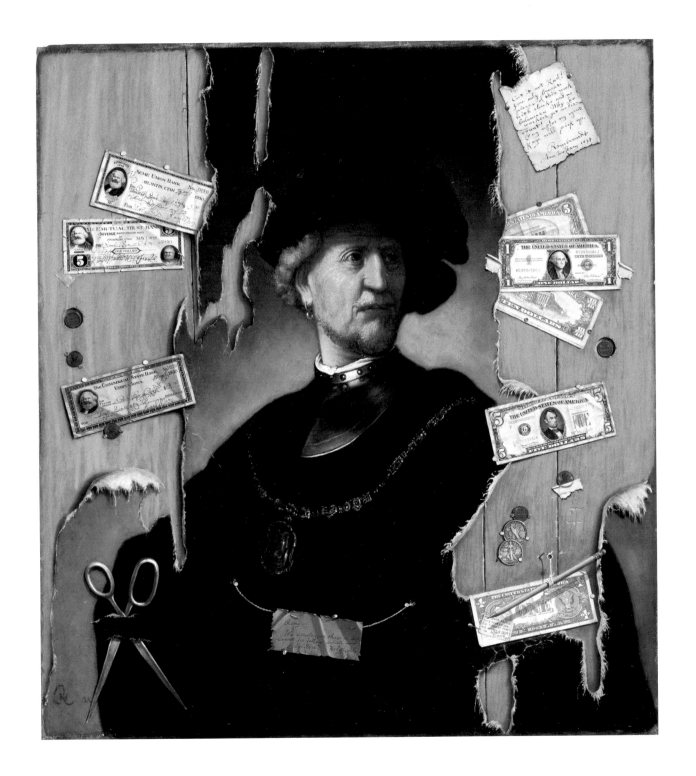

REMEMBRANCE OF THINGS PAST

1960, Oil on canvas mounted on board, 17½ x 30½ in.
Signed: [O] KAYE 1960
Private Collection, Illinois

In the 1950s Kaye painted a series of nudes in the carefree, loose style of traditional watercolor, many on the beaches of Indiana, Wisconsin, and Michigan. In 1960 he created this reclining nude in oil, her head on a golden pillow, her body on a shimmering white silk sheet. At her feet sits Proust's *Remembrance of Things Past*, along with one gold and one silver coin. Her identity is an enigma. The composition is Kaye's primary concern, showing us the beauty of the nude in the curves. While Kaye could have painted a realistic scene, with every fold of satin reflecting the light in his *trompe l'oeil* style, he chose instead to focus on creating a tonal composition with a limited palette.

GB

DOUBLE OR NOTHIN / CARTE BLANCHE

1961, Oil on wood, 29 x 37 in.
Signed: [O] KAYE
Private Collection, Illinois

Every endeavor involves an element of chance, from mining for gold to crossing a street. Otis Kaye metaphorically shows life's fortuity in his painting of two contrasting red violins. Against a blue background, he optically pushes them toward the viewer as far as *trompe l'oeil* permits.

The elegantly painted instrument on the left exudes wealth and success; the "broke" counterpart on the right (its front turned away from inspection as if in shame) conveys the degradation of poverty. Between the two, Kaye has created an association of elements that mirror the form of a third violin, balancing on the fulcrum of chance.

Starting at its top, a strip of ticker tape makes a fictional fingerboard revealing the painting's title: *DOU BLE OR NOT HIN*. What follows are multiple possibilities for success or failure. Four playing cards expose the universal display of chance, a royal flush. There is never been a gambler who has met an unturned card without anxiety, even one marked *SQUARE DEAL CARD Co / NEW*

DEAL / EVERY CARD. A visual fan of stock certificates and currency create a large arc mimicking the upper bout of a violin. The red document's serial number is *711711*, a doubly good omen. Issued by the *FT. TUNA [CO]*, it unequivocally certifies, *OTIS KAYE / the owner of dreams*. Its vignette features an ancient Roman woman seated beside a stock ticker and money cache. A second certificate guarantees *TRAUM*—German for dream. The ten- and fifty-dollar bills only add to the allure of securities, lots of promise, little delivery, as those who lived through the 1930s and the New Deal recall.

Kaye's ultimate *trompe l'oeil*, two brilliantly painted one-dollar bills, indistinguishable from each other, reiterate the double or nothing theme. Along with the iron horse shoe, they loosely suggest the curvature of a violin's lower bout. While the taped front and back of a half dollar offer a simple heads-or-tails approach to prosperity, red dice suspended at the painting's edge complete the panoply of choices.

Turning attention to the left violin we find paper currency of large denominations, gold and silver, a beautifully crafted diamond watch that hangs vertically, pointing to a white card which says it all: *Carte Blanche*. Or better yet, the pink sheet music tucked behind the fingerboard shows the lyrics of Irving Berlin's ironic 1929 tune, *PUT'N' ON THE RITZ*.

Moving to the damaged violin on the right, one sees a sadder song, from Beethoven's Opus 129 *RAGE OVER A LOST PENN(Y)*, along with *(BROTHER CAN YO)U SPARE A DIME* from *America(n) Favorit(es)*. The lamentable side of chance is echoed by low currency denominations, a burnt stock certificate, and a Mickey Mouse watch whose broken strap points to a penny (perhaps the one Beethoven lost), which stands in as the "O" in the signature. Whether one's life is played on a Stradivarius or a fiddle, according to Otis Kaye, depends on a lucky pick.

GB

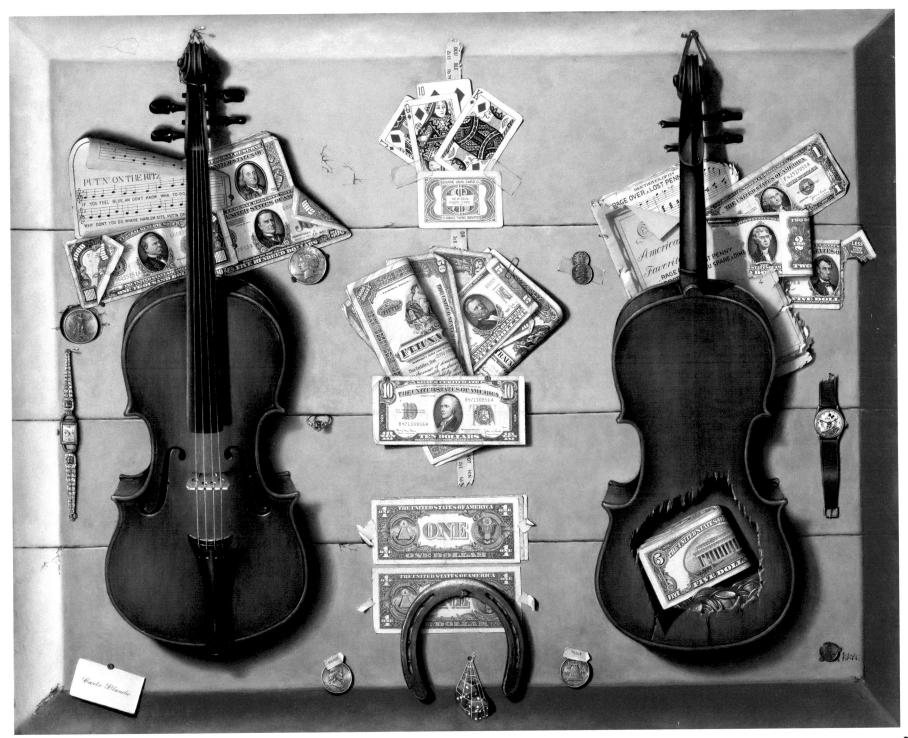

119

HEART OF THE MATTER

1963, Oil on canvas, 50 x 42½ in.
Signed: OK
Private Collection, Illinois

Kaye's *Heart of the Matter* is an extended visual rumination on Rembrandt's *Aristotle Contemplating the Bust of Homer.* To read this work, you need a key—Kaye's mix of English and ambiguous juggling of puns, metaphors, and sarcasms, and his reinterpretation of history and mythology to suit his ultimate purpose—to alter the facts and reframe them into humorous intellectualism. To this we can add Kaye's intense desire to bring the viewer in and out of physical and painted space and, when necessary, in and out of time by means of a lavish display of verisimilitude.

Kaye's visual dismantling of Rembrandt's *Aristotle Contemplating the Bust of Homer* could be interpreted as an astounding expression of Kaye's arrogance. Initially, you might think Kaye chose Rembrandt as an homage, which may well be true in part, but Kaye aggressively makes *Heart of the Matter* his own.

In Rembrandt's painting, chiaroscuro calls the viewer back from the picture plane into deep space and time, Homer's time. But that is merely the cover of the book. Kaye lurks in the pages, bringing us back to his own time with the cool gray flatness of the painted wood supporting the fragmented and abused Rembrandt canvas that the master once painted for a handsome price. Money is the literal heart of this painting—exposed or excised from Aristotle's body.

The diagonally suspended blue pencil highlights the dynamic encounter of Aristotle and Homer. Further linking the two Greeks is the compass form in an *A* and the carved *H* at upper right. From there, the viewer's eye is diverted downward by the parallel wide slashes in the canvas that terminate next to the blue paper note at the bottom right that reads: *WE CANT FIX IT BUT WE KNOW / ONE WHO CAN OTIS KAYE WILL / PUT HIM IN TOUCH WIT[H] PAY / $70.00 / HOMER / ARISTOPOLIS / KUNST / MR. VAN RYN: / WHAT WAS BEHIND / CANVAS OF YOUR / PAINTING / MEND.* Aristotle and Homer look to Rembrandt for meaning, and he, in turn, must consult Otis Kaye. Propped below the note is a gold coin inscribed *ARTIST ANONYMOUS*—a salute to Kaye himself.

Moving to the left, a sweeping arc created by the stout oxidized chain echoes Aristotle's golden circlet. Minor puns occur on the Royal Dutch Petroleum Stock Certificate imprinted *THE HANDOVER BANK* and certified *By Rembrandt.* The linear arc continues left and upward via the one-hundred-dollar bill and the yellow pencil but not before the viewer encounters a broken ruler engraved *AMERICAN RULER CO. GOLDEN COLO.* It is clear that Kaye is the rule breaker in this painting.

A cluster of currency, stock certificates, and the King of Hearts playing card complete the abstract perimeter of the two Greeks—a clever compositional device. The King of Hearts may be a metaphor for Kaye himself and for the well-loved Rembrandt, perhaps even equating the two. In a more humble vein, Kaye signed the painting *Otis Kaye* on the red stock certificate. A nearby gold coin is actually a token good for one meal at the Athens Restaurant.

For his precise *trompe l'oeil* style, Kaye employed a clear, smooth surface as well as a creamy, thick impasto that recalls Rembrandt's technique. Aristotle's white cloak bristles with a rich tactile quality that also characterizes the golden chain draped over his black tunic. There is careful concern to completely finish

the illusion of Rembrandt's brushwork with a linear pattern of cracked and chipped paint. The rolled, frayed canvas edges almost invite the viewer to run a hand over dangling loose threads like Zeuxis to convince the mind of what the eye sees—proof of a compelling *trompe l'oeil* work.

The Chicago Art Institute exhibited Rembrandt's *Aristotle Contemplating the Bust of Homer* during the *Century of Progress* exhibition (June 1–November 1, 1933) when Kaye was living in Chicago. The painting was also shown at the Parke Bernet Galleries in New York in November 1961 before it was purchased by the Metropolitan Museum of Art for $2,300,000—a record-breaking amount of money at that time. During one of Kaye's many visits to the Met, he must have contemplated, along with Rembrandt, the value of art. Would Rembrandt have approved of Kaye's incisive interpretation of his work? Probably so, for in their respective works they both sought truth, which is indeed the "heart of the matter."

GB

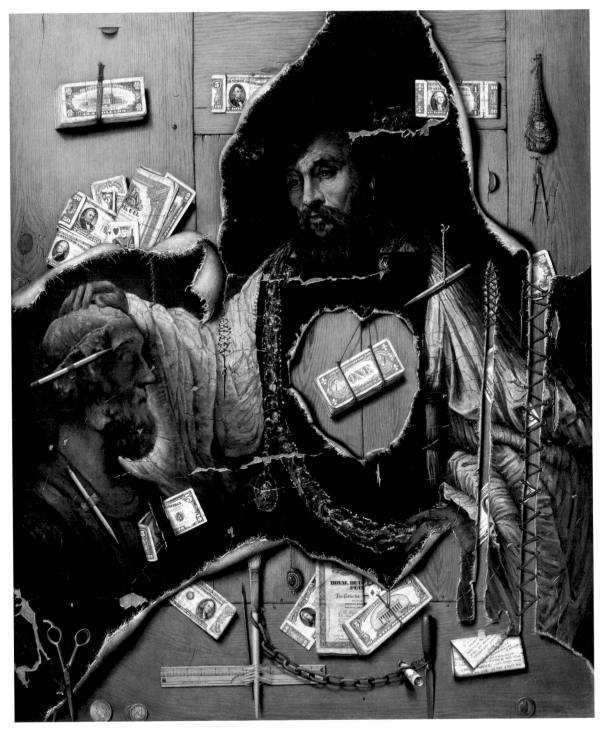

THE FAT LADY SINGS

1964, Etching, 15 x 13 in.
Signed in plate: O.KAYE 1964
Private Collection, Illinois

This is not just any lady. This is THE FAT LADY. Symbol of stock and bond trading worldwide. When she sings, it is all over; markets have peaked. Kaye brings her to life in this remarkable image, seated on a throne and wearing a helmet of sparkling jewels atop a crown of finely curled hair. Wrapped in a coat of plush fur, she clutches stacks of detailed currency, stocks and bond certificates, one of which states its owner to be Otis Kaye. Her lips are sealed, but there is an ominous look in her eyes. She remains smugly secure in her own wealth: shining coins, brilliant jewels, satin finery, and supple fur. Her simple but effective philosophy is written in the ticker tape symbols surrounding her. *BY LOW SE LL HI* and *U DO NOT CRY BU T SI NG SING.*

Kaye delights the viewer with his depiction of diverse textures in black and white. Achieving such variation in etching is the sign of a master. But the master may also be taunting the viewer, asking on which side of the Fat Lady's trade he will be.

GB

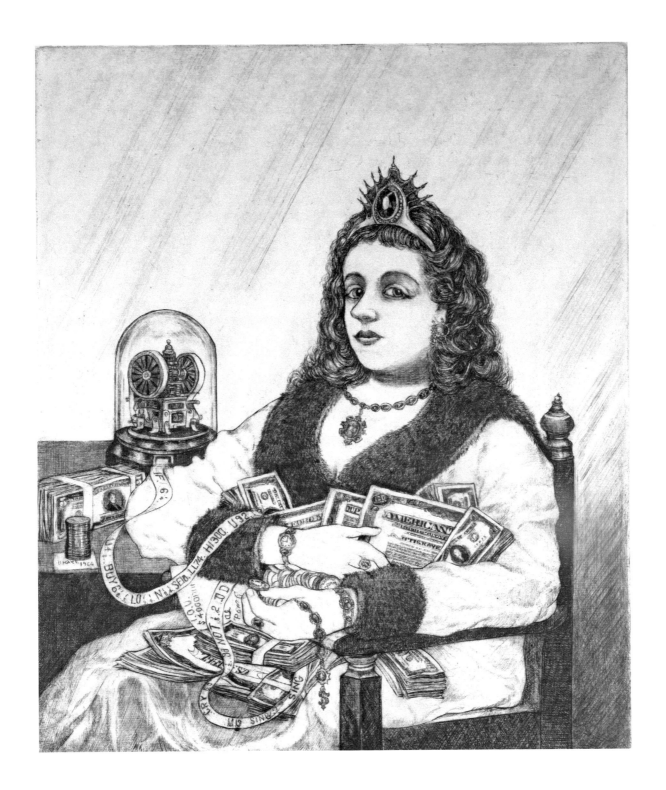

SEASONS GREETINGS II

1969, Oil on wood, 39¼ x 32 in.
Signed: O.KAYE
Private Collection, Illinois

The visual excitement begins at the bottom center edge of the painting where a wooden cigar box acts as a foundation for an imaginary tree trunk. Imprinted *JACK N BACHS / No.1 / CIGARS * INC. / CHICAGO / No 1 AGENT O. KAYE*, with the title, *Season's Greetings,* tacked to it, it projects the farthest from the picture plane. In the left corner a purple package of $1 bills, a generous *OVER RUN / GIFT OF / U.S. PRINTING u.ENG.* is accompanied by the *U.S. MINT / SURPLUS / GIFT* rolls of silver and gold coins, placed obliquely toward a vanishing point beyond the rear of the painting. On the right a yellow pencil atop a blue *UND[E]R RUN* pack of five-dollar bills and green and yellow ribbons form lines that complete a one-point perspective.

In the left corner, Santa is held hostage with a note pinned above his cap: *HONI SOI QUI $ / MAL Y PENSE,* evil on him who thinks evil, the motto of the Order of the Garter that surrounds the British Royal Coat of Arms. At the right as a counter comment, a Mason stick-pin holds the message *MET*

ON THE LEVE[L] / [DE]PARTED ON THE SQUARE, advising trust in each other, not a god. The adjacent yellow pencil labeled *MOOT POINT PENCIL Co.* leads to a candy cane question mark suspended by a golden angel playing a horn. Its song: *Wir glauben al / l an 1 Gott.* We all believe in one God. But Kaye seems to ask, "Do we now? Or is money another god?"

The visual ascent of the tree begins, with Kaye's usual irony, up a whiskey bottle of coins and continues over steps of currency to the vertical dollar, which at its midpoint acts as the tree trunk restating the oneness of God. The climb then moves up additional bills and certificates to the question mark candy cane on top.

Zig-zagging up the entire height of the tree is a ticker tape of Kaye's favorite axioms: *E PEN NY S MAK DOL LA R S, SA ID BUY LO SEL HI, GO FR OM RA GS TO RIC HES UN OL, A FOOL AND HIS MON EE R PAR TED, CAS H IS KI NG, U BUT TOO HI SUC KER HA HA, AME RI CA IS POW ER*

MON EY IS POW ER, SO WE KNO W ITS A THR OW OF THE DIC E, WHO KNO WS WHO LOA DED TH EY ARE.

Tree branches are constructed of single bills and packs of currency chosen to depict United States history. To the left of the bottle is the earliest American coin (1652) dangling from a pack of 1776 Continental cash signed by J. Hubly and O. Kaye, given by Daughters of the American Revolution. Tangent to the cash is a 1796 silver dollar. The shiny coins are presented like shimmering ornaments along with pearls and precious stones. To the right a Series 1880–90 Indian Chief five-dollar bill is a gift from Buffalo Bill himself; further to the left a pack of fractional bills, *Compliments Mr. K / C. DICKENS.* Under this dangles a Star of David.

Inching further upward, the *FEDERAL / RESERVE* is donor of a cluster of Fives, overlapping stock certificates issued by *BETHLEHEM STEEL* certifying S. KLA[US] as owner and signed by *MR. Otis Ka[ye]* This was donated by *AD ASTRA SECURITIES /*

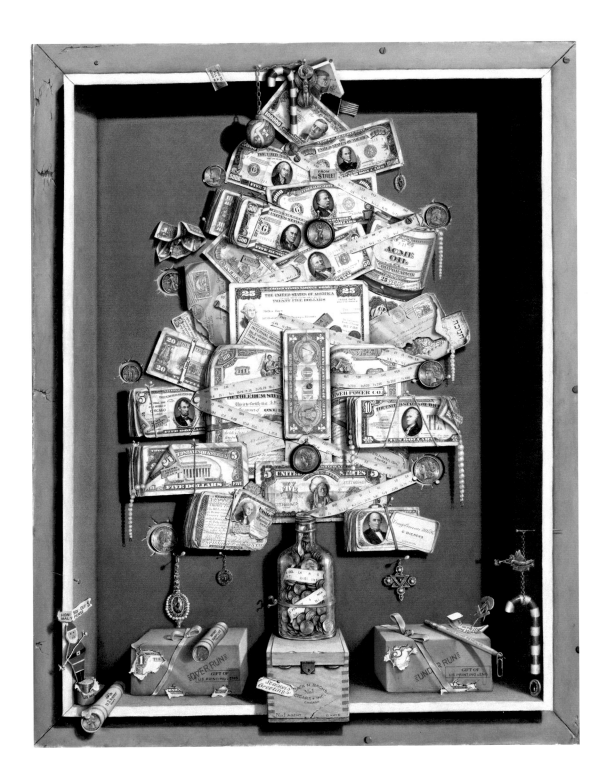

711 WALL ST, personalized: *Greetings / AL,* that is *A. PONZI pres.*—a nod to America's well-known fraudster, Charles Ponzi, who perfected pyramid sales schemes in the 1920s.

Another business card, from *E.N. HIM-MLISH / EQUITES*—heavenly deals—lies next to ten dollars from SCROOGE and a Stock Certificate for shares in *[Y]AHWEH POWER CO.*, signed by *JEHOVAH*. A yellow envelope with an oblong Channukah card for holding a money gift is addressed to *Shadrach Meshach Abednego / 3 E. Sunnyside, Megiddo Canaan.* There is a card from the *INTERNAL REVENU[E], / US FORM: (7-11 U 2 PAY) / Sec 8: HOLIDAY GREETINGS.* A blue envelope *for Simon Bar Jonah / 1813 Ruble St.* has been sent from Tremont with a green three-cent stamp, 1875–1950 American Bankers Association and postmarked Dec. 25, 1959.

There is a twenty-five-dollar Savings Bond *To Mr. Otis Kaye*, a gift from the *V.A.* (Veterans Administration), stamped *DEC 7 1941.* Then an *ACME / OIL / CORPORATION / GOLD BOND / at 25 PER[CENT]* from *[P] AWN SHOPS / [AM]ERICA* next to fifty and one-thousand dollar bills from anonymous givers. Even a counterfeit dollar is included, crinkled and pinned, an outsider's gift no

doubt. A gleaming twenty-dollar Gold Coin of 1933 is center, followed by big bills *FROM the $TREET:* one-, five-, ten-, fifty- and one-hundred-thousand-dollar bills. Every denomination is displayed, including five hundred dollars from the *AFL* (American Federation of Labor). At the very top of the painting, one-dollar bills form a globe, and our world hangs by a chain from a pagan amulet. A coin reminds us in Latin, *RENDER C ET DEO.* Render unto Caesar what is Caesar's, and to God what is God's. There also, a photo of Otis Kaye, by now an old man in his eighties who has completed his last major work, contemplating the inevitable question, "Why are we here?" Is the unfinished game of tic tac toe a clue—is it all a game?

All of the items showcase Kaye's obsession with verisimilitude. The harmony of the composition, the beauty of the coins nestled in their airy niches, the crinkled bill with its enticing shadows, the unparalleled detail of the currency, the puns and idiosyncratic collection of donors all offer clues to the question marks at the beginning and end of Kaye's Tree of Life. He leaves the viewers to draw their own conclusions, adding a sardonic *AND TO / ALL A / GOOD NIGHT.*

GB

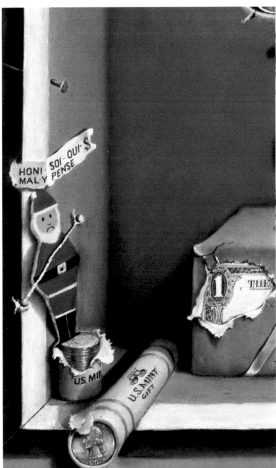

APPENDIX 1: TROMPE L'OEIL PAINTINGS

Hidden Assets, 1920
Oil on panel, 7⅛ x
9¾ in
Signed: OKAYE
Private Collection

*Three Bills and a
Theater Stub,* c. 1920
Oil on board, 11 x 13 in.
Unsigned
Private Collection

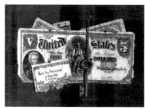

*Key to Success (A
Novel),* 1920s
Oil on board, 7 x 9¾ in.
Unsigned
Private Collection

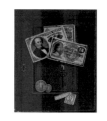

*The Only Constant Is
Change,* 1923
Oil on board, 9⅛ x
7¼ in.
Signed: OTIS KAYE
Private Collection

Money to Burn II,
1923–28
Oil on canvas mounted
on board, 8 x 9½ in.
Signed: Otis KAYE
Private Collection

Watch Yer Money, 1925
Oil on panel, 7⅜ x
10⅛ in.
Signed: [O]tis Kaye
Private Collection

Money to Burn, 1927
Oil on canvas mounted
on panel, 9¼ x 12½ in.
Signed: OKAYE
Private Collection

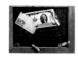

Learn about Money, 1928
Oil on panel, 9 x 12 in.
Signed: OTIS KAYE
Private Collection

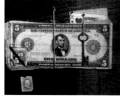

Key to Success III, 1928
Oil on panel, 7¾ x
10 in.
Signed: OTIS KAYE
Private Collection

Key to Success, 1928
Oil on canvas mounted
on panel, 8 x 9¼ in.
Signed: Otis Kaye
Private Collection

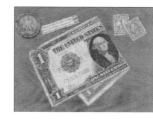

*Dollar and a Half,
Washington and Half
Dollar,* 1928
Oil on panel, 6¼ x
8 ¼ in.
Signed: OTIS KAYE
Private Collection

In Gold We Trust, 1928
Oil on panel, 11 x 13 in.
Signed: Otis Kaye
Private Collection

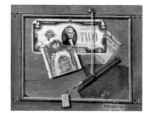

*Goods Not Called For /
Claim Check,* 1928
Oil on panel, 8½ x
10½ in.
Signed: Otis Kaye
Private Collection

Members of the Board,
1928–29
Oil on board, 7 x 10 in.
Signed: Otis Kaye
Private Collection

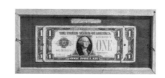

Bankers and Wall Street,
1928
Oil on panel, 6 x 12 in.
Signed: OTIS KAYE
Private Collection

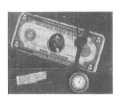

Break a Five / Time Is Money, 1929
Oil on canvas mounted on board, 8 x 10 in.
Signed: O Kaye
Private Collection

Make Sense, 1929
Oil on canvas mounted on panel, 8 x 10 in.
Signed: Otis Kaye
Private Collection

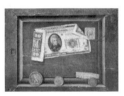

In Gold We Trust II, 1929
Oil on panel, 8 x 10 in.
Signed: Otis Kaye
Private Collection

Holding the Bag / Utilities, 1929
Oil on canvas, 16 x 11 in.
Signed: Otis Kaye
Private Collection

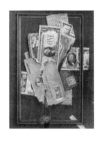

The Boys R OKAYE, c. 1929
Oil on panel, 5 x 6⅞ in.
Signed: OTIS KAYE
Private Collection

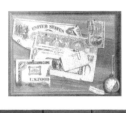

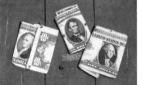

Change Is Timeless, c. 1929
Oil on panel, 13 x 18 in.
Signed: Otis Kaye
Private Collection

Folding Money, c. 1929
Oil on panel, 6 x 9 in.
Signed: [O]tis KAYE
Private Collection, Illinois

Fool and His Money, 1929
Oil on panel, 6¼ x 9½ in.
Signed: Otis Kaye
Private Collection

Fool and His Money II, 1929
Oil on panel, 5 x 7 in.
Signed: Otis Kaye
Private Collection

Love of Money, c. 1929
Oil on panel, 10 x 15¾ in.
Signed: Otis Kaye
Private Collection

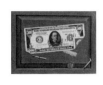

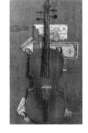

Money to Burn Almost, c. 1929
Oil on panel, 5 x 7 in.
Signed: OKAYE
Private Collection

Sweetest Notes, c. 1929
Oil on panel, 26 x 15 in.
Signed: [O]tis KAYE
Private Collection

Win Place Show / Three Bills Posted, c. 1929
Oil on canvas mounted on panel, 13 x 9¾ in.
Signed: Otis Kaye
Private Collection

Money to Burn, 1929–33
Oil on board, 6¾ x 8½ in.
Signed: Otis Kaye
Private Collection

Otis Kaye's Coin Collection / Money Costs, 1930
Oil on panel, 9½ x 6½ in.
Signed: OTIS KAYE
D. Brent Pogue

Five Dollar Bill, King, Joker, 1930
Oil on panel, 7¼ x 9¼ in.
Signed: Otis Kaye
Private Collection

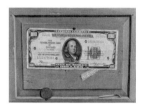

A Penny Saved, c. 1930
Oil on board, 6¾ x 8½ in.
Signed: [O]tis Kaye
Private Collection

All That Glitters, 1930s
Oil on panel, 10 x 10 in.
Signed: Mr. Otis Kaye
Private Collection

Five Dollars Bill & Watch, 1932
Oil on panel, 8 x 12¼ in.
Signed: Otis Kaye
Private Collection

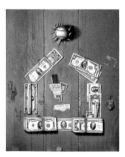

What a Hit!, 1932
Oil on canvas, 30 x 25 in.
Signed: [O] KAYE
The Hevrdejs Collection

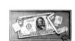

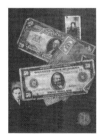

How to Stamp Out Poverty, 1933
Oil on panel, 5⅛ x 9½ in.
Signed: OKAYE
Private Collection

Washout / Hang the Wash, 1933
Oil on panel, 16 x 12 in.
Signed: [O]tis Kaye
Mongerson Gallery

Bank of Augusta / Old South, 1930s
Oil on panel, 4¼ x 8 in.
Signed: NA BROOKS NY
Private Collection

Black Jack, 1934
Oil on panel, 10 x 13 in.
Signed: O Kaye
Private Collection

Overdue Bills, 1934
Oil on panel, 8 x 10 in.
Signed: [O]tis Kaye
Private Collection

Pennies Make Dollars which Make a Bunch of Money, 1934
Oil on panel, 13 x 15 in.
Signed: KAYE
Private Collection

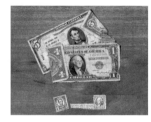

Does History Make the Man / Trompe l'Oeil with Currency and Stamps, 1935
Oil on panel, 8 x 10 in.
Signed: OTIS KAYE
Private Collection

Handel with Care / Overdue / Out with the Kids, 1935
Oil on canvas mounted on wood, 30 x 40 in.
Signed: Otis Kaye
Private Collection

Adam and Eve, 1930s
Oil on panel, 13 x 11¼ in.
Signed: OTIS KAYE
Private Collection

In the Bag, 1935
Oil on panel, 6¾ x 9½ in.
Signed: Otis Kaye
Private Collection

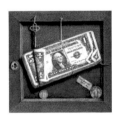

The One Key to It All, 1935
Oil on panel, 8½ x 9⅛ in.
Unsigned
Private Collection

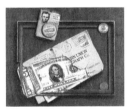

Five Dollar Bills, Lincoln Saves the Union, 1935
Oil on panel, 9 x 11 in.
Signed: OTIS KAYE
Private Collection

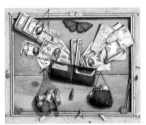

Easy Come, Easy Go, 1935
Oil on panel, 21 x 25½ in.
Signed: O. KAYE
Manoogian Collection

Little Something for the Fiddler, 1935–45
Oil on canvas, 30 x 20 in.
Signed: Otis Kaye
Private Collection

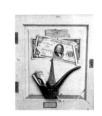

Put It in Your Pipe, 1935–45
Oil on panel, 12⅝ x 10¾ in.
Signed: Mr. Otis Kaye
Private Collection

There Are a Thousand and One Ways to Make Money, 1935–45
Oil on board, 6½ x 9¼ in.
Signed: [O]tis Kaye
Private Collection

Time Flys, 1935–45
Oil on panel, 10 x 15 in.
Signed: [O]tis Kaye
Private Collection

D'JIA-VU?, 1937
Oil on panel, 27 x 39½ in.
Signed: Otis Kaye
Cordover Collection LLC

Dutch Treat, 1938
Oil on canvas mounted on wood, 18 x 14 in.
Signed: [O]tis Kaye, Otis Kaye
Private Collection

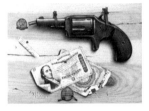

Small Change, 1940s
Oil on panel, 8 x 10 in.
Signed: O Kaye
Private Collection

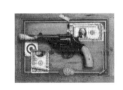

American Target Company, 1940s
Oil on board, 10 x 14 in.
Signed: Otis Kaye
Private Collection

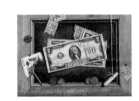

Two to Win, 1940
Oil on panel, 10½ x 12½ in.
Signed: OTIS KAYE
Private Collection

Face It, Money Talks, 1940
Oil on canvas mounted on board, 11⅛ x 15¾ in.
Signed: OK
Private Collection

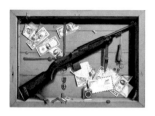

Land of the Free, Home of the Brave, 1944
Oil on panel, 25½ x 36¼ in.
Signed: O. KAYE
Private Collection,
Atlanta, Georgia

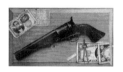

Two Old Ways, 1946
Oil on panel, 9 x 14 in.
Signed: O Kaye
Private Collection

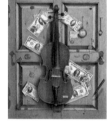

U.S. Musical Notes,
after 1946
Oil on panel, 30 x
24¾ in.
Signed: OK
Manoogian Collection

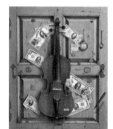

Two Sides to Everything,
c. 1946
Oil on board, 12 x 14 in.
Signed: OKAYE
Private Collection

Christmas Piggy Banks,
1946–49
Oil on panel, 6¾ x
9¾ in.
Signed: [O]tis KAYE
Collection of Walter
and Lucille Rubin

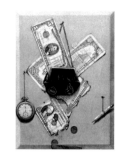

Time to Change Brokers,
1946–49
Oil on panel, 16 x 12 in.
Signed: Otis Kaye
Private Collection

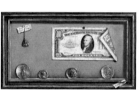

We're All Gold Bugs,
1949
Oil on cradled wood,
7 x 12½ in.
Signed: O. KAYE 1949
D. Brent Pogue

Pocket Money, 1949
Oil on panel, 5 x 7 in.
Signed: Otis Kaye
Private Collection

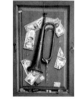

Horn of Plenty, 1949
Oil on panel, 28½ x
18½ in.
Signed: Otis Kaye
Private Collection

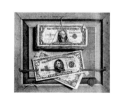

All for One, One for All,
1949–53
Oil on canvas mounted
on board, 10 x 12¼ in.
Signed: Otis K
Private Collection

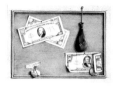

The Golden Touch, 1950
Oil on panel, 12 x 16 in.
Signed: O Kaye
Private Collection

Now Cash Is King, 1950
Oil on panel, 10⅝ x
12⅜ in.
Signed: Otis Kaye
Private Collection

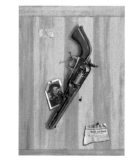

Bang Bang, 1950
Oil on canvas, 30 x 25 in.
Signed: O KAYE
Private Collection

*Bankers Know Pennies
Make Dollars*, 1950
Oil on board, 5 x 7 in.
Signed: O KAYE
Private Collection

Custer's Gun, 1950
Oil on canvas, glued on
wood, 19½ x 14¾ in.
Signed: Otis KAYE
The Hevrdejs Collection

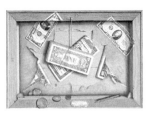

Hidden Assets, 1950
Oil on panel, 14¼ x
20 in.
Signed: Otis Kaye
Private Collection

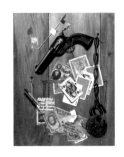

Break Out / Crash Out,
1950
Oil on canvas mounted
on board, 24 x 20 in.
Signed: Otis Kaye
Private Collection

Target Practice, 1950s
Oil on panel, 14½ x
18 in.
Signed: [O]tis Kaye
Private Collection

Hot Stock Tips, 1950
Oil on panel, 22½ x
35 in.
Signed: OKaye
Private Collection

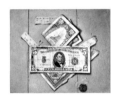

*But Abe, I Told You to
Buy Low*, 1950
Oil on panel, 8¾ x
10¾ in.
Signed: OTIS KAYE
Private Collection

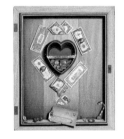

Nickel Dime Securities,
1950
Oil on panel, 12½ x
18 in.
Signed: O. KAYE 1950
Private Collection, Illinois

My Cup Runneth Over,
1950s
Oil on canvas mounted
on board, 39 x 29¾ in.
Signed: OK
Private Collection,
Illinois

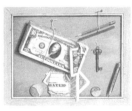

*All That Glitters Is Not
Gold*, 1950
Oil on panel, 10 x
12⅜ in.
Signed: OTIS KAYE
Private Collection

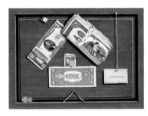

Amor Vincit Omnia, 1950
Oil on panel, 30 x 25 in.
Signed: [O]tis KAYE
1950
Private Collection, Illinois

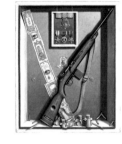

Soldier's Valor, 1950s
Oil on wood panel, 36
x 30 in.
Signed: O.KAYE
Private Collection,
Illinois

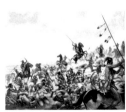

Custer Battle, 1950
Oil on panel, 48 x 72 in.
Signed: Otis Kaye
Private Collection

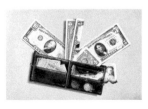

Easy Come, Easy Go,
1950
Oil on panel, 10½ x
15½ in.
Signed: OTIS KAYE
Private Collection

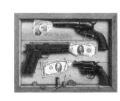

*Gunfight TODAY
OKAYES Corral*, 1951
Oil on panel, 14½ x
19¼ in.
Signed: OKAYE
Private Collection

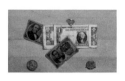

Old or New Money Is Money, 1952
Oil on panel, 9⅜ x 14⅝ in.
Signed: O KAYE
Private Collection

American Dream, 1953
Oil on panel, 8¼ x 10½ in.
Signed: Otis KAYE
Private Collection

Pennies Make Dollars, 1953
Oil on panel, 6¾ x 9½ in.
Signed: Otis Kaye
Private Collection

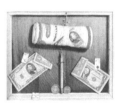

Bid and Ask, 1953
Oil on panel, 12⅛ x 15⅛ in.
Signed: Otis Kaye
Private Collection

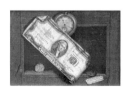

Timing Is the Key, 1953
Oil on panel, 6½ x 9½ in.
Signed: OKAYE
Private Collection

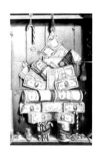

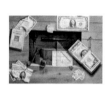

Seasons Greetings, 1953
Oil on panel, 38¾ x 29 in.
Signed: OTIS KAYE
Private Collection

How to Make Money, 1953
Oil on panel, 14¾ x 20 in.
Signed: OK
Private Collection

Hot Stock Tip Securities, 1953–60
Oil on panel, 10 x 12¾ in.
Signed: [O]tis Kaye
Private Collection

Stretching A Dollar, Cut It Out, 1954–60
Oil on panel, 8½ x 10 in.
Signed: Otis Kaye
Private Collection

Joshua's Horn, 1957
Oil on canvas, 24 x 36 in.
Signed: Otis Kaye
Private Collection

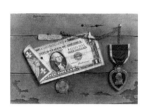

There Are Some Things Money Can't Buy, 1957
Oil on panel, 6½ x 9½ in.
Signed: [O] KAYE
Private Collection

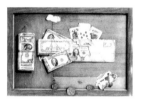

Send Money Quick, 1957
Oil on canvas mounted on board, 16¾ x 23¾ in.
Signed: Otis Kaye
Private Collection

Fate Is the Dealer, 1957
Oil on panel, 48 x 72 in.
Signed: OTIS KAYE
Private Collection, Illinois

Win, Place, Show, 1958
Oil on panel, 20¼ x 14¼ in.
Signed: Otis KAYE
New Britain Museum of American Art

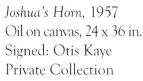

Custer II / Going Out of Business, 1958
Oil on panel, 48 x 60 in.
Signed: O.KAYE 1958
Private Collection, Illinois

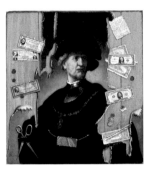

Checks and Balances,
1959
Oil on board, 34 x 31 in.
Signed: O.KAYE 1959
Private Collection, Illinois

Double or Nothin /
Carte Blanche, 1961
Oil on wood, 29 x 37 in.
Signed: [O] KAYE
Private Collection, Illinois

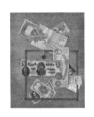

Happy Friends, Rack
Painting with Currency,
1962
Oil on panel, 19¼ x
14½ in.
Signed: Otis Kaye
Private Collection

Trompe l'Oeil for Bessie
Hoffman, 1962
Oil on panel, 21 x
12¾ in.
Signed: NA BROOKS
Private Collection,
Illinois

Time Is Money, 1962
Oil on panel, 9 x 12¾ in.
Signed: NA BROOKS
Private Collection

Heart of the Matter,
1963
Oil on canvas, 50 x
42½ in.
Signed: OK
Private Collection, Illinois

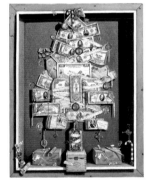

Seasons Greetings II,
1969
Oil on wood, 39¼ x
32 in.
Signed: O.KAYE
Private Collection, Illinois

Bet You Can't Do That
Again, 1969
Oil on wood, 18 x 13 in.
Signed: O KAYE
Private Collection

APPENDIX 2: OTHER PAINTINGS

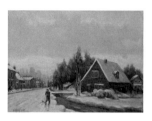

Chicago, Canalport, 1947
Oil on board, 14½ x
19½ in.
Signed: OKAYE
Private Collection, Illinois

Illinois Start of Fall, 1950s
Oil on board, 30 x 40 in.
Signed: OKAYE
Private Collection, Illinois

Mountain Stream, 1950s
Oil on board, 30 x 40 in.
Signed: OTIS KAYE
Private Collection, Illinois

Tremont, 1952
Oil on board, 15 x 20 in.
Signed: OKAYE
Private Collection, Illinois

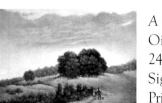

A Favorite Spot, 1955
Oil on board, 17½ x
24 in.
Signed: Kaye
Private Collection, Illinois

River and Cliff, 1957
Oil on board, 16½ x
21½ in.
Signed: OKAYE
Private Collection, Illinois

The Uncommon Man,
1958
Oil on board, 30 x 40 in.
Signed: O KAYE 58
Private Collection, Illinois

End of the Season, 1960
Oil on board, 20 x 24 in.
Signed: OKAYE
Private Collection, Illinois

Idyllic, Maybe, 1960s
Oil on board, 28½ x
36 in.
Signed: OKAYE
Private Collection, Illinois

Land for Sale, 1960s
Oil on board, 30 x 40 in.
Signed: OKAYE
Private Collection, Illinois

*Lake Michigan Shore on
the Rocks*, 1965
Oil on board, 30 x 40 in.
Signed: OKAYE
Private Collection, Illinois

Peaches and Cream, 1950s
Oil on board, 15 x 20 in.
Signed: Otis Kaye
Private Collection

*Pewter Cup and Blue
Bowl*, 1950s
Oil on board, 15 x 20 in.
Signed: [O] K
Private Collection

*Remembrance of Things
Past*, 1960
Oil on canvas mounted
on board, 17½ x 30½ in.
Signed: [O] KAYE 1960
Private Collection,
Illinois

APPENDIX 3: MIXED MEDIA WITH CURRENCY

NO IMAGE AVAILABLE

Self Portrait with Dime, 1930s
After Rembrandt van Rijn *Self Portrait,* (n.d.)
Etching and gouache on paper, 4½ x 3⅛ in.
Signed: Otis Kaye
Private Collection

NO IMAGE AVAILABLE

Trompe l'Oeil One Dollar Note, 1935
Etching with tempera on paper, 2¾ x 6½ in.
Signed: Otis Kaye
Private Collection

Dollar Bill, c. 1940
Etching with tempera on paper, 2¹¹⁄₁₆ x 6 in.
Signed: Otis Kaye
Sheldon Museum of Art, University of Nebraska-Lincoln, NAA—Gift of Carl and Jane Rohman

Pennies from Heaven, 1944
After Renoir *Sur la Plage a Berneval* (c. 1892)
Etching and gouache on paper, 5¼ x 3½ in.
Signed: O Kaye
Private Collection, Illinois

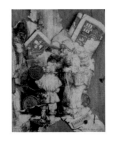

Trick or Treat, 1944
After Rembrandt van Rijn *Beggars Receiving Alms at the Door of a House* (1648)
Etching and gouache on paper, 6⅘ x 5 in.
Signed: Otis K
Private Collection, Illinois

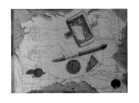

Bid, Ask, 1945
After Pablo Picasso *Vollard Suite* (1930–1937)
Etching and gouache on paper, 7½ x 10½ in.
Signed: [O] KAYE
Private Collection

My Ship Has Come In, 1945
After James McNeill Whistler *Eagle Wharf* (1859)
Etching and gouache on paper, 5¼ x 8¼ in.
Signed: Otis K
Private Collection, Illinois

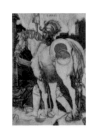

Al, Stop Horsing Around, n.d.
After Albrecht Dürer *The Large Horse* (1505)
Etching and gouache on paper, 6½ x 4½ in.
Signed: OK
Private Collection, Illinois

LEAD A HORSE TO GELD...CAN'T MAKE HIM REICH, n.d.
After Albrecht Dürer *Knight, Death and Devil* (1513)
Etching and gouache on paper, 9⅞ x 7½ in.
Signed: OK
Private Collection, Illinois

Rent Due (unfinished),
n.d.
After Albrecht Dürer
Holy Family (1509)
Etching and gouache
on paper, 6⅞ x 4½ in.
Signed: "less yellow,
more cream"
Private Collection, Illinois

Hot Stock Tips, n.d.
After Francisco Goya
*Los Caprichos: Hasta la
Muerte* (1799)
Etching and gouache
on paper, 8½ x 6⅛ in.
Signed: [O] KAYE
Private Collection, Illinois

Green with Envy, n.d.
After Francisco Goya
*Los Caprichos: Le
Descanona* (1799)
Etching and gouache
on paper, 8⅜ x 6 in.
Signed: O KAYE
Private Collection, Illinois

*That's Water Under the
Bridge*, n.d.
After Charles Meryon
*L'Arch du Pont Notre
Dame Paris* (1853)
Etching and gouache
on paper, 5¾ x 7½ in.
Signed: [O] KAYE
Private Collection, Illinois

*Pablo Picasso's Golden
Touch*, n.d.
After Pablo Picasso
*Faune Devoilant une
Femme* (1934)
Etching and gouache
on paper, 12 x 16 in.
Signed: [O]tis K
Private Collection

*The Almighty Dollar
Yad*, after 1948
After Rembrandt
van Rijn, *Faust in His
Study, Watching a Magic
Disk* (1652)
Etching and gouache
on paper, 8³⁄₁₆ x 6½ in.
Signed: Kaye
Private Collection, Illinois

*High Flyer V...Securities
Inc.*, 1949
After James McNeill
Whistler *The Mast* (1880)
Etching and gouache
on paper, 13½ x 6¼ in.
Signed: KAYE
Private Collection, Illinois

Mother's Day, 1949
After Rembrandt van
Rijn *Mother Seated at
a Table Looking Right*
(1631)
Etching and gouache
on paper, 6 x 5¼ in.
Signed: Otis K
Private Collection, Illinois

*You Have the Golden
Touch*, after 1949
After Rembrandt van
Rijn *Jan Lutma, the
Elder* (1656)
Etching and gouache
on paper, 7¾ x 6 in.
Signed: O Kaye
Private Collection

Buy Sell or Hold, n.d.
After Pablo Picasso
Faune Devoilant une Femme (1936)
Etching and gouache on paper, 12 x 16 in.
Signed: O Kaye
Private Collection

Father's Day, n.d.
After Rembrandt van Rijn *Old Man Seated with Flowing Beard, Fur Cap and Velvet Cloak* (1632)
Etching and gouache on paper, 5⅝ x 5⅛ in.
Signed: O Kaye
Private Collection

IRS But I Paid My Taxes, n.d.
After Rembrandt van Rijn *The Stoning of Saint Stephen* (1635)
Etching and gouache on paper, 3¾ x 3¼ in.
Signed: Otis K
Private Collection, Illinois

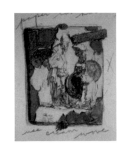

Slim Pickings (unfinished), n.d.
After Rembrandt van Rijn *Beggar Man and Beggar Woman Conversing* (1630)
Etching and gouache on paper, 3⅛ x 2¾ in.
Signed: OK
Private Collection, Illinois

We See Eye to Eye (unfinished), n.d.
After Rembrandt van Rijn *Self Portrait in a Flat Cap and Embroidered Dress* (1642)
Etching and gouache on paper, 3⅝ x 2⅜ in.
Signed: Otis Kaye
Private Collection, Illinois

Fit to Be Tied (unfinished), n.d.
After Rembrandt van Rijn *Old Man Seated with Flowing Beard, Fur Cap and Velvet Cloak* (1632)
Etching and gouache on paper, 5¾ x 5⅛ in.
Signed: OK
Private Collection, Illinois

My Cup Runneth Way Over (unfinished), n.d.
After Rembrandt van Rijn *Christ at Emmaus: The Larger Plate* (1654)
Etching and gouache on paper, 8¼ x 7 in.
Signed: Kaye
Private Collection, Illinois

All that Glitters Is Not Gold, n.d.
After Renoir *Le chapeau epingle* (1894)
Etching and gouache on paper, 4½ x 3¼ in.
Signed: KAYE
Private Collection

I Lost My Shirt on Them, n.d.
After Renoir *Baigneuse debout a mi-jambes* (1910)
Etching and gouache on paper, 6⅝ x 4⅜ in.
Signed: KAYE
Private Collection

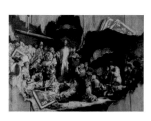

Untitled, n.d.
After Rembrandt van
Rijn *The Hundred
Guilder Print* (1649)
Etching and gouache
on paper, 11 x 15¼ in.
Signed: O Kaye
Private Collection, Illinois

Always a Square Deal,
1950
After Francisco Goya
Los Caprichos (1799)
Etching and gouache
on paper, 8½ x 6 in.
Signed: KAYE
Private Collection

Our Ship Has Come In,
1950
After James McNeill
Whistler *Rotherhithe*
(1860)
Etching and gouache
on paper, 10½ x 7¾ in.
Signed: KAYE
Private Collection

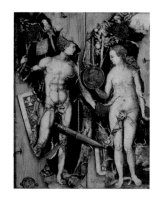

Eden Bonding Company,
1950
After Albrecht Dürer
Adam and Eve (1504)
Etching and gouache
on paper, 9¾ x 7¾ in.
Signed: O Kaye
Private Collection, Illinois

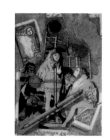

*A Fool and His Money
Are Soon Parted*, 1950
After Francisco Goya
*Los Caprichos Ya Tienen
Asiento* (1799)
Etching and gouache
on paper, 8¼ x 6 in.
Signed: O KAYE
Private Collection

Ten Dollar Bill (recto),
1950
Drawing pencil and
black ink on paper,
3 x 7¼ in
Signed: Otis Kaye
Private Collection

Ten Dollar Bill (verso),
1950
Black ink and pencil
on paper, 3½ x 7¼ in.
Signed: Otis Kaye
Private Collection

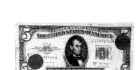

Five Dollar Bill (verso),
1950
Black ink and pencil
on paper, 3⅛ x 7½ in.
Signed: Otis Kaye
Private Collection

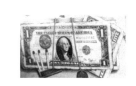

Money to Burn, 1950s
Etching with gouache
on paper, 4¼ x 8⅛ in.
Signed: Otis Kaye
Private Collection

Write on the Money, c.
1950
Etching with gouache
on paper, 4 x 7½ in.
Signed: Otis Kaye
Private Collection

Mille Francs Banque de France $1000, 1950
Ink, watercolor and pencil on paper, 3¾ x 7¼ in.
Signed: OTIS KAYE
Private Collection

Twenty Dollar Bill (recto), 1950
Graphite and ink on paper, 3½ x 7¼ in.
Signed: Otis Kaye
Private Collection

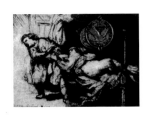

Potiphar's Wife with Quarter and Penny, c. 1950
After Rembrandt van Rijn *Joseph and Potiphar's Wife* (1634)
Etching and gouache on paper, 3 x 4½ in.
Signed: O. Kaye
Private Collection

NO IMAGE AVAILABLE

The Goldsmith with Buffalo Nickel, c. 1950
After Rembrandt van Rijn *Goldsmith* (1655)
Etching and gouache on paper, 4 x 3 in.
Signed: O. Kaye
Private Collection

NO IMAGE AVAILABLE

Frugal Repast with Coins, 1950s
After Pablo Picasso *Frugal Repast* (1904)
Etching and gouache on paper, 18 x 14¾ in
Signed: O. Kaye
Private Collection

NO IMAGE AVAILABLE

Jan Lutma with Half Dollar and Dime, 1951
After Rembrandt van Rijn *Jan Lutma* (1656)
Etching and gouache on paper, 7⅞ x 6 in.
Signed: O. Kaye
Private Collection

Tic Tac Toe, By Bye Pablo Picasso, 1951
After Pablo Picasso *Vollard Suite* (1930–1937)
Etching and gouache on paper, 10¾ x7⅘ in.
Signed: O KAYE
Private Collection

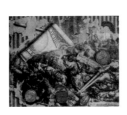

What No Change for a Five!, 1951
After Rembrandt van Rijn *Christ Driving the Money Changers from the Temple* (1635)
Etching and gouache on paper, 5½ x 6½ in.
Signed: Otis K.
Private Collection

Frank, Ben Said, Keep It Under Your Hat, 1952
After Francisco Goya *Francisco Goya y Lucientes, Pintor* (1799)
Etching and gouache on paper, 8½ x 6 in.
Signed: Otis
Private Collection, Illinois

But Adam, It's a Sure Bet, 1952
After Rembrandt van Rijn *Adam and Eve* (1638)
Etching and gouache on paper, 6⅜ x 4⅛ in.
Signed: KAYE
Private Collection, Illinois

Always Deal with a Sharp Pencil, Always!, 1952
After Rembrandt van Rijn *Abraham and Isaac* (1635)
Etching and gouache on paper, 5¹⁵⁄₁₆ x 5¹⁄₁₆ in.
Signed: Kaye
Private Collection

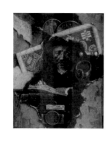

Penny for My Thoughts?, 1952
After Rembrandt van Rijn *Rembrandt van Rijn Drawing at a Window* (1648)
Etching and gouache on paper, 6⅛ x 5 in.
Signed: KAYE
Private Collection

NO IMAGE AVAILABLE

NO IMAGE AVAILABLE

NO IMAGE AVAILABLE

Penny for My Thoughts (unfinished), n.d.
After Rembrandt van Rijn *Rembrandt van Rijn Drawing at a Window* (1648)
Etching and gouache on paper, 6⅛ x 5 in.
Unsigned
Private Collection, Illinois

Penny for My Thoughts with blue pencil (unfinished), 1952
After Rembrandt van Rijn *Rembrandt van Rijn Drawing at a Window* (1648)
Etching and gouache on paper, 6⅛ x 5 in.
Signed: OK
Private Collection, Illinois

Raising of Lazarus, c. 1952
After Rembrandt van Rijn *The Raising of Lazarus* (1632)
Etching and gouache on paper, 14 x 10 in
Signed: O. Kaye
Private Collection

NO IMAGE AVAILABLE

NO IMAGE AVAILABLE

NO IMAGE AVAILABLE

The Gold Weight, c. 1950s
After Rembrandt van Rijn *The Goldsmith* (1655)
Etching and gouache on paper, 4 x 3 in.
Signed: O. Kaye
Private Collection

St. Etienne du Mont, c. 1952
After Charles Meryon *The Church of St. Etienne du Mont* (1854)
Etching and gouache on paper, 9½ x 5 in.
Signed: O. Kaye
Private Collection

Christ Preaching, c. 1952
After Rembrandt van Rijn *The Hundred Guilder Print* (1649)
Etching and gouache on paper, 11 x 15¼ in.
Signed: O. Kaye
Private Collection

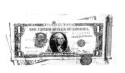

Always Deal with a Sharp Pencil, 1952
Etching with tempera on paper, 4½ x 8 in.
Signed: Otis Kaye
Private Collection

Always Deal with a Sharp Pencil, 1952
Pencil, ink and watercolor on paper, 11 x 8 in.
Signed: Otis Kaye
Private Collection

NO IMAGE AVAILABLE

Portrait of Franciscus Frank, 1953
After Anthony Van Dyck *Portrait of Franciscus Frank* (n.d.)
Etching and gouache on paper, 10½ x 7⅙ in.
Signed: O. Kaye
Private Collection

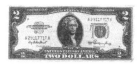

Two Dollar Bill (recto), 1953
Ink and pencil on paper, 3¼ x 7 in.
Signed: Otis Kaye
Private Collection

Two Dollar Bill (verso), 1953
Green ink on paper, 3 x 6 in.
Signed: Otis Kaye
Private Collection

Money from Home, 1953
Pen, pencil, ink and gouache on paper, 11 x 8 in.
Signed: O. Ka
Private Collection

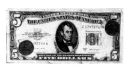

Five Dollar Bill (recto), 1953
Ink and gouache on paper, 2⁷⁄₁₀ x 6 in.
Signed: Otis Kaye
Private Collection

NO IMAGE AVAILABLE

Dollar with Coins, 1950s
Etching with gouache on paper, 3½ x 7 in.
Signed: Otis Kaye
Private Collection

My Ship Has Sailed!, 1953
After James McNeill Whistler *Black Lion Wharf* (1859)
Etching and gouache on paper, 6 x 8¾ in.
Signed: KAYE
Private Collection

Think Big Son!, 1953
After Rembrandt van Rijn *Peasant Family on the Tramp* (1652)
Etching and gouache on paper, 4½ x 3½ in.
Signed: OK
Private Collection

Brother, Spare a Dime, Or?, 1953
After Rembrandt van Rijn *A Peasant in a High Cap Standing, Leaning on a Stick* (1639)
Etching and gouache on paper, 3¹⁄₁₆ x 1¾ in.
Signed: O. KAYE
Private Collection

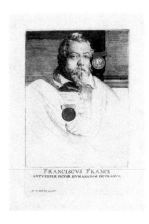

Untitled with Dime and Penny, 1953
After Anthony
van Dyck *Portrait of Franciscus Franck* (n.d.)
Etching and gouache on paper, 11¹¹⁄₁₆ x 8³⁄₁₆ in.
Signed: [O] KAYE
Collection of the Board of Governors of the Federal Reserve System, Gift of the Whitehead Foundation

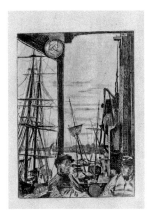

Untitled with Half Dollar, Quarter and Penny, 1953
After James McNeill Whistler *Rotherhithe* (1860)
Etching and gouache on paper, 13 x 9¼ in.
Signed: O. KAYE
Collection of the Board of Governors of the Federal Reserve System, Gift of the Whitehead Foundation

Come Up and See My Etchings, 1954
After Rembrandt van Rijn *Joseph and Potiphar's Wife* (1634)
Etching and gouache on paper, 3¹⁄₁₆ x 4³⁄₈ in.
Signed: OKAYE
Private Collection

HAPPY BIRTHDAY, LAZARUS, AGAIN, 1954
After Rembrandt van Rijn *The Raising of Lazarus* (1632)
Etching and gouache on paper, 14³⁄₁₆ x 10⅛ in.
Signed: OKAYE
Private Collection

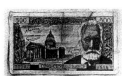

Five Hundred Franc Note, 1955
Pencil, ink and gouache on paper, 3½ x 6¼ in.
Signed: Otis Kaye
Private Collection

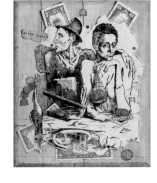

After Taxes, 1956
After Pablo Picasso
Frugal Repast (1904)
Etching and gouache on paper, 18 x 15 in.
Signed: [O] KAYE
Collection of the Board of Governors of the Federal Reserve System, Gift of Rachel and Nathan Young

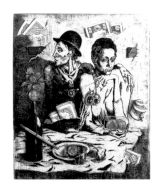

Before Taxes, 1956
After Pablo Picasso
Frugal Repast (1904)
Etching and gouache on paper, 18 x 15 in.
Signed: O. KAYE
Collection of the Board of Governors of the Federal Reserve System, Gift of Rachel and Nathan Young

The Buck Starts Here, 1957
Etching with gouache on paper, 3¾ x 7½ in.
Signed: [O]tis Kaye
Private Collection

They Move Like Hot Cakes, 1957
After Rembrandt van Rijn *The Pancake Woman* (1635)
Etching and gouache on paper, 4⅕ x 3 in.
Signed: OKAYE
Private Collection

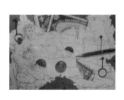

Post the Bans Now, n.d.
After Pablo Picasso *Vollard Suite* (1930–1937)
Etching and gouache on paper, 7½ x 10½ in.
Signed: OKAYE
Private Collection, Illinois

Frugal Repast with Currency, n.d.
After Pablo Picasso *Frugal Repast* (1904)
Etching and gouache on paper, 18 x 14 in.
Signed: OKAYE
Private Collection

NO IMAGE AVAILABLE

NO IMAGE AVAILABLE

Coins on Rembrandt van Rijn, n.d.
After Rembrandt van Rijn *Raising of Lazarus* (1632)
Etching and gouache on paper, 14 x 10 in.
Signed: OKAYE
Private Collection

Faust, n.d.
After Rembrandt van Rijn *Faust in His Study* (1652)
Etching and gouache on paper, 9 x 8 in.
Signed: O. Kaye
Private Collection

Faust with Quarter, Nickel and Penny, n.d.
After Rembrandt van Rijn *Faust in His Study* (1652)
Etching and gouache on paper, 9 x 8 in.
Signed: O. Kaye
Private Collection

Goldsmith with $10 Goldpiece,, n.d.
After Rembrandt van Rijn *Goldsmith* (1655)
Etching and gouache on paper, 4 x 3 in.
Signed: KAYE
Private Collection

Day Dreams, n.d.
After James McNeill Whistler *Rotherhithe* (1860)
Etching and gouache on paper, 10½ x 7¾ in.
Signed: O Kaye
Private Collection

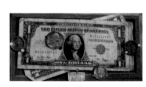

The One I Love, 1966
Etching with gouache on paper, 4 x 7½ in.
Signed: Otis Kaye
Private Collection, Illinois

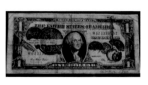

It Makes Cents, 1967
Etching with gouache on paper, 2¾ x 6¼ in.
Signed: OKAYE
Private Collection, Illinois

APPENDIX 4: ETCHINGS

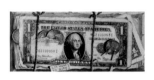

Got Money to Burn?, 1969
Etching with gouache
on paper, 3½ x 7½ in.
Signed: in plate Otis
Kaye
Private Collection, Illinois

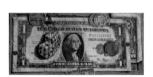

A Buck for Luck, 1970
Etching with gouache
on paper, 3¾ x 7½ in.
Signed: OK
Private Collection, Illinois

Seated Nude with Mirror,
1925
Etching, 7¼ x 4½ in.
Signed in plate: O KAYE
Private Collection, Illinois

Bums at Fire, 1931
Etching, 6¼ x 8 in.
Signed in plate: O KAYE
Private Collection, Illinois

Boy Sleeping, 1937
Etching, 4½ x 6⅜ in.
Signed in plate: O. Kaye
Private Collection, Illinois

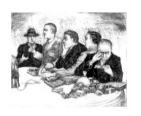

Always a Buyer, 1937
Etching, 7⅞ x 9⅞ in.
Signed in plate: OKAYE
Private Collection, Illinois

Beat the Dealer, 1939
Etching, 5⅞ x 9 in.
Signed in plate: OKAYE
Private Collection, Illinois

Speculators, 1940
Etching, 8 x 8⅞ in.
Signed in plate:
OKAYE
Private Collection, Illinois

Proposal, 1946
Etching, 10⅞ x 8¾ in.
Signed in plate:
OKAYE
Private Collection, Illinois

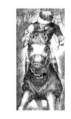

In the Lead, 1947
Etching, 9⅞ x 4 in.
Signed in plate: OKAYE
Private Collection, Illinois

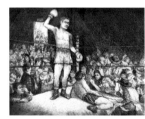

Conqueror, 1948
Etching, 8⅞ x 11 in.
Signed in plate:
OKAYE
Private Collection, Illinois

Artist Studio, 1948
Etching, 9¾ x 7¾ in.
Signed in plate: OKAYE
Private Collection, Illinois

Seated Nude, 1948
Etching, 7½ x 4½ in.
Signed in plate: OKAYE
Private Collection, Illinois

Emma, 1949
Etching, 8⅞ x 5⅞ in.
Signed in plate:
OKAYE
Private Collection, Illinois

Gambling, 1949
Etching, 5¾ x 8¼ in.
Signed in plate: OTIS
KAYE
Private Collection, Illinois

Adam and Eve, 1949
Etching, 12 x 15 in.
Signed in plate:
OKAYE
Private Collection, Illinois

Monkey Business, 1949
Etching, 10 x 8 in.
Signed in plate:
OKAYE
Private Collection, Illinois

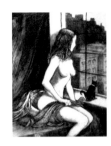

Seated Nude with Black Cat, 1949
Etching, 10 x 8 in.
Signed in plate: OKAYE
Private Collection, Illinois

Seated Nude, 1950
Etching, 7⅛ x 4⅞ in.
Signed in plate:
OKAYE
Private Collection, Illinois

Striptease, 1950
Etching, 8⅛ x 5⅞ in.
Signed in plate: OKAYE
Private Collection, Illinois

Sure Bet #2, 1950
Etching, 9 x 12 in.
Signed in plate: OKAYE
Private Collection, Illinois

Babylon, 1954
Etching, 8½ x 7½ in.
Signed in plate: OKaye
Private Collection, Illinois

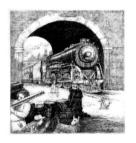

Chicago, 1956
Etching, 7½ x 7⅛ in.
Signed in plate: OTIS
KAYE
Private Collection, Illinois

Reclining Nude, 1957
Etching, 3⅞ x 7½ in.
Signed in plate: OKAYE
Private Collection, Illinois

Grows on Trees, 1958
Etching, 9¾ x 6 in.
Signed in plate:
OKAYE
Private Collection, Illinois

Negro Head, n.d.
Etching, 6⅜ x 5 in.
Signed in plate: Otis K
Private Collection, Illinois

Grosvater Hoffman, n.d.
Etching, 5⅛ x 4 in.
Signed in plate: Otis K
Private Collection, Illinois

Man with Crutch, n.d.
Etching, 5⁹⁄₁₀ x 8 in.
Signed in plate: OKAYE
Private Collection, Illinois

Bull in Stockyard, n.d.
Etching, 7⅛ x 6¼ in.
Signed in plate: OTIS
KAYE
Signed in pencil:
OTIS KAYE
Private Collection, Illinois

Society Anonomous
Artist, n.d.
Etching, 5⅞ x 8½ in.
Signed in plate: OTIS
KAYE
Signed in pencil:
OTIS KAYE
Private Collection, Illinois

Peoria, n.d.
Etching, 8 x 6⅜ in.
Signed in plate: OTIS
KAYE CHI
Private Collection, Illinois

No Help Wanted, n.d.
Etching, 7¼ x 5⅜ in.
Not signed in plate
Private Collection, Illinois

Street Car 79th Western, n.d.
Etching, 6¾ x 6⅝ in.
Signed in plate: OTIS
KAYE
Private Collection, Illinois

Emma, n.d.
Etching, 10¾ x 8⅞ in.
Signed in plate: OKAYE
Private Collection, Illinois

Nude on Roof, n.d.
Etching, 10 x 13⅛ in.
Signed in plate: O KAYE
Private Collection, Illinois

Nude Seated at a Pool, n.d.
Etching, 5⅞ x 5½ in.
Signed in plate: O KAYE
Private Collection, Illinois

Danae, n.d.
Etching, 7⅞ x 8¾ in.
Signed in plate twice:
OKAYE
Private Collection, Illinois

Minsky's Presents
Erotica, n.d.
Etching, 5½ x 4¾ in.
Signed in plate: OTIS K
Private Collection, Illinois

Adam and Eva, n.d.
Etching, 5½ x 4¾ in.
Signed in plate: OTIS K
Private Collection, Illinois

Large Adam and Eve, n.d.
Etching, 10⅝ x 7½ in.
Signed in plate: O KAYE
Private Collection, Illinois

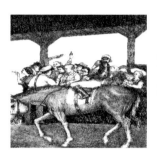

Jockey with Crowd, n.d.
Etching, 6⅞ x 6¼ in.
Signed in plate: OKAYE
Private Collection, Illinois

A Sure Bet, n.d.
Etching, 11¾ x 5⅞ in.
Signed in plate: OTIS
KAYE
Private Collection, Illinois

Artist Model, n.d.
Etching, 10⅝ x 8⅞ in.
Signed in plate: O KAYE
Private Collection, Illinois

At Rest, n.d.
Etching, 9 x 6 in.
Signed in plate:
OKAYE
Private Collection, Illinois

Adam and Eve, n.d.
Etching, 9 x 6 in.
Signed in plate: OKAYE
Private Collection, Illinois

Taking A Break, n.d.
Etching, 12 x 9 in.
Signed in plate:
OKAYE
Private Collection, Illinois

At Sea without a Paddle, n.d.
Etching, 10¼ x 15 in.
Signed in plate: OTIS
KAYE
Private Collection, Illinois

American Union Bank, n.d.
Etching, 12 x 9 in.
Signed in plate: OKAYE
Private Collection

Wary Intersection, n.d.
Etching, 9½ x 10¾ in.
Signed in plate: OKAYE
Private Collection, Illinois

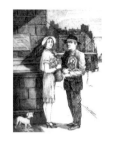

A Good Deal, n.d.
Etching, 12 x 9 in.
Signed in plate: O KAYE
Private Collection, Illinois

Halt!, n.d.
Etching, 4 x 5 in.
Signed in plate: OKAYE
Private Collection, Illinois

The Fat Lady Sings, 1964
Etching, 15 x 13 in.
Signed: O.KAYE 1964
Private Collection, Illinois

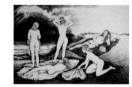

Coming Storm, 1969
Etching: 12 x 18 in.
Signed: O KAYE
Private Collection, Illinois

APPENDIX SA: DRAWING AND SKETCHES

Bella, 1920
Pencil on paper, 6 x 4 in,
Signed: O KAYE
Private Collection, Illinois

Danae, 1920s
Pencil on paper
mounted on matte
board, 9 x 12 in.
Signed: OKAYE
Private Collection, Illinois

Shoppers, 1920s
Pencil on paper
mounted on matte
board, 11½ x 8½ in.
Signed: OK
Private Collection, Illinois

Reclining Nude, 1932
Pencil and black conte
crayon on paper, 4²⁄₅ x
7¾ in.
Signed: O KAYE
Private Collection, Illinois

Horse body and legs, 1932
Pencil and red conte
crayon on paper,
6 x 8 in.
Signed: KAYE
Private Collection, Illinois

Horses, 1932
Red conte crayon on
paper, 8 x 9¼ in.
Signed: OKAYE
Private Collection, Illinois

Franz R., 1936
Pencil on paper, 3½ x
2¾ in.
Signed: OK
Private Collection, Illinois

Herr Dr. Meyer, 1939
Pencil on paper, 4⁴⁄₅ x
4⁹⁄₁₀ in.
Signed: O KAYE
Private Collection, Illinois

Wayne Radcliff Jones, 1939
Pencil and black conte
crayon on paper, 6½ x
4½ in.
Signed: OTIS K
Private Collection, Illinois

Seated nude, arms in lap,
1940
Pencil on paper, 8 x
5²⁄₅ in.
Signed: OKAYE
Private Collection, Illinois

Standing nude leaning right,
1940
Pencil and black conte
crayon on paper, 9³⁄₅ x
5¼ in.
Signed: OKAYE
Private Collection, Illinois

*Three Drawings of Hand
and Arms*, 1940
Red conte crayon on
paper, 8½ x 9¾ in.
Signed: OKAYE
Private Collection, Illinois

Three Hands, 1940
Red conte crayon on
paper, 5¾ x 5 in.
Signed: OK
Private Collection, Illinois

Seated Black Woman,
1940
Pencil and ink on
paper, 7²/₅ x 6 in
Signed: OKAYE
Private Collection, Illinois

Man in Suit, Wall Street,
1940
Pencil on paper, 4¾ x
3¾ in.
Signed: OK
Private Collection, Illinois

*Man with Wavy Hair, Wall
Street,* 1940
Pencil on paper, 4½ x
4 in.
Signed: OK
Private Collection, Illinois

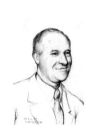

Smiling Man, Wall Street,
1940
Pencil on paper, 5¼ x
3⅞ in.
Signed: OKAYE
Private Collection, Illinois

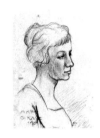

Mary, 1940
Pencil on paper, 3 x 2 in.
Signed: OKAYE
Private Collection, Illinois

JAYN M, 1940
Pencil on paper, 4⁹/₁₀
x 4 in.
Signed: OKAYE
Private Collection, Illinois

Two Nudes on Beach, 1941
Pencil and black conte
crayon on paper, 11½
x 10 in.
Signed: OKAYE
Private Collection, Illinois

Two Hands Clasped, 1941
Red conte crayon on
paper, 3¼ x 8¼ in.
Signed: OK
Private Collection, Illinois

Emma, n.d.
Pencil and black conte
crayon on
paper, 12 x 9 in.
Signed: OKAYE
Private Collection, Illinois

Emma, 1942
Pencil and black conte
crayon on
paper, 12 x 9¹/₁₀ in.
Signed: OKAYE
Private Collection, Illinois

Male in Trunks, 1942
Pencil on paper, 8 x
5½ in.
Signed: OKAYE
Private Collection, Illinois

Otto, 1942
Pencil on paper, 4³/₅ x
3¼ in.
Signed: OKAYE
Private Collection, Illinois

Three Men, 1942
Pencil and black conte
crayon on paper, 8²/₅ x
11 in.
Signed: OK
Private Collection, Illinois

Geo. Stuhl, 1942
Pencil on paper, 6½ x
3²/₅ in.
Signed: OKAYE
Private Collection, Illinois

Two Hands, 1943
Pencil on paper, 7 x
7 in.
Signed: OKAYE
Private Collection, Illinois

Men with Cards, 1940s
Pencil and black conte
crayon on paper, 8½ x
11²/₅ in.
Signed: OK
Private Collection, Illinois

Two Men, 1940s
Pencil and black conte
crayon on paper, 8²/₅ x
11½ in.
Signed: OK
Private Collection, Illinois

Lake Michigan, 1940s
Pencil on paper
mounted on cardboard,
9 x 12 in.
Signed: OK
Private Collection, Illinois

Lake Michigan Pier, 1940s
Pencil on paper
mounted on cardboard,
9 x 12 in.
Signed: OK
Private Collection, Illinois

Margo, 1946
Pencil on paper, 4⁴/₅ x
4⁴/₅ in.
Signed: OKAYE
Private Collection, Illinois

Karl Franz, Erick, 1946
Pencil on paper, 10 x
7 in.
Signed: OTIS K
Private Collection, Illinois

Standing Nude Woman,
1948
Pencil and black conte
crayon on paper, 10½
x 3½ in.
Signed: OKAYE
Private Collection, Illinois

Three Figures, Sketch 1948
Pencil and black conte
crayon on paper, 9 x
12 in.
Signed: OK
Private Collection, Illinois

Fritz, 1958
Pencil on paper, 10²/₅ x
7³/₅ in.
Signed: OKAYE
Private Collection, Illinois

Virgina, 1948
Pencil on paper, 6½ x
4½ in.
Signed: OKAYE
Private Collection, Illinois

Men with Papers, 1940s
Pencil on paper, 8¼ x
11²/₅ in.
Signed: OK
Private Collection, Illinois

Two Hands, 1940s
Black conte crayon on
paper, 9½ x 6¾ in.
Signed: OKAYE
Private Collection, Illinois

Man with Glasses, Wall St.,
1940
Pencil on paper, 5¼ x
2¾ in.
Signed: OKAYE
Private Collection, Illinois

Man Wall Street, 1949
Pencil on paper, 4¾ x
3¾ in.
Signed: OK
Private Collection, Illinois

Standing Nude Woman,
1950
Red conte crayon on
paper, 7¾ x 3¼ in.
Signed: OKAYE
Private Collection, Illinois

*Seated Nude, Shoulders to
Feet*, 1950
Pencil and red conte
crayon on paper,
10¾ x 8 in.
Signed: OKAYE
Private Collection, Illinois

Hand, 1950
Red conte crayon on
paper, 5 x 3 in.
Signed: OKAYE
Private Collection, Illinois

Six Men, 1950
Pencil and ink with
light wash on paper,
8²⁄₅ x 6¾ in.
Signed: OKAYE
Private Collection, Illinois

Two Female Nudes, 1950s
Pencil and black conte
crayon on paper, 9 x
11¾ in.
Signed: OK
Private Collection, Illinois

Nudes and Artist, 1950s
Pencil on paper, 9 x
12 in.
Signed: OK
Private Collection, Illinois

Two Seated Nudes, 1950s
Pencil, black conte
crayon on paper, 8³⁄₅ x
12 in.
Signed: OK
Private Collection, Illinois

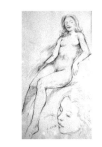

Seated Nude and Head,
1950s
Red conte crayon on
paper, 15¼ x 8½ in.
Signed: O KAYE
Private Collection, Illinois

Two Female Nudes, 1950s
Pencil on paper, 12 x
9 in.
Signed: OK
Private Collection, Illinois

Seated Nude Profile, 1950s
Red conte crayon on
paper, 9 x 11¾ in.
Signed: OKAYE
Private Collection, Illinois

Male Stretching, 1950s
Red conte crayon on
paper, 7⁹/₁₀ x 10½ in.
Signed: OK
Private Collection, Illinois

Three Indians, 1950s
Pencil on paper, 9½ x
10½ in.
Signed: OK
Private Collection, Illinois

Men, 1950s
Pencil and black conte
crayon on paper, 9²/₅ x
12 in.
Signed: OK
Private Collection, Illinois

Indian with Knife, 1950s
Pencil on paper, 8 x
5¼ in.
Signed: OK
Private Collection, Illinois

Three Figures, 1950s
Pencil and black conte
crayon on paper, 9 x
12 in.
Signed: OK
Private Collection, Illinois

Three Men, 1950s
Pencil and black conte
crayon on paper, 9 x
12 in.
Signed: OK
Private Collection, Illinois

Horses and Jockeys, 1950s
Pencil and black conte
crayon on paper, 9 x
12 in.
Signed: OK
Private Collection, Illinois

Jockeys and Horses, 1950s
Pencil and black conte
crayon on paper, 8¼ x
11½ in.
Signed: OK
Private Collection, Illinois

Standing Female Nude,
1951
Pencil and black conte
crayon on paper, 10³/₅
x 4¾ in.
Signed: OKAYE
Private Collection, Illinois

Professor Cravens, 1951
Pencil on paper, 5¾ x
3³/₅ in.
Signed: OKAYE
Private Collection, Illinois

Nude Red Drape, 1952
Pencil on paper, 8¹/₁₀ x
2½ in.
Signed: OKAYE
Private Collection, Illinois

Two Male Heads, 1952
Pencil on paper, 3³/₅ x
5¼ in.
Signed: OKAYE
Private Collection, Illinois

Cows, 1952
Pencil and black conte
crayon on paper, 9⁹/₁₀
x 11 in.
Signed: OK
Private Collection, Illinois

Three Heads Custer #2,
1956
Pencil on paper, 4½ x
7¼ in.
Signed: OKAYE
Private Collection, Illinois

Two Hands, 1956
Red conte crayon on
paper, 6¾ x 10½ in.
Signed: OKAYE
Private Collection, Illinois

Male Waist to Foot, 1958
Red conte crayon on
paper, 9⁹⁄₁₀ x 3⁹⁄₁₀ in.
Signed: OKAYE
Private Collection, Illinois

Male Back and Legs, 1958
Red conte crayon on
paper, 10¾ x 3½ in.
Signed: OKAYE
Private Collection, Illinois

Indian Study, 1958
Red conte crayon on
paper, 11⁹⁄₁₀ x 7 in.
Signed: OK
Private Collection, Illinois

*Male Nude Indian
Spear*, 1958
Red conte crayon on
paper, 6⅝ x 9 in.
Signed: OK
Private Collection, Illinois

Indian Nude on Knees,
1958
Red conte crayon on
paper, 7 x 8¼ in.
Signed: O KAYE
Private Collection, Illinois

Legs, 1958
Red conte crayon on
paper, 7 x 7 in.
Signed: OK
Private Collection, Illinois

Study Rear Leg, 1958
Red conte crayon on
paper, 11⅗ x 4 in.
Signed: OK
Private Collection, Illinois

Standing Nude, 1956
Pencil and red conte
crayon on paper, 11⅖
x 4⅗ in.
Signed: OK
Private Collection, Illinois

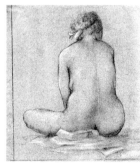

Seated Nude, 1959
Pencil on paper, 7¾ x
6¾ in.
Signed: OKAYE
Private Collection, Illinois

APPENDIX 5B: DRAWING AND SKETCHES
PRESENTATION DRAWINGS

Cup and Gravy Boat,
1932
Ink and tempera on
paper, 5¾ x 7 in.
Signed: OKAYE
Private Collection, Illinois

Lobster, 1934
Ink and tempera on
paper, 9 x 7 in.
Signed: OTIS KAYE
Private Collection, Illinois

Jewel Box, 1938
Ink and tempera on
paper, 7 x 10 in.
Signed: Otis K
Private Collection, Illinois

Purple Flower, 1938,
reverse
Ink and tempera on
paper, 10 x 7 in.
Unsigned
Private Collection, Illinois

Monarch Butterfly, 1938
Ink and tempera on
paper, 4 x 3¼ in.
Signed: O KAYE
Private Collection, Illinois

Green Butterfly, 1938
Ink and tempera on
paper, 7½ x 4 in.
Signed: OK
Private Collection, Illinois

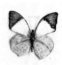

Orange Butterfly, 1938,
reverse
Ink and tempera on
paper, 4½ x 7 in.
Signed: OKAYE
Private Collection, Illinois

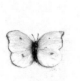

Yellow Butterfly, 1938
Ink and tempera on
paper, 4¾ x 7½ in.
Signed: OTIS K
Private Collection, Illinois

Monarch Butterfly,
1938, reverse
Ink and tempera on
paper, 4¾ x 7½ in.
Signed: OK
Private Collection, Illinois

Monarchs, 1938
Ink,and tempera on
paper, 5 x 7½ in.
Signed: OTIS KAYE
Private Collection, Illinois

Two Moths, Nine Ants,
1940
Ink and tempera on
paper, 7½ x 7¼ in.
Signed: O KAYE
Private Collection, Illinois

Three Grasshoppers,
1940, reverse
Ink and tempera on
paper, 7½ x 7¼ in.
Signed: OTIS K
Private Collection, Illinois

Red Tulip, 1940s
Ink and tempera on
paper, 10 x 7 in.
Signed: O KAYE
Private Collection, Illinois

Three Turtles, 1945
Ink and tempera on
paper, 6½ x 7¾ in.
Signed: OTIS KAYE
Private Collection, Illinois

Green Frog, 1945
Ink and tempera on
paper, 3 x 3²/₅ in.
Signed: OKAYE
Private Collection, Illinois

Two Gorillas, 1946
Ink and tempera on
paper, 9 x 7 in.
Signed: OTIS KAYE
Private Collection, Illinois

Green Bird, 1948
Ink and tempera on
paper, 8³/₅ x 7 in.
Signed: OKAYE
Private Collection, Illinois

Rhino Skull, 1948
Ink and tempera on
paper, 4³/₅ x 5¾ in.
Signed: OK
Private Collection, Illinois

Two Beetles, 1948
Ink and tempera on
paper, 7½ x 6 in.
Signed: O KAYE
Private Collection, Illinois

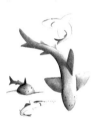

Four Sharks, 1948
Ink and tempera on
paper, 10³/₁₀ x 7¾ in.
Signed: O KAYE
Private Collection, Illinois

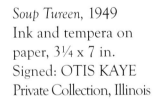

Soup Tureen, 1949
Ink and tempera on
paper, 3¼ x 7 in.
Signed: OTIS KAYE
Private Collection, Illinois

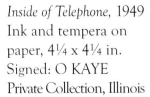

Inside of Telephone, 1949
Ink and tempera on
paper, 4¼ x 4¼ in.
Signed: O KAYE
Private Collection, Illinois

Pitcher, 1949
Ink and tempera on
paper, 9½ x 6 in.
Signed: OK
Private Collection, Illinois

Pekingese Dog, 1949,
reverse
Ink and tempera on
paper, 6 x 9½ in.
Signed: OK
Private Collection, Illinois

Blackbird, 1949
Ink and tempera on
paper, 7 x 10¼ in.
Signed: O KAYE
Private Collection, Illinois

Two Brown Moths, 1950s
Ink and tempera on
paper, 4²/₅ x 7¼ in.
Signed: O KAYE
Private Collection, Illinois

Yellow Butterfly, 1950s
Ink and tempera on
paper, 3¼ x 5¼ in.
Signed: O KAYE
Private Collection, Illinois

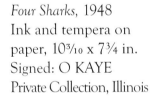

Blue Green Butterfly,
1950s
Ink and tempera on
paper, 3 x 5¼ in.
Signed: OK
Private Collection, Illinois

Man of Muscles, 1950
Ink and tempera on
paper, 11¼ x 7³/₅ in.
Signed: O KAYE
Private Collection, Illinois

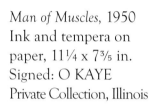

Green Newt, 1950
Ink and tempera on
paper, 4 x 8 in.
Signed: O KAYE
Private Collection, Illinois

Gray Fish, 1950
Ink and tempera on
paper, 6 x 10 in.
Signed: O KAYE
Private Collection, Illinois

Monkey, 1950s
Ink and tempera on
paper, 5 x 6½ in.
Unsigned
Private Collection, Illinois

Skeleton and Skull, 1950s
Ink and tempera on
paper, Reverse
Unsigned
Private Collection, Illinois

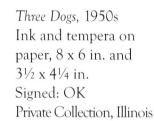

Three Dogs, 1950s
Ink and tempera on
paper, 8 x 6 in. and
3½ x 4¼ in.
Signed: OK
Private Collection, Illinois

Three Dogs, 1950s
Pencil and graphite on
paper, 10 x 6¾ in.
Signed: O KAYE
Private Collection, Illinois

Three Monkeys, 1951
Ink and tempera on
paper, 9 x 7¾ in.
Signed: O KAYE
Private Collection, Illinois

Robin Redbreast, 1952
Ink and tempera on
paper, 6⁴/₅ x 6¼ in.
Signed: OKAYE
Private Collection, Illinois

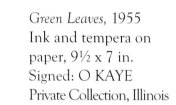

Old Forester, 1952
Pen and India ink on
paper, 9¼ x 4½ in.
Signed: O KAYE
Private Collection, Illinois

Green Leaves, 1955
Ink and tempera on
paper, 9½ x 7 in.
Signed: O KAYE
Private Collection, Illinois

*Squash and Purple
Grapes,* 1955
Ink and tempera on
paper, 7 x 12¼ in.
Signed: O KAYE
Private Collection, Illinois

*Bird Skeleton, Armor,
Ants,* 1955
Ink and tempera on
paper, 8½ x 6¾ in.
Signed: O KAYE
Private Collection, Illinois

Armor, 1955
Ink tempera on paper,
8 x 6³/₅ in.
Unsigned
Private Collection, Illinois

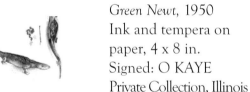

APPENDIX 6A: WATERCOLORS AND GOUACHE

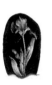

Lizard Skeleton, Helmet, 1955
Ink and tempera on paper, 8⅖ x 4⁹⁄₁₀ in.
Signed: O KAYE
Private Collection, Illinois

Purple Iris Ada's Yard, 1958
Ink and tempera on paper, 10 x 7 in.
Signed: OTIS K
Private Collection, Illinois

Buckingham Fountain, c. 1928
Gouache on paper, 8 x 12½ in.
Signed: Otis Kaye
Private Collection

Marshall Field Clock, c. 1928
Gouache on paper, 10 x 16½ in.
Signed: Otis Kaye
Private Collection

Three Shoppers 47th and Ashland, c. 1928
Gouache on paper, 7½ x 12 in.
Signed: Otis Kaye
Private Collection

Chicago Street in Winter, 1928
Gouache on paper, 6¼ x 9¾ in.
Signed: Otis Kaye
Private Collection

Chicago Street Water Tower, 1928
Gouache on paper, 7½ x 12 in.
Signed: Otis Kaye
Private Collection

Clock at Marshall Field, 1928
Gouache on paper, 6½ x 10½ in.
Signed: Otis Kaye
Private Collection

NO IMAGE AVAILABLE

47th and Ashland, 1928
Gouache on paper, 6 x 11 in.
Signed: Otis Kaye
Private Collection

State Street, 1929
Gouache on paper, 7½ x12 in.
Signed: O Kaye
Private Collection

Tivoli, 1941
Gouache on paper, 7½ x 12 in.
Signed: Otis Kaye
Private Collection

Englewood Station, c. 1945
Gouache on paper,
7½ x 12 in.
Signed: Otis Kaye
Private Collection

Hyde Park Station, 1945
Gouache on paper,
7½ x 12 in.
Signed: O Kaye
Private Collection

Blind Soldier, 1945
Watercolor on paper,
20½ x 15 in.
Signed: O.KAYE
Private Collection, Illinois

Two Soldiers, 1945
Watercolor on paper,
20 x 28 in.
Signed: O KAYE
Private Collection, Illinois

ROCK I TRAIN, n.d.
Watercolor on paper,
4½ x 6½ in.
Unsigned
Private Collection, Illinois

Loading Up, 1950s
Watercolor on paper,
18½ x 24½ in.
Signed: O KAYE
Private Collection, Illinois

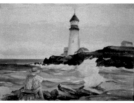

A Profitable Day, 1950
Watercolor on paper,
20 x 29½ in.
Signed: O KAYE
Private Collection, Illinois

Rapids, 1950s
Watercolor on paper,
17½ x 21½ in.
Signed: O KAYE
Private Collection, Illinois

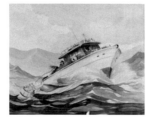

SS OKAYE, 1950
Watercolor on paper,
19½ x 24½ in.
Signed: O KAYE
Private Collection, Illinois

Misdirected, 1950s
Watercolor on paper,
22½ x 24½ in.
Signed: OTIS KAYE
Private Collection, Illinois

Got It!, 1950s
Watercolor on paper,
17 x 21½ in.
Signed: O KAYE
Private Collection, Illinois

Couple on Mich. Shore, n.d.
Watercolor on paper,
15 x 25 in.
Signed: OKAYE
Private Collection, Illinois

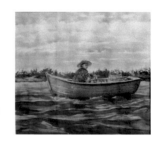

Now What?, 1950s
Watercolor on paper,
17 x 19 in.
Signed: OKAYE
Private Collection, Illinois

The Bait, 1951
Watercolor on paper,
9½ x 8 in.
Signed: OKAYE
Private Collection, Illinois

Al L. Fisch Securities, 1951
Watercolor and
gouache, 6 x 8 in.
Signed: OK
Private Collection, Illinois

Driftwood, 1950s
Watercolor on paper,
17¼ x 28¾ in.
Signed: O KAYE
Private Collection, Illinois

Falling Currency, 1950
Watercolor on paper,
23 x 39 in.
Signed: O. KAYE
Private Collection, Illinois

Irises, 1950s
Watercolor on paper,
19 x 12 in.
Signed: O KAYE
Private Collection, Illinois

Stock Ticker, 1950
Watercolor on paper,
20 x 28 in.
Signed: O KAYE
Private Collection, Illinois

Hen Pecked, 1950
Watercolor on paper,
20¼ x 27½ in.
Signed: OTIS KAYE
Private Collection, Illinois

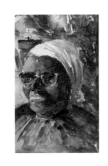

Woman with Turban,
1950
Watercolor on paper,
10 x 6¾ in.
Signed: O KAYE
Private Collection, Illinois

Jake's Ladder Service, 1950
Watercolor and
gouache on paper,
10¾ x 14 in.
Signed: OKAYE
Private Collection, Illinois

Petunias, 1951
Watercolor on paper,
17 x 20 in.
Signed: O KAYE
Private Collection, Illinois

Flower Pot, 1950s
Watercolor on paper,
20 x 15 in.
Signed: OKAYE
Private Collection, Illinois

Beauty's Reward, 1950s
Watercolor on paper,
21 x 27½ in.
Signed: OKAYE
Private Collection, Illinois

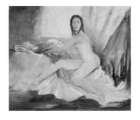

Emma in the Studio, 1950s
Watercolor on paper,
17 x20 in.
Signed: OKAYE
Private Collection, Illinois

On Stage, 1952
Watercolor on paper,
20 x 15 in.
Signed: OKAYE
Private Collection, Illinois

Red Bird, 1952
Watercolor on paper,
21½ x 30½ in.
Signed: O KAYE
Private Collection, Illinois

Red Bird, n.d.
Watercolor on paper,
19¼ x 26 in.
Signed: OKAYE
Private Collection, Illinois

Pekin Park, n.d.
Watercolor on paper,
17 x 22½ in.
Signed: OKAYE
Private Collection, Illinois

St. Augustine, 1953
Watercolor on paper,
12½ x 15 in.
Signed: OKAYE
Private Collection, Illinois

Almost, 1950s
Watercolor on paper,
18½ x 24½ in.
Signed: OKAYE
Private Collection, Illinois

Too Little Too Late, 1950s
Watercolor on paper,
22½ x 24½ in.
Signed: OTIS KAYE
Private Collection, Illinois

On Course, 1950s
Watercolor on paper,
22 x 26 in.
Signed: O KAYE
Private Collection, Illinois

Two Nudes Seated,
1950s
Watercolor on paper,
9 x 14 in.
Signed: O KAYE
Private Collection, Illinois

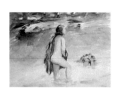

Dara, 1950s
Watercolor on paper,
10 x 14 in.
Signed: O Kaye
Private Collection, Illinois

Nude with Red Blanket,
1950s
Watercolor on paper,
11 x 7 in.
Unsigned
Private Collection, Illinois

The Fix, 1950s
Watercolor on paper,
15½ x 19 in.
Signed: OKAYE
Private Collection, Illinois

Don't Hog It All, 1950s
Watercolor on paper,
20¾ x 25½ in.
Signed: O KAYE
Private Collection, Illinois

Chicken feed, 1950s
Watercolor on paper,
22 x 17 in.
Signed: OKAYE
Private Collection, Illinois

A Windy Day, 1950s
Watercolor on paper,
18 x 27½ in.
Signed: OKAYE
Private Collection, Illinois

Oasis, 1950s
Watercolor on paper,
18 x 23 in.
Signed: OKAYE
Private Collection, Illinois

Oregon Fog, 1953
Watercolor on paper,
15¼ x 21 in.
Signed: OKAYE
Private Collection, Illinois

Houston, First Texans,
1953
Watercolor on paper,
7½ x 6½ in.
Signed: OKAYE
Private Collection, Illinois

Washed Up, 1953
Watercolor on paper,
20 x 28 in.
Signed: OKAYE
Private Collection, Illinois

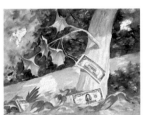

Money Grows on Trees,
1953
Watercolor on paper,
21½ x 29 in.
Signed: O. KAYE 1953
Private Collection, Illinois

Autumn Bills, 1953
Watercolor on paper,
27 x 18½ in.
Signed: O KAYE
Private Collection

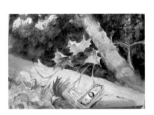

*Does Money Grow on
Trees?*, 1954
Watercolor on paper,
20 x 29 in.
Signed: OKAYE
Private Collection

63rd Halstead, Chicago,
1954
Gouache on paper,
8½ x 8 in.
Signed: Otis Kaye
Private Collection

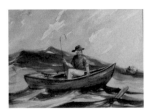

Beyond Reach, 1954
Watercolor on paper,
20 x 28 in.
Signed: OKAYE
Private Collection, Illinois

Mich. Nude, 1954
Watercolor on paper,
5½ x 8¾ in.
Signed : OK
Private Collection, Illinois

*How Does Your Garden
Grow?*, 1954
Watercolor on paper,
20 x 25 in.
Signed: OKAYE
Private Collection, Illinois

Night Withdrawal, n.d.
Watercolor on paper,
21 x 22½ in.
Signed: OKAYE
Private Collection, Illinois

Cash Cow, 1950s
Watercolor on paper,
12 x 8 in.
Signed: OKAYE
Private Collection, Illinois

Mr. E. Arly Bird, 1956
Watercolor, gouache
and graphite on paper,
7½ x 6¾ in.
Signed: Otis Kaye
Private Collection, Illinois

Sure to Win, 1958
Watercolor on paper,
15½ x 22 in.
Signed: O KAYE
Private Collection, Illinois

Bowl of Peaches, 1958
Watercolor on paper,
12½ x 16 in.
Signed: OKAYE
Private Collection, Illinois

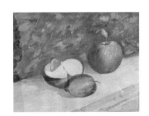

Fruit of Our Labor, c.
1958
Watercolor on paper,
12½ x 16 in.
Signed: OKAYE
Private Collection, Illinois

Apples and Cents, n.d.
Watercolor on paper,
14½ x 19 in.
Signed: OKAYE
Private Collection, Illinois

Sedona, 1959
Watercolor on paper,
16 x 20 in.
Signed: OKAYE
Private Collection, Illinois

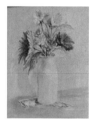

Bouquet, 1959
Watercolor on paper,
19½ x 14¾ in.
Signed: OKAYE
Private Collection, Illinois

Nude Reading, 1960
Watercolor on paper,
16½ x 20 in.
Signed: OKAYE
Private Collection, Illinois

Sunday at the Dunes,
1960
Watercolor, 15¾ x
19½ in.
Signed: O KAYE
Private Collection, Illinois

Laura Mich. Dunes
(nude reading), 1960
Watercolor on paper,
19 x 24 in.
Signed: OKAYE
Private Collection, Illinois

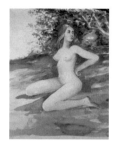

Nude, n.d.
Watercolor on paper,
21 x 16 in.
Signed: O KAYE
Private Collection, Illinois

Lone Shark, 1960s
Watercolor on paper,
20 x 28¾ in.
Signed: OKAYE
Private Collection, Illinois

Watch Out for Sharks,
1960s
Watercolor on paper,
20 x 28½ in.
Signed: OKAYE
Private Collection, Illinois

Circling the Cash, 1960s
Watercolor on paper,
18¾ x 29½ in.
Signed: OKAYE
Private Collection, Illinois

Gold, 1960s
Watercolor on paper,
20 x 28 in.
Signed: OKAYE
Private Collection, Illinois

Two for the Money, 1960s
Watercolor on paper,
16 x 20¼ in.
Signed: OKAYE
Private Collection, Illinois

At the Planetarium, n.d.
Watercolor on paper,
15¾ x 19½ in.
Signed: OKAYE
Private Collection, Illinois

Custer Battle, n.d.
Watercolor and gouache
on paper, 9 x 12 in.
Signed: O KAYE
Private Collection, Illinois

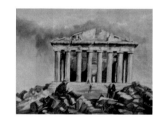

Parthenon, 1962
Watercolor on paper,
23 x 31 in.
Signed: O KAYE
Private Collection, Illinois

Octopus Ticker Co, n.d.
Watercolor on paper,
22⅗ x 30½ in.
Unsigned
Private Collection

APPENDIX 6B: WATERCOLOR SKETCHBOOK

Windy Day, 1960s
Watercolor on paper,
18 x 27 in.
Signed: OKAYE
Private Collection, Illinois

In the Park, 1960s
Watercolor on paper,
20 x 28 in.
Signed: OKAYE
Private Collection, Illinois

Rainbow Milk Co., 1962
Watercolor on paper,
18 x 24 in.
Signed: OKAYE
Private Collection, Illinois

Union Station, 1969
Watercolor on paper,
28 x 19 in.
Signed: O KAYE
Private Collection, Illinois

*Becker House, Tremont,
Ill.,* 1954
Watercolor on paper,
4²/₅ x 7¹/₁₀ in.
Signed: OK
Private Collection, Illinois

Lake in Colo., 1957
Watercolor on paper,
3⁴/₅ x 7²/₅ in.
Signed: OK
Private Collection, Illinois

Idaho 6-24-59, 1959
Watercolor on paper,
4½ x 8½ in.
Signed: OK
Private Collection, Illinois

Baker, Idaho 6-24-59,
1959
Watercolor on paper,
4½ x 8½ in.
Signed: OK
Private Collection, Illinois

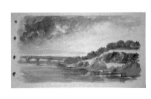

Colo 8-29-59, 1959
Watercolor on paper,
4¹/₁₀ x 8 in.
Signed: OK
Private Collection, Illinois

Colo 8-29-59, 1959
Watercolor on paper,
3³/₅ x 4½ in.
Signed: OK
Private Collection, Illinois

Downtown Pekin '60, 1960
Watercolor on paper,
3²/₅ x 5¼ in.
Signed: OK
Private Collection, Illinois

Oak Creek Canyon, 1960
Watercolor on paper,
4½ x 8½ in.
Signed: OK
Private Collection, Illinois

Oak Creek Sedona, 1960
Watercolor on paper,
4½ x 8½ in.
Signed: OK
Private Collection, Illinois

Rock Island Train, 1960
Watercolor on paper,
4½ x 8½ in.
Signed: OK
Private Collection, Illinois

Monument Valley, 1960
Watercolor on paper,
4½ x 8½ in.
Signed: OKAYE
Private Collection, Illinois

El Capitan Arizona, 1960
Watercolor on paper,
4½ x 8½ in.
Signed: OKAYE
Private Collection, Illinois

Pagosa Springs, 1960
Watercolor on paper,
4⅖ x 8 in.
Signed: OK
Private Collection, Illinois

Washington 1-26-60, 1960
Watercolor on paper,
4½ x 8½ in.
Signed: OK
Private Collection, Illinois

Washington, 1-26-60, 1960
Watercolor on paper,
4½ x 8½ in.
Signed: OK
Private Collection, Illinois

Columbia River, 1960
Watercolor on paper,
4½ x 8½ in.
Signed: OK
Private Collection, Illinois

Falls Wash 1-26-60,
1960
Watercolor on paper,
6½ x 4¾ in.
Signed: OK
Private Collection, Illinois

Bridal Falls, 1960
Watercolor on paper,
8½ x 4½ in
Signed: OK
Private Collection, Illinois

Washington, DC, 1960
Watercolor on paper,
4³⁄₁₀ x 8½ in.
Signed: OK
Private Collection, Illinois

Penn, 1960
Watercolor on paper,
4½ x 8½ in.
Signed: OK
Private Collection, Illinois

Penn Beaver Creek, 1961
Watercolor on paper,
4½ x 8½ in.
Signed: OKAYE
Private Collection, Illinois

Penn, 1961
Watercolor on paper,
4½ x 8½ in.
Signed: OK
Private Collection, Illinois

Pagosa Springs, Colo, 1961
Watercolor on paper,
3¾ x 7⅜ in.
Signed: OK
Private Collection, Illinois

Pagosa Springs, Colo, 1961
Watercolor on paper,
4½ x 8½ in.
Signed: OK
Private Collection, Illinois

Pagosa Springs, Colo,
1961
Watercolor on paper,
4½ x 8½ in.
Signed: OK
Private Collection, Illinois

Lake Colorado not Tremont, 1961
Watercolor on paper,
3 x 8 in.
Signed: OK GO OK
Private Collection, Illinois

Monument Valley, 1961
Watercolor on paper,
4½ x 8½ in.
Signed: OK
Private Collection, Illinois

New Mexico, 1961
Watercolor on paper,
3¼ x 6 in.
Signed: OK
Private Collection, Illinois

Cardaas Blanca Calif,
1961
Watercolor on paper,
4⅕ x 6 in.
Signed: OK
Private Collection, Illinois

Cardaas Blanca, 1961
Watercolor on paper,
4 x 8½ in.
Signed: OK
Private Collection, Illinois

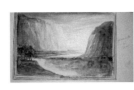

Yosemite, 1961
Watercolor on paper,
4¹⁄₁₀ x 6 in.
Signed: OK
Private Collection, Illinois

Calif Big Sur fog, 1961
Watercolor on paper,
4½ x 8½ in.
Signed: OK
Private Collection, Illinois

Big Sur fog, 1961
Watercolor on paper,
4½ x 8½ in.
Signed: OK
Private Collection, Illinois

Cactus Plants, 1961
Watercolor on paper,
3½ x 4¾ in.
Signed: OK
Private Collection, Illinois

Bridal Falls, 1961
Watercolor on paper,
8½ x 4½ in.
Signed: OK
Private Collection, Illinois

Redding Calif Mt. Shasta, 1961
Watercolor on paper,
4½ x 8½ in.
Signed: OK
Private Collection, Illinois

Cambria Pines Calif, 1961
Watercolor on paper,
4½ x 8½ in.
Signed: OK
Private Collection, Illinois

Calif, 1961
Watercolor on paper,
4 x 8½ in.
Signed: OK
Private Collection, Illinois

Yucca Valley, 1961
Watercolor on paper, 4
x 8½ in.
Signed: OK
Private Collection, Illinois

Dome Yosemite, 1961
Watercolor on paper,
4½ x 8½ in
Signed: OK
Private Collection, Illinois

Domes Yosemite, 1961
Watercolor on paper,
4½ x 8½ in.
Signed: OK
Private Collection, Illinois

Yosemite Valley, 1961
Watercolor on paper,
4½ x 8½ in.
Signed: OK
Private Collection, Illinois

Colorado, 1962
Watercolor on paper,
4¼ x 6⅞ in.
Signed: OK
Private Collection, Illinois

OK 62, 1962
Watercolor on paper,
4½ x 8½ in.
Signed: OK
Private Collection, Illinois

OAK CREEK, 1962
Watercolor on paper,
4½ x 8½ in.
Signed: OK
Private Collection, Illinois

62 OK, 1962
Watercolor on paper,
8 x 4½ in
Signed: OK
Private Collection, Illinois

Snake River twin falls Idaho, 1962
Watercolor on paper,
8½ x 4½ in.
Signed: O. Kaye
Private Collection, Illinois

APPENDIX 7: PASTELS

Circling #7, 1928
Pastel on canvas,
20 x 26 in.
Signed: O KAYE
Private Collection, Illinois

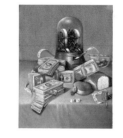

Pass the Bread! Jack, 1949
Pastel on canvas,
29 x 21 in.
Signed: O. KAYE 1949
Private Collection, Illinois

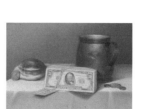

A Loaf of Bread? A Jug of? And?, 1952
Pastel and pencil on paper mounted on masonite, 11½ x 17 in
Signed: O Kaye
Private Collection, Illinois

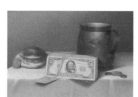

A Loaf of Bread, A Jug of Wine, A Thou, 1952
Pastel and pencil on paper mounted on masonite, 12½ x 17¾ in.
Signed: O Kaye
Private Collection, Illinois

A Loaf of Bread, A Jug of Wine and, 1953
Pastel and pencil on paper laid on masonite, 13 x 17¾ in.
Signed: Otis Kaye
Private Collection

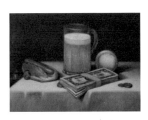

Play Ball, 1954
Pastel and pencil on paper mounted on masonite, 12¾ x 18 in.
Signed: Otis Kaye
Private Collection

Will You Play Ball?, 1954
Pastel and pencil on paper mounted on Masonite, 12¼ x 17¼ in.
Signed: Otis KAYE 1954
Private Collection, Illinois

APPENDIX 8: ORIGINAL LETTERS

<u>1937 Two Paintings</u>

37 München Freitag 8:20 AM

Lieber Paul u. Bess

G. Gott! Ich bin zurück von Dresden. I visited old school pals and found nothing in common with them; also Oskar would not come home! I can do nothing with him. I tried to repay Frau Goldstein's kindness to him with a gift of two paintings I brought with me—a $1 u. a $5 with coins. I inscribed them to her on backsides as I always do to the relatives, but she said, "Ich will es nicht!" She refused me! Her nephew, Horst, took me around München for drinks. We had a nasty time with a drunk in a bar—the son of a bitch! over Roosevelt's politics. I've done no painting here and will not do any—no time! I am surely sorry you helped send me here. After having shown the couple of paintings I brought with me to Mr. Kisselman, I was forced to sell them to him because of the very high praise he expressed. It seemed to touch the humor in him, even after I told him what they meant. He said he didn't care. I think you hit the mark—things are really booming here—but believe me—I'll be happy to return home.
Wishing and waiting, Otis

*Grüsse und Küsse an Euch alle!

4 June 1942 JJ Byllesby & Associates

J.J. Byllesby & Associates
INDUSTRIAL ENGINEERS
14 So. LaSalle St.
Chicago 20, Ill

Copy Ph. RA 3-7376
PB BANKS PRES. O. KAYE Consulting Eng.
6-4-42

Mr. John J. Jones Works Manager
Western Elec Co.
Hawthorne Station 30 Chgo Ill.

Dear Mr. Jones
Re: Proposal of Manufacturing Facilities
For Production of 100,000 (Plumbing) Ballcocks per month

Enclosed herewith are three drawings, namely; the material (raw & purchased parts) flow chart, the floor plan and the plot. The three drawings considered together comprise a so called proposed "plant layout" scheme.

In determining the capacity of the proposed plant, it was decided [deleted *taken into account*] that 103,000 ballcock assemblies would have to be made to assure 100,000 (customer) acceptable ones. The additional 3000 would make up for expected scrapped parts on assemblies.

Provisions for the plant capacity to produce 150,000 ballcock units [54,500 (total) including scraps] are included in this plant plan.

These provisions consist in removing certain walls, relocating portions of aisle area to provide more space – area for additional machine units by presently allocating more ground space for plant expansion in terms of more floor space, re., expansion [deleted *along*] in the horizontal level [deleted *floor*]. Vertical expansion is not considered in this plant layout because of the ground area available, which is more than ample for this project.

194?? Visit to Sr. Laurencia

Sunday 12:00 PM

Dear Bess & Paul

Tony and I took your advice on that De Soto; the result was the solenoid was bad—as you suspected. Once that was accomplished, we went out to Lisle to see Sister Laurencia to cheer her up a bit. She looks much stronger now—but then always did maintain a frail pious manner.

Because She always liked the dwg. [drawing] of the crucifixion I let her have it for a while and will exchange later. Frank & Ada and the kids were visiting on Sunday—but just missed them by an hour. Sister said Ada wants you and Bess to visit after they return from the Dells.

Sister was delighted when I showed her "Musical Notes" & was quick to see the dollar sign the bills make in conjunction with the violin. But of course she missed the cross that the wood makes behind violin.

Tony pointed out to her the coins & flags that have numerical and musical equality. He intervened in time. She doesn't like anyone to play around with religion—as you well know!

Paul, she still has ill will against you for designating God as just pure energy—devoid of religious interpretation. Better not pursue that philosophy with her. You must realize she went into the convent as a kid and has no relevance to contemporary life.

Still she wants to see you and the kids more often. There! Consider your hand slapped!

Tony Skeetchok and I are taking you to the Oak St. Beach—or maybe the 77th St. beach next week. No excuses!

Yours truly, Otis

*you can't wear that old black suit or we will put you under the sand

24 May 1944 Baltimore Visit

5-22-44 3:00pm Baltimore

Dear Paul,

There wasn't a room to [delete to] be had in town for love or money. The hotel said there was no reservation for JJ Bill. Apparently you can bribe anyone in Wash. except hotel managers. As last resort I have to stay with Charlie Ashe and his wife (bastard and bitch) at his wife's house—until I can pin down our man on those contracts—may take more than we're willing to give.

Housing is a disaster everywhere. Bess, you were right when you wanted Paul to buy two bungalows. Since you paid $4,500 in '40, you'll surely make money.

And you were right to push him to make the name change legal. I wish my father had done it. You know my choice for you—SKNAB—just a joke!

I'll complete my task in 2 ½ wks. and hop a train back—sitting in someone's lap no doubt. Trains are true cattle cars.

Wish me luck,
Otis

[Envelope] Mr. & Mrs. Paul Bancak 7729 So. Seeley Chgo Illinois
[Postmark] Baltimore MD 9AM

<u>5 November 1944 Land of the Free</u>

10:30AM 11-5-44

Dear P. & B.

Within 10 days I should return to Chicago—my foot infection still hampers much moving about without the use of the cane, [deleted *enter*] which renders me dependent too much on others. Otto Drexler came here to the house, but I was sleeping so Ada gave him my modifications of your gyro questions (K = 0.75 is the correction of importance.)

Frank is still planting too many trees; if he doesn't stop, he'll have a forest in a few years.—

Bess—last week Ada said Grossmutter Hoffman cried deeply when Harry told her Donald was missing in action. When I met Don at your house, I was impressed—he is a nice kid. It is always the young who pay the most in these hellish things—that rotten bastard Fuhrer!

Paul—I'm angry and want to strike back, so with much free time these days, I started to piece together a large ptg [painting] about this damn war. In it I try to relate all American wars by their common factors: a rifle and money You know I think greed for the power of wealth is the basis of war—hidden behind cheap philosophies—But you've heard all that before!

Fast hätte Ich die Hauptsache vergessen!

When you return from Detroit with those contracts, give your little boys a hug for me from old uncle Otis

Grüsse und Küsse an Euch alle,

Otis

1946 Etching note to Fritz Hofmann

F
This is a man to man talk & not to be construed as a formal complaint—But
If you cannot personally use your own head as a printer
then let this be my complaint:
prints are too dense!
Don't run away from a problem—
Solve it!

Response from Fritz:
Otis Go to Hell!
Fritz

Note on Print of $1 Bill in red ink

Fritz great job on this
Saw $500 $1000 n A Bank Exhibit in Chgo.
I made dwgs! How about a try?

Otis

<u>30 May 1950 Colorado</u>

5-30-50 4:00 Colo

Liebe Paul,

Finnally [sic] got started after weeks of urging by Eddy; he, Fritz and I stopped work—we told Grössmutter Hoffman and Albert to watch the house u. cats. Eddy and I fixed his truck to top performance.

After an Omaha stop for fuel, we got a flat on the grounds of the gas station!

Colorado is everything anyone ever said about it. I plan to start H2O's u. landshaften [sic]. Your kids would love it here—horseback riding u. hiking—
Get off your ass u. take them.

Eddy met some woman at a bar, he's going on a date tomorrow.

Wonders never cease!

Viele Grusse Otis

[Envelope] Mr & Mrs Paul Banks 77 29 Sol Seeley Chicago Illinois
[Postmark] June 1 5:30 PM 1950 COLO

<u>**21 February 1966 Letter to Paul and Jeri Banks**</u>

2-21-66 4:30 pm NY

Dear Paul Jr. & Jeri,

Congratulations, Cookie, and Jeri (of whom I hear from everyone) your beautiful brilliant wife. That I missed your wedding was unavoidable and sad to me. I had some business to conclude here in this fast city. It's very fast—but I can still go!

Most unfortunate of all is not getting to kiss the bride. Jeri, can you give a geezer a raincheck on that point? Did you find Europe pleasant? Whenever you kids can get over to Ada's in Dyer, please select 2–3 good size pieces of my work stored there or take the Big Aristotle. And I do mean big. Paul, you'll need a truck to do the job. I say, when anyone gives, Take with both hands! I'll inform Ada of your coming.

With affection, Otis

[Envelope]
Mr. & Mrs. Paul Banks JR.
5750 South HERMITAGE AVE.
CHICAGO, ILLINOIS

Lincoln Square Motor Inn Facing Lincoln Center 66th and Broadway, New York, NY 10023
[Postmark] New York NY Feb 23 1966

Undated Letter to Bess and Paul Banks II

Monday NY Bess & Paul

Dear Bess & Paul

This is the first day in five that I have been feeling well enough to write. After supper I went outside to shop. I took a bus from 58th & Broadway to 34th St. & Broadway. Macy's is located here. Did not go in, but found a men's shop where I bought a good pair of pajamas for $2.00 and 4 pairs of socks for $2.50.

When you take the bus during the rush hour, one gets a good cross- section of masses of the people in [deleted *of*] N.Y. City. The faces seem le[ss] animated than when I was here as a young man many years ago. Enclosed find three [deleted *fo*] good drawings of people I will use in larger paintings.

Please store them in the pink box next to the large ptgs. [paintings] at [deleted *in*] Frank & Ada's house. Make sure they face each other with cardboard between—like we did on Ruble St. Remember how Ada dusted the pastel I gave her, thinking it was an oil. I was so angry at her.

Saw a horse & buggy moving thru the cabs & busses mess (over) toward central park. The horse had blinkers on. It was nice to see something from the old days. If I have time, I would like to look up some of the fellows I knew many years ago. They're probably all curled up by now.

I will drop you a note when I get settled in Dresden. I hope [deleted *heard*] you're still not attacking the church, Paul, they have some fine points!

Good health to Bess & the kids & (watch Ada)
Otis Kaye

P.S. How much did you get for the old house.
O.

29 May 1967 Condolence Letter

5-29-67
3:00 PM
Chg.

Liebe Bess,

I just got back from Mich. this moment and Joe told me of Paul's passing. A phone call would have been inappropriate at this time.

Sknab was like a brother to me. He's gone but is forever in my heart—as you are. His quick wit was always a challenge to me. You're lucky to have the kids.

Joe is renting me one of his flats for a month, but I'd like to stay with you for a day or two—if you can put me up? Since Toddy lives near you, I'd like to see him too before my plans take me to Europe. Eddy u. Fritz are interested in coming with me, but Eddy is tied to Tremont's grain elevator u. Fritz is not reliable—as you know. I may or not make it to Dresden; however, I would attempt to look up your dad's folks in Bonfeld.

With deep regret,
Otis
*see you soon!

Undated Calculus

Calculus
FRAUD INC.

Calculus is a higher branch of mathematics, [above a tree with small drawing of a tree] It is a higher
but not more [deleted *different*] difficult to understand than arithmetic, trigonmetry [sic] algebra [above
interline *it stems from the same tree*] [deleted *etc*] branches [above *LIMITS*] which deal with fixed quantities.
(How much do you want to expand). The derivative is a mathematical [deleted *mathematic*] device used to
represent the <u>Point</u> properties of a curve and function.

TIME—No Mathematician [above *or Physician*] invented anything in this Universe—it was there before he
was born. These scholars merely observed what was happening in their living living [sic] period of time.

The <u>TIME</u> Quantity Quantity [sic] is the ALL IMPORTANT FACTOR IN OUR EARTHLY LIFE a split
second difference can mean life or death.

The Fraud of Costumes
(1) Priests of all religions use costumes to set themselves apart from their arbitrarily imagined or better yet from their fraudulent
(2) Apes—& their costumes to hide their ape nature
(3) [deleted *Apes have an*]—& their
(4) [above *seemd*] The Ape—is always striving to hide his true nature by costumes, talk, social status, manner of walk, gaining favor of false friends, joining clubs, being a dastardly do-gooder,
(5) A do-gooder is a goof who is used by a money hungry (confidence man) to solicit hard earned money from thousands of factory workers

Undated What did they have?

What did they have? Poverty, subjugation of the intellect. The people were classed as animals. The Czar, the ruler, brought about Communism.

The dreadful Gestapo, or some Russian counterpart was the invention of the Czars, the Kaisers, the ruling classes of parasites—Patience, as the Negro would say—just have patience. Things will right themselves. Just be patient.

Let us not condemn for not having religion! Because they have seen that religion was a playing partner of the rulers. How could you expect them to embrace religion when the religious were part rulers of the country. The Rulers and their religious minor rulers had a strangle hold on the people. Why did Communism have to be. Because they had no choice. Either be ruled by they best [illegible] beings or fight.

APPENDIX 9: LIFE MAGAZINE ARTICLES NOTATED BY OTIS KAYE

Article: *Burchfield's America*
Published: December 28, 1936
Note:
Wild sold his first painting for 25 cents not $25

Article: *Associated American Artists*
Published: October 11, 1937
Note:
Checked reproductions of works by Thomas Benton, George Elmer Browne, John Stuart Curry, Peter Hurd, Raphael Soyer, Grant Wood

Article: *European Artists Sweep Carnegie Show*
Published: December 20, 1937
Note:
I don't know what the hell it is!
junk
fine, clean design

Article: *European Artists Sweep Carnegie Show*
Published: December 20, 1937
Note:
junk
fine, clean design

Article: *The Frick Collection*
Published: December 27, 1937
Note:
Best!

Article: *A Terrible Blunder Puts Japan's Ambassador on the Anxious Seat*
Published: December 27, 1937
Note:
doodle

Article: *England's Greatest Portraitists in America*
Published: January 24, 1938
Note:
grid lines for scaled reproduction

Article: *Dreams of Adolph Hitler and Benito Mussolini*
Published: March 28, 1938
Note:
two bastards!

Article: *Benton Nudes People the Ozarks*
Published: February 20, 1939
Note:
I can't draw. Good.

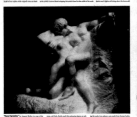

Article: *Metropolitan Museum*
Published: March 20, 1939
Note:
Phrases indicated:
show man's higher self

Rodin made his embracing figures sublimely sensuous as Wagner's great love music.

Article: *Metropolitan Museum*
Published: March 20, 1939
Note:
Phrases indicated:
valued today at $400,000. At Rembrandt's death in 1669, his works sold for 6¢

$87,000. She gave it to the museum in 1929.

Article: *Grant Wood Paints George Washington*
Published: February 19, 1940
Note:
too simple

Article: *The Death of Dillinger*
Published: March 11, 1940
Note:
Ugly!
No form – depravity

Article: *The Death of Dillinger*
Published: March 11, 1940
Note:
Ugly!
No form – depravity

Article: *Renoir Painted Hundreds of Pictures of Gabrielle*
Published: August 3, 1942
Note:
not all good

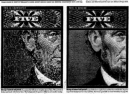

Article: *Counterfeit Money*
Published: Aug. 24, 1942
Note:
like nitric acid use 2HCL acid finer line

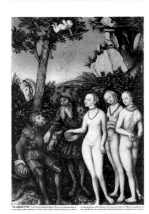

Article: *City Art Museum It is the Great Pride and Problem of St. Louis*
Published: November 9, 1942
Note:
We like Durer better

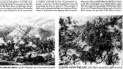

Article: *Speaking, of Pictures*
Published: June 21, 1948
Note:
Sketching on reproductions of several versions of Custer's Last Stand

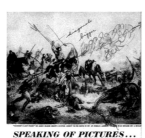

Article: *Speaking, of Pictures*
Published: June 21, 1948
Note:
Sketching on reproductions of several versions of Custer's Last Stand
diagonals bigger

Article: *Artists Paint Michigan*
Published: August 23, 1948
Note:,
Why or burned!

Article: *How to Beat the Communists*
Published: August 29, 1949
Note:
Americans too liberal- should jail them.

Article: *100 Years of American Taste*
Published: August 29, 1949
Note:
doodle
cheap they fell apart wrong!
A lot of class for an Irishman

Article: *100 Years of American Taste*
Published: August 29, 1949
Note:
No—both bad

Article: *100 Years of American Taste*
Published: August 29, 1949
Note:
Hm-m!
looks like Ada

Article: *Sold: One Town*
Published: October 22, 1951
Note:
Nahma Michigan

Article: *Gems from the Greatest Collection of US coins*
Published: April 27, 1953
Note:
How about pennies—don't they count none located here?
Who are they!
Coins checked